KU-209-554

Publisher's Acknowledgements
Special thanks to **Wendy Williams** and **Jerry Gorovoy**, New York. We would also like to thank the following authors and publishers for their kind permission to reprint texts: **Editions Julliard**, Paris; and the following for lending reproductions: **Cheim & Read**, New York; **The Estate of Robert Mapplethorpe**, New York. Photographers: Berenice Abbott, Anders Allsten, Peter Bellamy, Christopher Burke, A.C. Cooper, Nancy Crampton, Frédéric Delpech, Andrew Dunkley, Claudio Edinger, Allan Finkelman, Zindman Fremont, Blake Gardner, Donald Greenhaus, Eeva Inkeri, Marcus Leith, Armin Linke, Jochen Littkemann, Rafael S. Lobato, Robert Mapplethorpe, Attilio Maranzano, Christian Martin, Helaine Messer, Peter Moore, Sebastian Piras, Ernst Scheidegger, Marcus Schneider, Aaron Siskind, Lee Stalsworth, Andrea Stappert, Nicholas Walster.

Artist's Acknowledgements
Wendy Williams and Jerry Gorovoy, John Cheim and Howard Read of Cheim & Read, New York, Karsten and Claudia Greve of Galerie Karsten Greve, Cologne.

All works are in private collections or owned by the artist unless otherwise stated.

Phaidon Press Limited
Regent's Wharf
All Saints Street
London N1 9PA

Phaidon Press Inc.
180 Varick Street
New York, NY 10014

www.phaidon.com

First published 2003
Reprinted 2004, 2007, 2008
© 2003 Phaidon Press Limited
All works of Louise Bourgeois
are © Louise Bourgeois

ISBN 978 0 7148 4122 9

A CIP catalogue record of this book is available from the British Library.

Designed by Ben Dale (Onespace)
Printed in Hong Kong

cover, front, **Precious Liquids**
1992
Wood, metal, glass, alabaster, cloth, water
425.5 × 445 cm
Collection, Musée National d'Art Moderne, Centre Georges Pompidou, Paris

cover, back, **Endless Pursuit**
2000
Blue fabric
45.5 × 30.5 × 30.5 cm

page 4, foreground, **Maman**
1999
Bronze, stainless steel, marble
h. 927 cm
background, **Spider**
1996
Bronze
h. 326.5 cm
Installation, State Hermitage Museum, St. Petersburg, Russia, 2001

page 6, **Louise Bourgeois**, 1993
background, **Shredder**
1983
Wood, metal
211 × 150 × 211 cm
foreground, **Spider** (in progress)
1994
Steel, glass, water, ink
116 × 198 × 172.5 cm

page 26, **The Winged Figure**
1948
Bronze, paint
179 × 95 × 30.5 cm
Collection, National Gallery of Art, Washington, DC

page 94, **Cell (You Better Grow Up)** (detail)
1993
Steel, glass, marble, ceramic, wood
211 × 208 × 212 cm

page 104, **No Exit**
1989
Wood, painted metal, rubber
209.5 × 213.5 × 244 cm

page 144, **Louise Bourgeois**
with her parents, *c.* 1915

Robert Storr Paulo Herkenhoff Allan Schwartzman

Louise Bourgeois

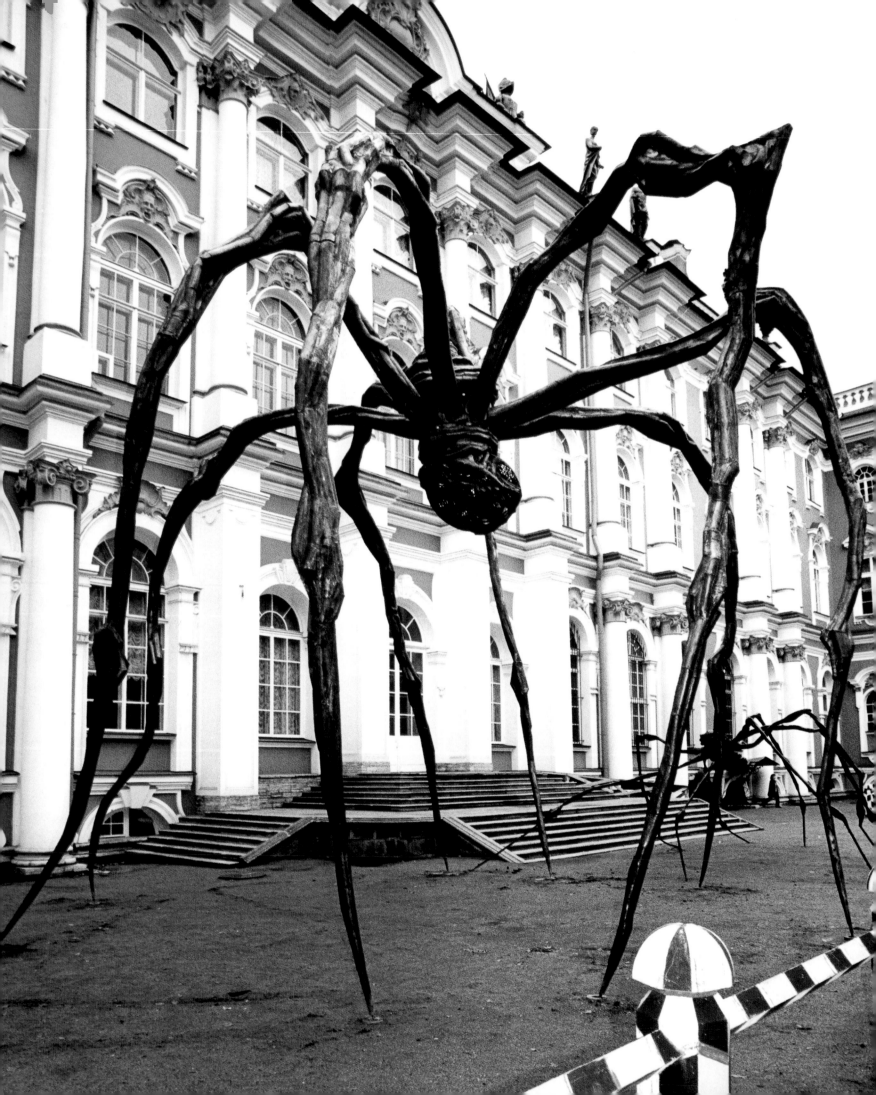

Contents

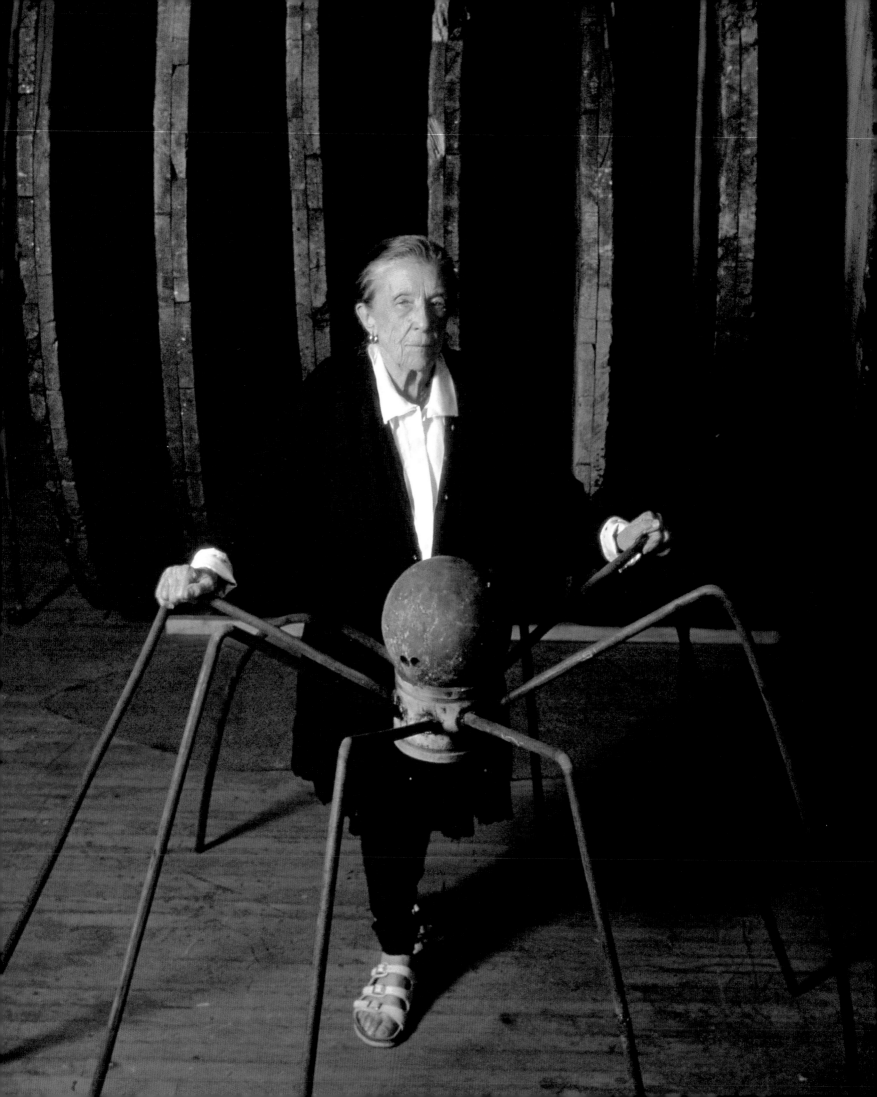

Contents

Interview

Paulo Herkenhoff in conversation with **Louise Bourgeois**, transcribed and edited by **Thyrza Nichols**

Paulo Herkenhoff in conversation with **Louise Bourgeois**, transcribed and edited by **Thyrza Nichols Goodeve**

Louise Bourgeois **Let us get something clear before we begin. In general I don't need an interview to clarify my thoughts. It is absurd, a pain in the neck! Interviews are a process of clarification of other people's thoughts, not mine. In fact I always have to know more about you than you know about me. All the same I like to be crystal clear when I speak. I like to be a glass house. There is no mask in my work. Therefore, as an artist, all I can share with other people is this transparency.**

Paulo Herkenhoff You have always kept a diary, ever since you were a child. Moreover, you write on the backs of your drawings and you take notes. All this writing must have a very clear meaning for you.

Bourgeois **I use these writings for clarification. I worship transparency. I search for transparency. You see, there is no mask in my work. I am perfectly at ease with language, so much so that when I married somebody who did not speak my own language, it did not make any difference to me. I learn your language, you learn my language. In the end it does not matter, because the language of the eye, the intensity of the gaze and the steadiness of that gaze are more important than what one says. Language is useful but not necessary. You cannot fool me in the visual world, but you can get the better of me in the verbal world.**

Jerry Gorovoy [Louise's assistant of twenty years] When Louise is writing it is very spontaneous. Very direct. Her writing flows so tightly, as if in direct contact

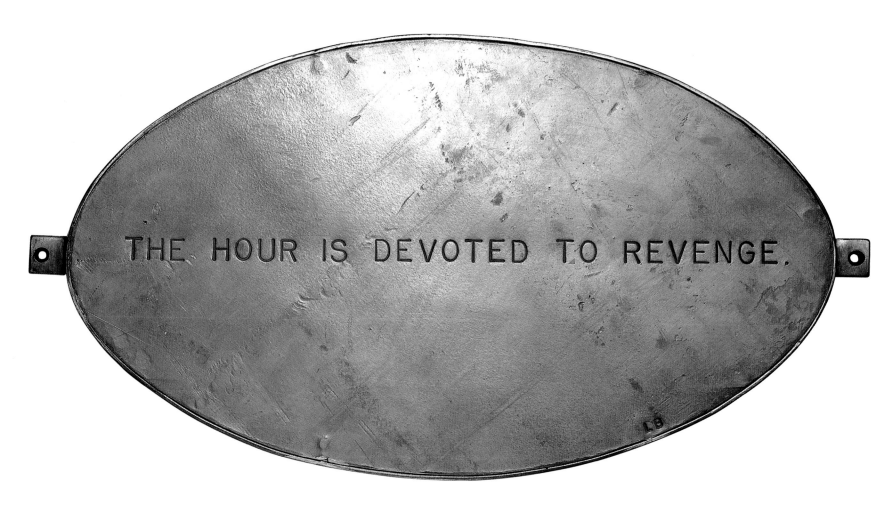

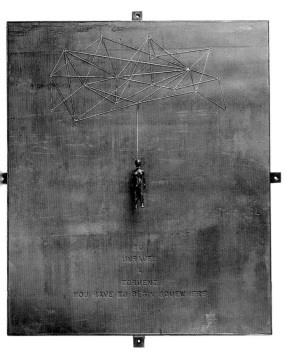

above, **Torment**
1999
Wall Relief: steel, thread and lead
68.5 × 63.5 × 4 cm

opposite, **The Hour is Devoted
to Revenge**
1999
Wall Relief: steel and lead
28 × 54.5 × 1 cm

with the subconscious. I've seen Louise write something on the back of a
drawing and when she reads it again she sometimes can't even remember
where it came from.

I can tell you the six key events in Louise's early life: the first is the
introduction of Sadie, the children's governess, into the family and Sadie's
ten-year relationship with Louise's father while living in the house. The second
is the death of her mother in 1932. The third, her marriage to Robert Goldwater
in 1938; the fourth, their moving to New York. And then there was the adoption
of Michel in 1940 followed by the birth of Jean-Louis that same year.

Bourgeois **The most important event in my life was the birth of Jean-Louis.
He was born on the 4th of July. He was born early; he was supposed to be
born on the 14th of July.**

Herkenhoff Your children took the name Bourgeois, not Goldwater. Why?
Was this your choice?

Bourgeois **No. My father wanted descendents, and since nobody else in the
family had any children at the time he thought my children should take the
name Bourgeois.**

Herkenhoff What were your biggest losses in life?

Bourgeois **The death of my husband and the death of my mother. So, 1932
and 1973 are dates that I cannot forget.**

Herkenhoff So, your mother died before you left for the United States?

Bourgeois **Yes; that is why I came to the United States. My father had lovers
all the time. It was a family situation that I could not stand. I come from a
dysfunctional family.**

Herkenhoff You never really positioned yourself as a foreigner in New York.
The role of the foreigner, Julia Kristeva has argued, is that of being the revealer
of a hidden significance in a community.[1] Louise, could you give me an
indication of that?

Bourgeois **I have no desire to express myself in French. I am an American
artist.**

Herkenhoff Do you vote in the United States?

Bourgeois **Certainly. It is a crime not to vote. I am a registered Democrat.**

Herkenhoff You have spoken at length about the effect of your father's
authoritarian role over you and your family when you were growing up. Since he
was so controlling, how did you assert yourself in relation to him?

Bourgeois **Probably the best answer to that question is to speak of my trip to
Russia in 1934, at the suggestion of my instructor at the Sorbonne in Paris,**

Paul Collin. Ostensibly I went to Russia to see the Moscow subway. I went as a reporter for *L'Humanité*, I was going to publish an article on the subject. The trip was an act of political independence.

Herkenhoff Were you a Marxist? Did you belong to the Communist Party?

Bourgeois I mean political in the sense of rebellion against the father. The trip was an investigation and an expression of that rebelliousness. My independence was due to the fact that my father did not have to pay for me. You know, to be supported by your father is a great responsibility.

I do not remember feeling anything at the time. I was just moving, moving on. You know, it is very difficult to remember – even if it is indispensable, to remember. Memory has become so important to me because it gives me the feeling of being in control, in control of the past.

Herkenhoff It is quite interesting how you tamper with time by retouching photographs. You rearticulate what was frozen by photography.

Bourgeois The technique of photo retouching was my first paid job. You are speaking of the photo of Deauville? I wanted my vision of my brother and myself undisturbed, so I took the unwelcome presence – Sadie – out. I did it because it gave me pleasure to suppress her presence. It made me feel omnipotent. You see, I do not have to be generous but I must be consistent.

Herkenhoff Would you say you played God when you took Sadie out of the photograph? Is there a relationship between retouching a photograph and mending or reparation?

Bourgeois It is just that I did not want the past exposed in the way it was in that photograph. I wanted my own vision of the past. In fact I felt very guilty when I did the re-touching. To exclude or obliterate my own father reminds me of the death of my dog. It is like when my father buried my dog in the backyard. He did not dig deep enough, so every time I went to the yard I would see that mound where my dog had been buried. My father was just too lazy to bury him correctly. So the dog continued to exist. It is like this with these photographs with Sadie. I must bury them properly or they will not go away. But the truth is I don't need a photograph to remember. Photographs allow you to forget or forgive.

Herkenhoff Do you like to be photographed?

Bourgeois No, I detest it. I am not what I look like. I am my work. I cannot escape being myself all the time. I wish I was a loser. I would be less black and white. Less rigid.

Herkenhoff Which photographs of yourself do you like most?

Bourgeois You know, when I went to have my photograph taken by Robert Mapplethorpe I took the sculpture *Fillette* (1968) as a precaution. In truth I think very little about photographers. Very seldom are they intelligent. When I went to pose for Berenice Abbott I was careful to put on my see-through

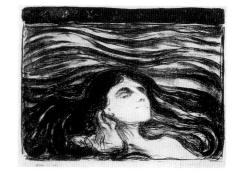

dress. I put on my very best clothes. I was trying to help the photographer. And I did the same thing for Mapplethorpe.

Herkenhoff In your portrait, Berenice Abbott emphasized your head. It is like a monument. It is an architectural portrait of the *femme-maison*.

Bourgeois **Yes, as if I were looking up, looking for the future. Berenice was interesting. She had clients who asked her to photograph people or furniture but she was really interested in buildings. But you know, I am not really interested in my photo-biography. It may be useful but I have no interest in it.**

Herkenhoff Why have you never made a realistic self-portrait?

Bourgeois **Because I am not interested in myself. I am interested in the Other. The purpose of the Salons on Sundays was for people to talk about themselves, not about me. 'I, me, myself' horrifies me.**

Herkenhoff Would you say there is a feminine geometry? What is the importance of geometry in your work?

Bourgeois **Stability. As in life, in my drawings a woman's hair is either well-organized, carefully braided and parted, or dishevelled. There is a message in either case. In the first case, the girl is in control of herself, is self-confident, but in the second, the dishevelled girl is subject to depression. So there is another connection: a dishevelled girl is melancholic. Munch drew a dishevelled woman in the water, her hair was mixed with the water, like Shakespeare's Ophelia. Thus I am saying that there is a feminine geometry. A torsade is something that revolves around an axis. This geometry is founded on poetic freedom and promises security.**

Herkenhoff Is there a job which you think suits your character?

Bourgeois **One of my jobs is to wind the clocks in the house.**

Edvard Munch
Lovers in the Waves
1896
Lithograph
31 × 42 cm

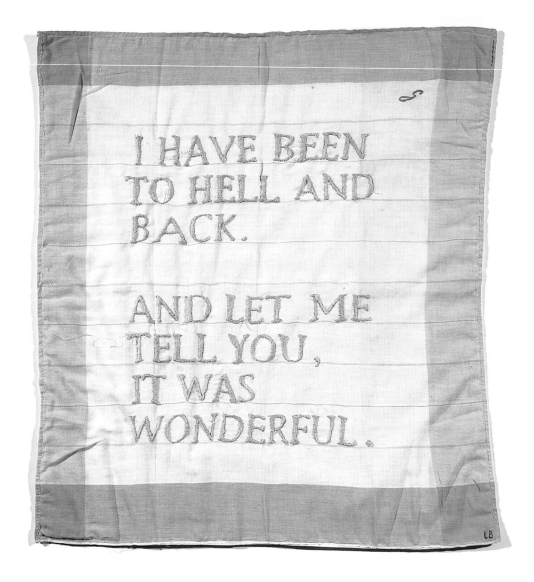

left, **Untitled (I Have Been to Hell and Back)**
1996
Mixed media sewn on fabric handkerchief
49.5 × 45.5 cm

below, **Rejection**
2000
Magic marker on handkerchief
31 × 30 cm

Herkenhoff You always pay attention to small details and from there you draw major conclusions, so I would like simply to ask, why is winding the clocks important to you?

Bourgeois **Because to rewind is to make a spiral. And the action demonstrates that even though time is unlimited, there is a limit to how much you can put on it. As you are tightening the spiral you must take care. If you tighten too much you risk breaking it. It is the same with sewing. Sewing without a knot at the end of the thread is not sewing. In this sense the spiral is a metaphor of consistency. I am consistent in my spiral. For me there is no break. There is never an interruption in the spiral because I can not stand interruptions.**

Herkenhoff You said that forgetting bothers you, that it is a suffering.

Bourgeois **Yes. It is tiresome to look and not to find. It proves the impotence. It is a manifestation of impotence**

Herkenhoff Before this conversation started you said you had a topic for us.

Bourgeois Here is a subject that interests me today: *l'attente/attendre* [the wait/waiting]. What is going on in your head when you wait?

Herkenhoff In your work, waiting is a projection of your fears of abandonment, fears of being rejected, fears of being forgotten.

Bourgeois Waiting makes the other too strong. When one waits one is dependent. Waiting for the phone to ring. Waiting when the phone does not ring. Sartre said, '*l'enfer c'est les autres*' [Hell is other people]. And for me, *l'enfer d'être sans toi* [the hell of being without you], the absence of the Other. If you have been rejected, you can rebound. You have been rejected, but you don't have to die on the spot.
 Let's focus on the issue of jealousy because it is the most interesting subject. The question is: do you admit it? Jealousy is not humiliating, it is painful! Unconscious jealousy is the topic of Françoise Sagan's book *Bonjour Tristesse* (1954). It is more threatening than conscious jealousy, which is not really dangerous because it is out in the open.

Herkenhoff What about envy and jealousy? They are not the same thing.

Bourgeois Let's go to the dictionary.

Herkenhoff From the Oxford English Dictionary: envy, 'mortification and ill-will occasioned by the contemplation of another's superior advantages'; jealousy, 'solicitude or anxiety for the preservation or well-being of something. The state of mind arising from the suspicion, apprehension or knowledge of rivalry.'

Bourgeois You see? Jealousy is the more interesting. It has to do with preserving the well-being of something. My father and my mother were jealous over which of them I liked most! Jealousy and abandonment are common feelings for young boys and girls.

Herkenhoff What about the relationship between jealousy and fear?

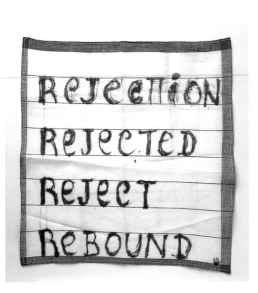

Bourgeois We can answer that with the story of Penelope in Homer's *Odyssey*. Why does she make the tapestry? Because she is afraid Ulysses will not return. It is a question of defeating fear, a question of coming to terms with fear. You convert the menace, the fear, the anxiety, through the redemptive force of art. *[Louise takes Paulo's notebook and writes the following poem in red pencil:]*
 Quelle est la couleur de la peur? [What is the colour of fear?]
 Quelle est sa chaleur? [What is its heat?]
 Quelle est sa valeur? [What is its value?]

Herkenhoff What are your reactions when you feel impotent?

Bourgeois *Quand les chiens ont peur, ils mordent* [When dogs are afraid, they bite]. If you make me impotent, I reach for my dagger. There is also the anger of understanding, the anger of travelling, the anger of pardoning.

Herkenhoff Your print *What is the size of the problem?* confronts two apparently similar and yet different zones? Is it an unfaithful mirror?

Bourgeois The print is related to the ambivalence of perception. The printing was done after a drawing and a quotation from the 1940s. Ambivalence is for the emotions. Ambiguity is for the brains.
[Louise reaches for the tiny bottle of Shalimar perfume that she always keeps at her desk and opens it to enjoy the perfume.]

Evanescence and stability are the ground of some of my feelings. The fear of losing – this is very important for me. Evanescence means a come-and-go. The evanescence of memories is very important. You have souvenirs which appear to you and then all of a sudden disappear. Evanescence gives birth to the fear of losing. I want to give my work permanence.

Herkenhoff So, Louise, you fight between evanescence and permanence.

Bourgeois A spiral is also a metaphor for consistency in my drawing. The soul is a continuous entity. I am consistent. You can trust her because she is consistent. If Louise tells you that she loves you she is not likely to change her mind.

Herkenhoff Fear is the thing? The result? Your work resists the idea of suffering. Does suffering ever have something to do with sculpture?

Bourgeois No, because it is too vague. How can art save someone from suffering, from insanity? You have to ask a doctor. I can not answer that because I have never been there. I carry my psychoanalysis within the work. Every day I work out all that bothers me. All my complaints. This way there's always a component of anger in beauty.

Paulo, let me write in your book.
[She writes in red pen:]
I do
I undo
I redo
[Underneath she draws a large circle with the phrase 'the pregnant O'.]

That is the beauty of the drawing. Drawing opens our eyes and the eyes lead to our soul. What comes out is not at all what one had planned. The only remedy against disorder is work. Work puts an order in disorder and control over chaos. I do, I undo, I redo. I am what I am doing. Art exhausts me. Yet I work every day of my life.

Herkenhoff Do you lose the notion of time when you are carving or drawing?

Bourgeois Of course you lose track of time. You follow the pleasure of the activity of drawing. You do not care what the result is going to be. All the connections are unconscious. You do not know where you are going to end. It is a journey without an aim.

Herkenhoff The unconscious brings up Surrealism, a term you reject when applied to your work.

Bourgeois I was not a Surrealist, I was an existentialist. That is the magic word. I love the literature of Albert Camus. I despise nihilism, however.

below, **Untitled**
c. 1970
Paint on board
119.5 × 150 cm

opposite, foreground to background,
I Do
1999–2000
Steel, stainless steel, fabric, glass, wood
1,651 × 600 × 600 cm
I Undo
1999–2000
Steel, stainless steel, wood, glass, epoxy
1,300.5 × 450 × 350.5 cm
I Redo
1999–2000
Steel, stainless steel, marble, fabric, glass, wood
1,750 × 899.5 × 600 cm
Installation, Turbine Hall, Tate Modern, London, 2000

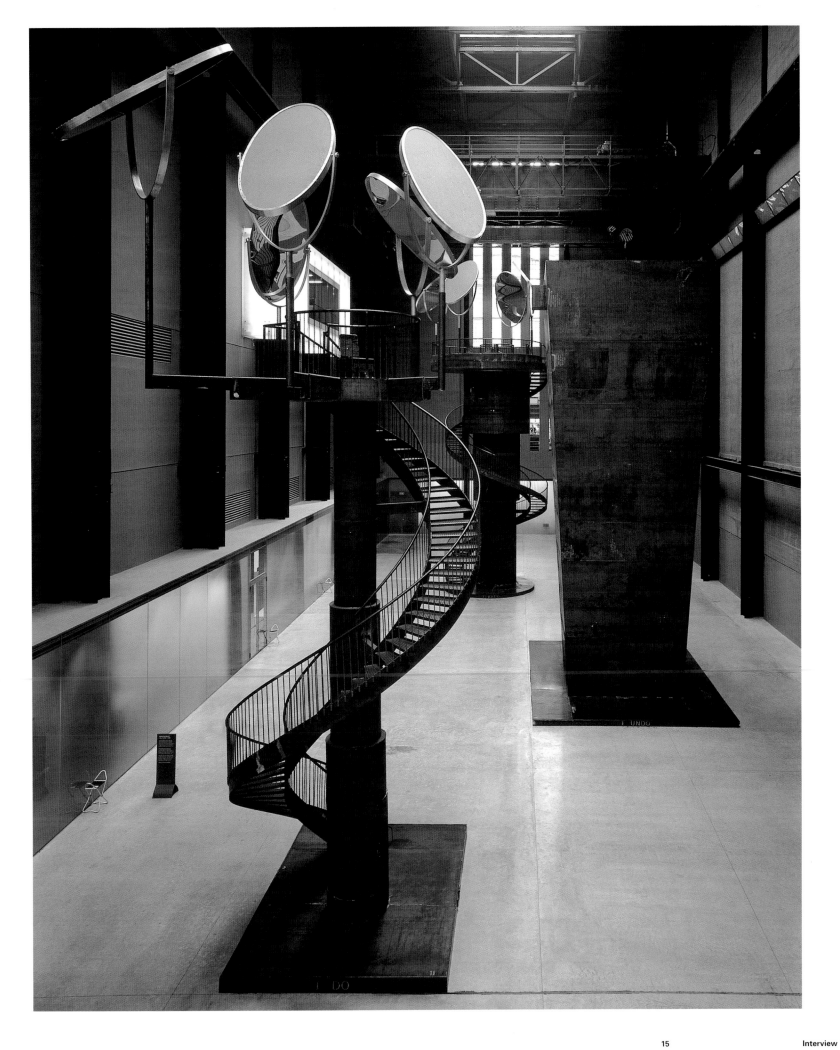

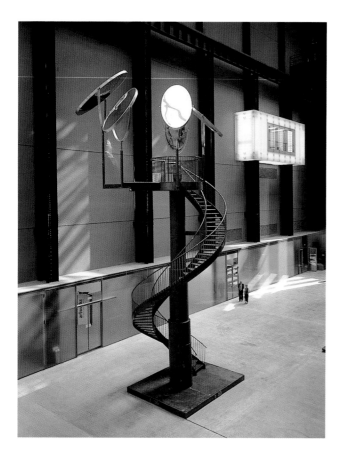

I Do
1999–2000
Steel, stainless steel, fabric,
glass, wood
1,651 × 600 × 600 cm
Installation view and details,
Turbine Hall, Tate Modern,
London, 2000

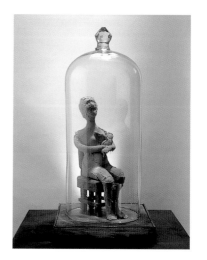

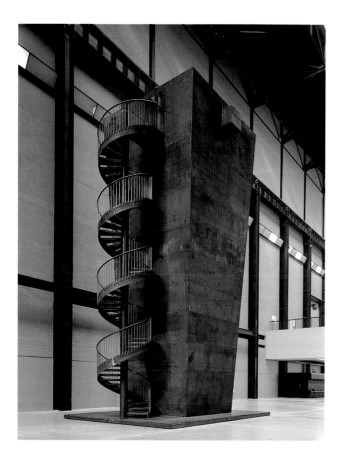

I Undo
1999–2000
Steel, stainless steel, wood,
glass, epoxy
1,300.5 × 450 × 350.5 cm
Installation view and details,
Turbine Hall, Tate Modern,
London, 2000

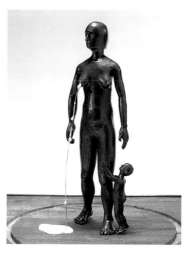

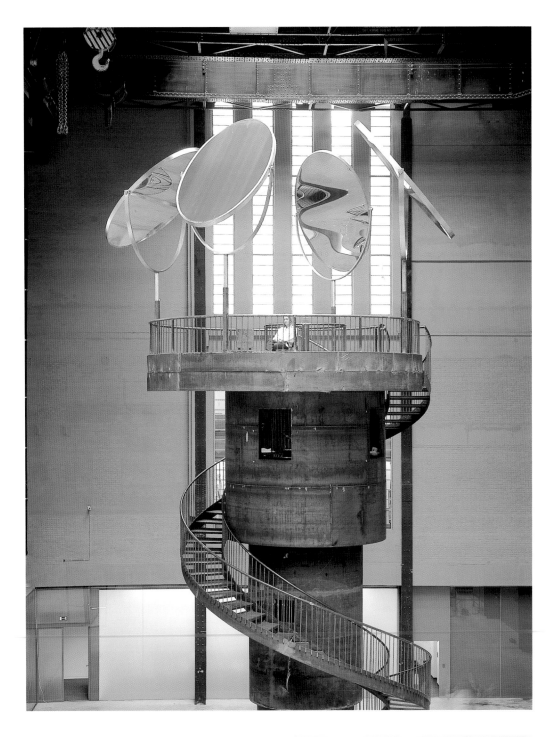

◄ **Redo**
1999–2000
Steel, stainless steel, marble,
fabric, glass, wood
1,750 × 899.5 × 600 cm
Installation view and details,
Turbine Hall, Tate Modern,
London, 2000

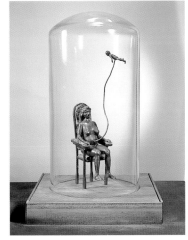

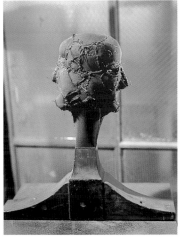

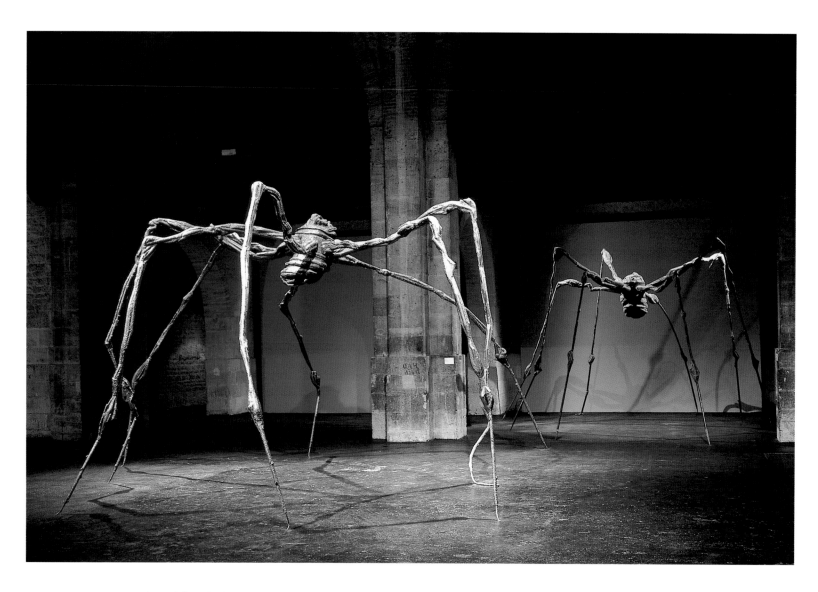

Herkenhoff You are an existentialist who fights back.

> Bourgeois **Perhaps. It is simply that looking is my job. But I am afraid of looking at things that confuse me. To be confused and not know you are confused is the definition of stupidity. Here you see my fear is not fear itself but the fear of being met by confusion. That is why I prefer images. An image never betrays you; if you look hard enough you will make order out of disorder. When I witness mental confusion in another person I fear contamination. Let me live in a world of image and I will never complain.**

Herkenhoff What do you think about the state of the visual world today? What do you think of the use of new media, such as computers, in the visual arts? You seem scared of computers.

> Bourgeois **I don't even know what a computer is. I don't think about it. It does not help me. It does not bother me.**

Herkenhoff So, what comes to your mind when I say 'the Web'?

> Bourgeois **Oh, I think of a spider's web, of course. She weaves her web. You know, *Ode à ma mére* has been a very important subject because it has been at the basis of all my spiders. It relates to industriousness, protection,**

, to r.,
Spider
1996
Steel
826 × 757 × 706 cm

Spider
1995
Steel, marble
812.5 × 655.5 × 787.5 cm
Collection, Musée d'art moderne
de la ville de Paris
Installation, capc, Musée d'art
contemporain de Bordeaux, 1998

self-defense and fragility. The spiders I have made over the last decade have been a big success. And I do not object to how such a statement might sound to others, because success is sexy!

Herkenhoff Is art not an obsession?

Bourgeois No. In art one must avoid obsession. Because obsession is a state of being. It is an unfortunate state of being. If you are possessed by an obsession you cannot function. Some artists are unsuccessful, non-pecuniary and yet very good. Some are derivative. Some are original. Ultimately to be an artist is a privilege; it is not a *métier*. You are born an artist. You can't help it. You have no choice.

Herkenhoff What is your process of creation?

Bourgeois Conception and realization of art. There is not one without the other, but the conception comes first. I can be contradictory from one piece to the other. The realization of a work may take place two or three years after the conception.

Herkenhoff Is there an emotion one can be possessed by and still make art?

Bourgeois Yes, compassion. Without compassion there is no work, there is no life, there is nothing. That is it. But at the same time art has nothing to do with love, it is rather the absence of love. To create is an act of liberation and every day this need for liberation comes back to me. In terms of making a statement in art, which do you prefer, to scream or to be silent? It depends on what you want. If you want attention, you scream.

Spider IV
1996
Steel, wall relief
203 × 180.5 × 53.5 cm
Installation, capc, Musée d'art
contemporain de Bordeaux, 1998

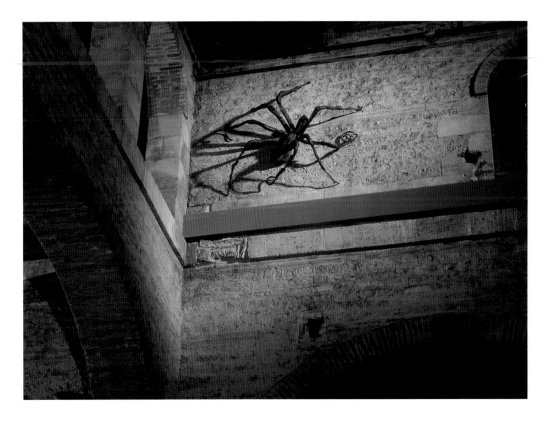

Herkenhoff Then what would be the value of silence?

Bourgeois **The gaze is much more important than words. Silence is intimacy. If there is a solid intimacy, the intervention of one and the Other is not necessary. The non-spoken is more important than what is spoken. Sometimes we are not sure that communication exists. Communication is not indispensable. I don't work to communicate and sometimes I wonder if I do.**

Herkenhoff In terms of body language, you say that the eyes play an important role. How do you relate that to art? Is making art a body language?

Bourgeois **It is the answer to a need. Actually, you don't know what the need is until after the work is done. With words you can lie all day long, but with the language of the body you cannot lie.**

Herkenhoff Is the body an existential sculpture?

Bourgeois **Oh yes, our body is being influenced by our life. And yet our body is more than the sum of its parts. We are after all more than the sum of our experiences. We are as malleable as wax. Descartes wrote about wax. We are sensitive to the souvenirs of what has happened before and apprehensive to what is going to happen after. Consequently, everything is energy. I experiment with people who are like iron – who are not malleable at all. I have no confidence in my ability to manipulate other people. The Moebius strip is a fascinating topological structure. It stands for the dance of desire. However, I represent the sexual encounter from the point of view of the woman. She won't let it go.**

Herkenhoff Tell me about your exhibition with Francis Bacon and Franz Xaver Messerschmidt, at the Cheim & Read Gallery in New York in 1998?

Bourgeois **We three are brothers under the skin. I identify myself with extreme emotions. Messerchmidt could also be the image of the father, or the image of the teacher, of someone superior. That I detest. I am the author of *The Destruction of the Father*. I am not following or referring to great figures of history. I am just doing my work according to the stream of life, the flow of life.**

Herkenhoff Certain objects incorporate the drives in your sculpture, such as clothing. Louise, is there a basic language of clothing?

Bourgeois **We must talk about the passivity and activity of the coming and going of clothes in one's life. When I come upon a piece of clothing I wonder, who was I trying to seduce by wearing that? Or you open your closet and you are confronted by so many different roles, smells, social situations. For me clothes are always someone else's. That is to say that I have never bought or made my own clothes. Never, never, never. Clothes are a gift, a choice, a test of the presence of a man to a woman. They are a test of taste. Does he see me like a balloon? Does he see me like a sylph?**

left, **Pink Days and Blue Days**
1997
Steel, fabric, bone, mixed media
296.5 × 211 × 183 cm.
Collection, Whitney Museum of
American Art, New York

right, **Cell (Clothes)**
1996
Wood, glass, fabric, rubber,
mixed media
211 × 442 × 365.5 cm

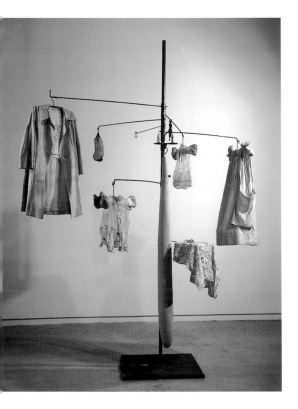

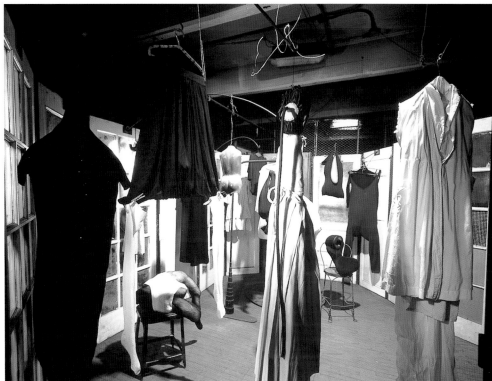

Herkenhoff You enjoy discussing styles and social references in couture, Roland Barthes and the semiology of fashion, or your private memories connected to clothing. Do you think you could have been a fashion designer?

Bourgeois **I could have become a designer of men's clothes, because of my interest in the elegance of men. I am not interested in women. One of my interests in men's clothes is sleepwear. Let's make it very clear – I mean only men's sleepwear, not women's. But in general, for myself, I believe in the uniform, because of the Lycée Fenelon of my youth where all the students wore a uniform. If in one of my installations you find a section called *Les Tabliers d'enfant*, these are my uniforms from when I was young. You cannot be confused if you notice the style of a garment.**

Herkenhoff Why are you interested in sleepwear?

Bourgeois **Because we spend as much time asleep as awake. In other words, we are wrapped in cloth as we sleep as much as we are wrapped in cloth during the day. Sleepwear for me means all bed wear, that is to say, bed sheets, linens, pillowcases and very special blankets. The clothes I include in my work belong to the artist, the maid and to friends. It is very inclusive. 'Friends' means anybody who has visited the house and who, by inadvertence, left an old book, a scarf, or galoshes, and by doing so enters the 'collection'. For example, Le Corbusier forgot his glasses.**

Herkenhoff How were you supposed to dress around your family?

Bourgeois **Both my parents dressed me, and competed with one another over it. They were rivals at getting me the best dresses and the latest fashion**

statement. I was dressed in Chanel, Poiret, lingerie suisse, furs, foxes, boas. Here is an amusing story about my refusal to wear the clothes my father bought me, in the days of the Galerie Lafayette and Au Printemps, the big Parisian department stores. It was a privilege for me to refuse to wear the fox that he had bought me.

Herkenhoff You once said that you are constantly learning the experience of time.

Bourgeois **You should never waste your time because time will never come back. Time can be represented by dust. If you don't clean your books the dust will gather and you will have to blow it off. In this sense, to gather dust is to negate time. Otherwise, you can retell your life and remember your life by the shape, the weight, the colour, the smell of the clothes in your closet. Fashion is like the weather, the ocean – it changes all the time.**

Herkenhoff How is time sculpted in your memory as a lived experience, *les temps vécu*? Your work implies a very particular phenomenology of time. How do you confront the idea of duration and the passage of time?

Bourgeois **It is water under the bridge, because time never comes back. Time is independent and supercedes my consciousness. For instance, if you say 'time and tide wait for no man' it means that time excludes man, it is not dependent on man. So my consciousness is only a little consciousness within the context of time; time goes on undisturbed, indifferent. What is ultimately most important about *durée* for me is the way it crystallizes into a shape, a form, an image, a metaphor.**

Herkenhoff Thus, this might be more about the administration and expression of time.

Bourgeois **We use the word itinerary when we travel in space, say from Australia to Russia, all over the world. But there is also an itinerary in time. When people ask me how come I'm not going to an opening it is because I travel in time. I travel in memory.**

Herkenhoff And what about Marcel Proust's classic *A la Recherche du temps perdu*? What is your madeleine?

Bourgeois **It is really *perdu* because the book is *perdu*. I would not necessarily think of [a taste or a] smell. It is most of all about light. Time is the tributary of the light of the day, of the sunset, of the night, of the dawn. *Le plein jour, ça c'est ma madeleine*. It is necessary to search for the balance between yesterday and tomorrow, since the present escapes me.**

Herkenhoff You confront the hierarchy between male and female. Thus, in your work hysteria applies to both genders and its psycho-organic arch is made by the contractions of the male body in *Arch of Hysteria* (1993). This disrupts the scientific principles of early psychiatric technology, from Jean-Martin Charcot to Sigmund Freud. What does it mean for you point out the rational, emotional and erotic limits of the male and the fragility of men? In your extensive body of sculpture very few works deal with male anatomy: *Fillette* (1968), *The*

Destruction of the Father (1974), *Confrontation* (1978), *Portrait of Robert* (1969) and *Arch of Hysteria*.

Bourgeois **My intention is to put down, debunk the abstract male, whose image is constructed by society. In** *Banquet / A Fashion Show of Body Parts* **(1978) I wanted [to present] an art historian, a critic who was also a man. Therefore I chose G., a specialist in Henry Füseli. He went too far in making fun of himself. There is the ridiculous male. Most of those sculptures deflate the male psyche as a structure of power.** *Mamelles* **(1991) points out that Don Juan's need to sleep with many women meant an inability to love. Did Don Juan sleep with older women? Isn't 'Don Juan complex' in the dictionary? Or 'Don Juan syndrome'? Syndrome is a very, very good word. It is the concurrence of a set of symptoms, a repetition. That shows a pathology.**

Herkenhoff You aim for the equilibrium between men and women. *Fillette* deals with an object of desire. Why does this sculpture, representing a penis of large dimensions, have as its title *Fillette,* meaning 'little girl'?

Arch of Hysteria
1993
Bronze, polished patina
84 × 101.5 × 58.5 cm
Collection Hakone Open-Air
Museum, Japan

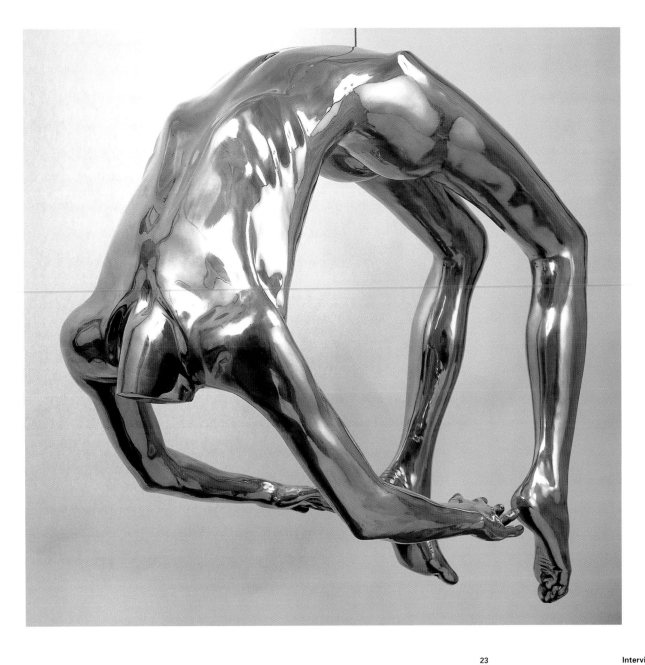

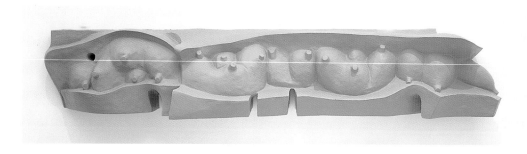

left, **Mamelles**
1991
Rubber wall relief
48 × 305 × 48 cm

below, **Homage to Bernini**
1967
Bronze
54.5 x 51 x 58.5 cm

bottom, **Gian Lorenzo Bernini**
The Ecstasy of Saint Theresa
1647–52
h. 350 cm
Marble
Cornaro Chapel, Santa Maria della
Vittoria, Rome

Bourgeois **The little male has to be taken care of.**

Herkenhoff In *Portrait of Robert* you've represented Robert Goldwater, your
husband, with many penises.

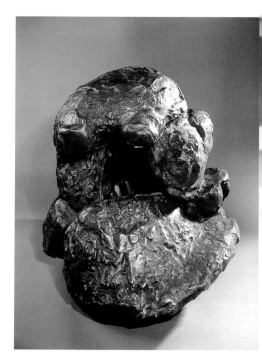

Bourgeois **It is a sign of his virility and sexual appetite. I wanted to flatter
him. I wanted to please him and let him be pleased with himself. This was
to make him sexy. A sex symbol.**

Herkenhoff Was Marcel Duchamp sexy?

Bourgeois **I always felt he was completely un-sexy. I felt that Marcel
Duchamp always played with the truth. Sometimes it is much more
interesting to deny the truth. Duchamp was a charmer. He was very sociable.
He got along very well with Robert, they shared a sense of irony and a sense
of humour. Duchamp liked to tease people.**

Herkenhoff You mean he was a prankster?

Bourgeois **No. It wasn't so much that he did things to people, but he tricked
people into believing he was a genius.**

Herkenhoff Did he like to play games of seduction with women?

Bourgeois **No. I never saw him in that role. Never. I think that Marcel
Duchamp became a great man when he reached America. His was a
successful exile. The French did not appreciate him.**

Herkenhoff Architecture is a very complex issue in your memories and work;
let's focus on one aspect of that. Quite often you mention the *maison vide* and
the *femme-maison* as referring to the challenges of domesticity.

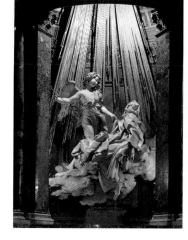

Bourgeois **I find the duty of running a house almost overwhelming. You have
to be so practical, so patient, so energetic and resourceful. Remember that I
have done many works representing myself as the *femme-maison*. The
maison is quite symbolic as architecture, the subject and life. I made a work
called *Homage to Bernini* (1967). It was a homage to a sculptor whose work
was full of folds. There was no emptiness [in this work], not an inch which
was not filled with folds, as if emptiness was Bernini's enemy. The *maisons
vides* [empty houses] are a metaphor for myself. The *maisons vides* are
houses where I have lived or worked in the past; they are all empty now.
Therefore they are the constructions where we exist, the architecture of our**

Portrait of Robert
1969
Bronze, painted white
33 × 31.5 × 25.5 cm

life, that is, the different places where we exist. So this is the history of a life.
I try to make them come out of the shadows and make them appear under
the light of the present.
Life is organized around what is hollow.

1 Julia Kristeva, *Étrangers à nous-mêmes*, Fayard, Paris, 1988. Translated into English by Léon Roudiez as *Strangers to Ourselves*, Harvester
Wheatleaf, London, 1991; Columbia University Press, New York, 1991.

Contents

I.

So far the average age of the artists in Phaidon's Contemporary Artists monograph series has been forty-three. When his book was appeared, the youngest was Doug Aitken. The oldest, Nancy Spero (born 1926), was 70, with Yayoi Kusama (born 1929), a close second at 71. In an art world where the 'new' is at a premium, youth is often assumed to be the predicate of innovation. In this context, it is striking that of the senior figures to have been given such attention, the first two – and now three – are women. This fact tells us something about the generally delayed recognition women's accomplishments have received during the second half of the twentieth century. It also says much about the sustained effort such

recognition has demanded. In their case it has not been enough to be 'new' once. Rather they have been constantly forced to revise and reinforce that claim in the face of rising stars, without, at the same time, being able to rely on the critical, institutional and commercial powers that buttressed the reputations of so many of their male counterparts during the creative transitions and professional pauses that punctuate the lives of all serious artists of either sex.

At 91, Louise Bourgeois enters this series to drive the point home with a vengeance. Moreover she takes her place alongside such emerging or mid-career talents as Marlene Dumas, Mike Kelley, Raymond Pettibon, Pipilotti Rist and Luc Tuymans – not as honoured elder but as a busy

l. to r.,
Untitled
1940
Pencil on paper
28 × 22 cm

Untitled
1941
Ink on graph paper
28 × 21.5 cm

Untitled
1943
Ink and pencil on grey paper
12.5 × 7 cm

Skains
1943
Ink on grey paper
30.5 × 23 cm

Girl Falling
1947
Ink and charcoal on paper
28.5 × 18 cm

contemporary and, occasionally, an active competitor. Anyone leafing through recent art magazines and catalogues, or meandering through major museums in the cultural capitals of the world, not to mention smaller galleries in far-flung cities, is likely to come upon examples of her work that are startling in their inventiveness and intensity. Not the least surprising realization is that some of those works may date from twenty or perhaps fifty years ago, and yet look as fresh as anything being made today by artists a third or half her age. Meanwhile other works Bourgeois has created much more recently confirm the unrelenting urgency with which the artist has always sought to confront her demons and give them their due, harnessing the energies they

release in her to the task of fundamentally transforming the language of modern sculpture.

To say that Bourgeois has only lately achieved recognition would be an overstatement, but for many who have followed her fitful ascent over the years, the degree of her present fame and ubiquity was unanticipated. Indeed Bourgeois' up, down and sideways progression has been marked by several moments of relative prominence followed by partial retreat and subsequent rediscovery. Briefly, these periods of renown occured in the late 1940s and early 1950s; the mid-1960s; the early to mid-1970s; the early 1980s; and most dramatically in the mid- to late 1990s. In each instance she came forward with a distinctive body of work. And in each case, until the 1980s, she pulled back,

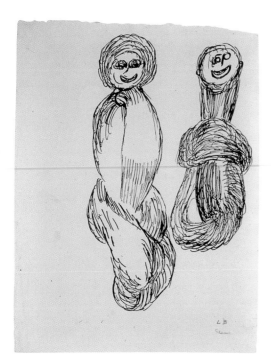

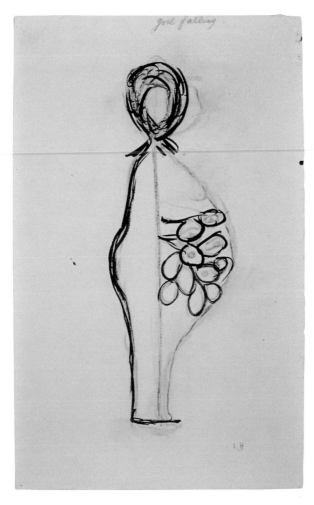

opposite, clockwise from top left,
Untitled
1947
Ink on paper
28 × 19 cm

Untitled
1947
Ink and charcoal on paper
28 × 22 cm

Untitled
1947
Ink and charcoal on paper
29 × 18 cm
Collection, Solomon R.
Guggenheim Museum, New York

below, installation view,
'Retrospective',
The Museum of Modern Art,
New York, 1982
Photo © by Peter Moore

yielding some of the ground she had gained, only to launch herself again from another, unexpected position. The cumulative effect of these separate forays into public view has been to confuse many observers who lost track of what she was up to in the intervals. But those comings and goings have also served to build a diverse group of admirers who have got to know her in one guise and, puzzled as they may also be by the changes in her art, have been intrigued rather than put off by her metamorphic re-appearances. Compared to those artists who marshal their ideas, work and supporters on the field and march forward with the wind of art history at their back, Bourgeois has pursued a guerrilla strategy. Advancing, regrouping and advancing again while making necessary concessions to the anomalous nature of her large, evolving ambition and to her vulnerabilities – psychological rather than aesthetic – she has mounted multiple, carefully targeted attacks on 'mainstream' art. Eventually she has won the day by stamina, guile, vision and sheer artistic audacity.

Among Bourgeois' moments in the limelight, the one that did most to consolidate her reputation was the 1982 retrospective of work at The Museum of Modern Art in New York organized by Deborah Wye. Not for the first or last time it was a case of a young critic or curator seeing in Bourgeois' art all those things that older colleagues had missed or undervalued. The intergenerational affinity for Bourgeois felt by writers and exhibition-makers had parallels among younger artists whose appreciation has also contributed much to Bourgeois' current reputation. The MoMA show gave Bourgeois' work a visibility outside the realm of galleries and alternative spaces that it had never had before, and made her famous. Indeed, although it opened during the artist's seventy-first year, that exhibition was just the beginning.

Ordinarily such a belated retrospective is a kind of valedictory salute, after which nothing much is awaited from the artist finally installed in their niche. Bourgeois had an altogether different scenario in mind. As soon as she had escaped the fate of being a so-called 'artist's artist' – someone admired by peers but of no discernable consequence to the culture at large – she was embraced by a disparate public (young and old, male and female) that craved the kind of emotionally imperative and formally risky work in which she specialized. Almost immediately she started to show signs of being the public icon, the alternately good and bad – charming and acerbic, wise and harsh – 'mother-of-us-all' that she has since come to epitomize. Against this background Bourgeois first spoke about her early family life in terms that are now familiar to many who identify with the psychological roles she has verbally sketched, even though the same people may know only a handful of the paintings, drawings and sculptures in which such roles were fleshed out. And it was in the same setting that pictures of an aging, mercurial but seldom camera-shy woman began to circulate not only in art magazines but in lifestyle and fashion glossies as well as newspapers, along with deliciously quotable remarks that together have made Bourgeois the darling of the popular press.

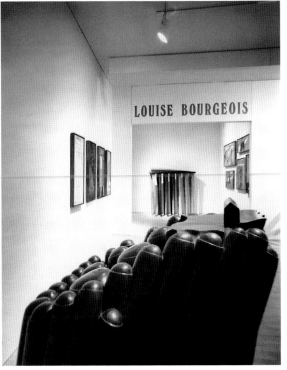

It was during the time of the 1982 retrospective at The Museum of Modern Art in New York, when I helped her prepare the slide show which accompanied the exhibition (the first detailed account of her childhood), that I first got to know Bourgeois. Since then my involvement with the artist has continued on many levels, and if, as a critic and biographer, I briefly step forward, it is only to remark on the complications that come with the position I occupy. Watching Bourgeois' transformation into a celebrity has stirred mixed feelings in me, and I sometimes fear that Bourgeois' persona is on the verge of eclipsing the person herself, just as the fundamentally true but richly ornamented myth of origins she has embroidered threatens to obscure many of the most interesting facts of her life. Of course the persona is an extension and integral part of the person. The difference between them is that she who makes and animates the work is plural and conflicted: now a child, now a woman; now fearful, now an unstoppable force; now an uneasy, even helpless object of desire; now an avenging fury; now a strong if precariously situated maternal presence; now a regretful and retiring shadow of that presence. In her public image the fault lines that demarcate these many facets have been fused, and the sudden mood shifts that their friction generates have been modulated or stylized.

Moreover, the myth upon which so much of what she has said about her art rests is not just a validating explanation for what exists but raw material for work in progress. Those who listen carefully will realize that her retelling of various episodes is less a dialogue with the public than an inner monologue made audible. Each time she returns to some incident or character, her emphasis changes. And sometimes crucial details change as well; someone named as the subject of a piece on one occasion may, on another, mutate into someone else with similar traits who, for whatever reason, is more on her mind that day. Or the original model may be described from an alternative perspective – as passive rather than aggressive, for instance – reconfiguring the symbolic dynamics of the image as a whole as well as all its other components.

It is axiomatic to the understanding of fiction or poetry that one should not confuse the 'I' of the text with its author. Yet Bourgeois' insistent recourse to first-person narration makes it harder than ever (borrowing William Butler Yeats' phrase) 'to tell the dancer from the dance'. However, if her extraordinary achievement is finally to be given its full due it must increasingly be separated from her charismatic presence and from the shorthand versions of her life and motivations she has provided in such vivid instalments. Bourgeois' work is deeply rooted in her experience, and those roots continue to nourish what she makes in her tenth decade even as the memory of particulars has begun to fade. Nevertheless, the content of her art is not primarily autobiographical but archetypal, an astonishingly rich, nuanced, sometimes alarming, often funny and almost always startling fusion of classical personifications of human passions and terrors, Symbolist variations on them, Freudian reinterpretations of both, and direct or indirect transcription of her own unblinking glimpses into the murkiest waters

Untitled

1946–48

Oil on linen

76 × 152.5cm

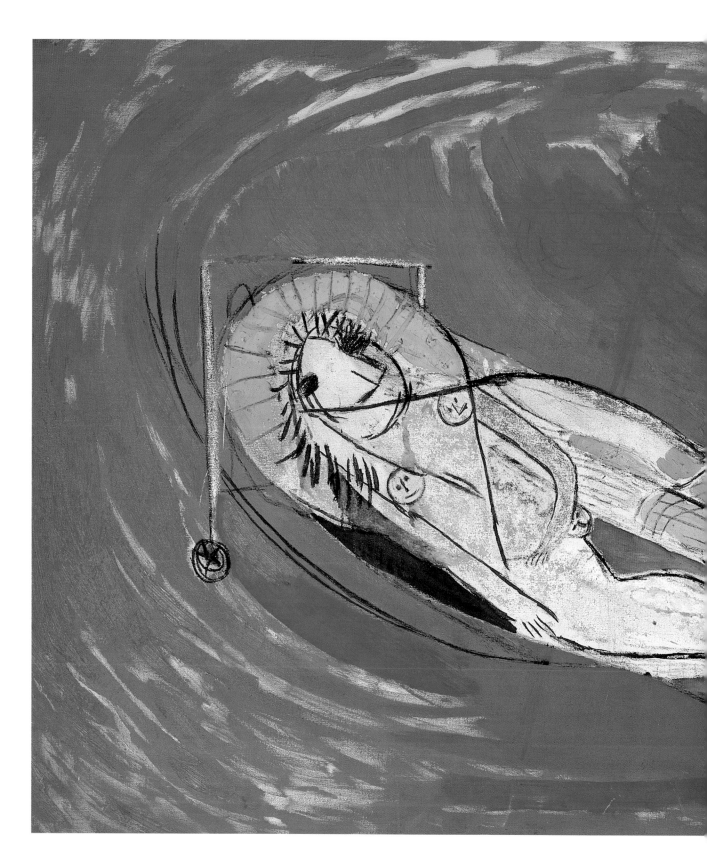

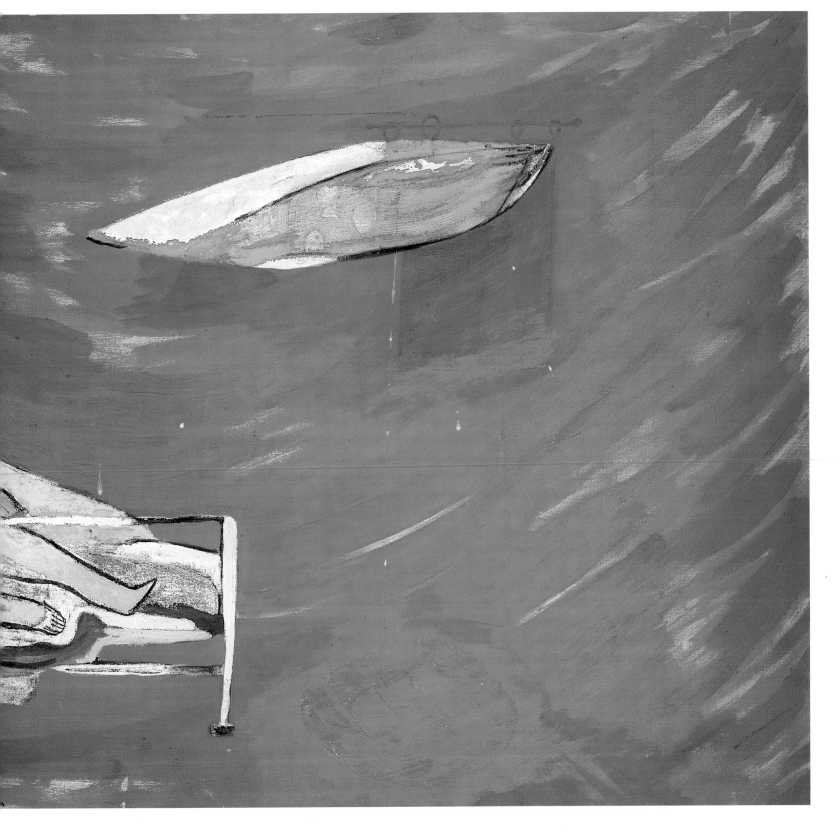

Resin Eight
1965
Resin over hemp
5 × 18 × 6 cm
Photo ' by Peter Moore

of the psyche. And so, while faithful to the essence of that experience, the inconsistencies in her different accounts of the past—never a matter of deliberate misrepresentation or pure invention but akin to the sort of literary licence Mark Twain s Huck Finn called stretchers —and the shifting accents in her analysis of particular works reflect a hard-earned imaginative freedom. Acting as the polymorphous protagonist of her own drama, she assumes multiple guises and assigns as diverse a set of parts to her chosen antagonists as suit her immediate needs.

Thus, Bourgeois the yarn-spinner creates folktales for traumatized or disillusioned modern sensibilities, and the response she has received indicates the hunger for discursive metaphor in an

ostensibly hard-nosed and rational age. Bourgeois the protean form-maker has touched the same bruised or ragged nerves but in a much more profound, complex and aesthetically fundamental way. In a necessarily synoptic attempt to give substance to that claim, I will take the liberty of glossing over much of her childhood and early adulthood to concentrate on her artistic maturity and the work itself. Furthermore, having introduced the notoriously engaging artist in her old age, I will escort her to the wings, dispensing also with the kind of colourful quotes that normally embellish writings about her, my own included. Nor, for that matter, will I bother much with the growing critical literature on her, though one of the signs of Bourgeois arrival is the fact that critics are now fighting over the meaning of her work. On the whole, this is a healthy thing.

Instead I intend to speak from the vantage point of someone who has known Bourgeois for a long time, worked closely with her and witnessed all her temperamental states; someone who has seen old work in dusty corners, shelves and boxes as well as new work as it first appeared in notes to herself, or in fragments in the studio; and, finally, someone who has never ceased to be amazed by her psychological and aesthetic insight and her unpredictability. Combined with the courage to go her own way, it is this last quality above all that has secured her a unique place among the younger artists in this series and in countless exhibitions and collections of contemporary art. By way of illustration I offer this anecdote. Some years ago while installing an exhibition at The Museum of Modern Art, I walked with Bruce Nauman from the

space devoted to his video piece into the next gallery where Bourgeois had placed two huge, black metal tubes, one of which slid on rails into the other as if they were a monstrous piston – or two machines copulating – all in the glow of red flashing emergency lights (*Twosome*, 1991). Nauman, who, at 25, had first exhibited with Bourgeois in 1966 in Lucy Lippard's seminal show 'Eccentric Abstraction' at the Fischbach Gallery in New York, looked at the massive machine, shook his head and said, 'You've gotta watch that woman.' He was right.

II.

The basic narrative of Bourgeois' early years is easily summarized. She was born in Paris in 1911 into a hard-working and ultimately prosperous family whose business was the repair and resale of seventeenth- and eighteenth-century tapestries and other decorative textiles. Since her father, Louis, had wanted a son, and had thus far been deprived of one (a sister, Henriette, was six years older than Louise, and a brother, Pierre, was born fifteen months after her) his wife Josephine shrewdly suggested that their second daughter be named after him. This ploy eased his disappointment, but throughout her childhood Louise competed relentlessly for his attention even as she suffered its effects. After World War I, during which Louis served at the front and was wounded, family life was divided between an apartment in the fashionable St Germain district of Paris above the showroom where the Bourgeois sold their wares to the carriage trade – in particular to wealthy Americans fitting out their townhouses and rural

estates with the trappings of French aristocracy – and a villa and workshop outside Paris where the actual restoration of antique Gobelins and Aubussons was carried out by a team of young women under Josephine's supervision. During the week, Louise and her siblings went to school in the city. There, as an adolescent, she attended the prestigious Lycée Fénelon where she excelled in mathematics and, to the dismay of her parents, showed signs of becoming a serious scholar.

The family also participated in the routines of the *atelier* which involved washing and mending tapestries that had gone threadbare in the halls of vacant châteaux or been left to rot in attics or stables. When a local expert in redrawing and restitching the wasted lower margins of these neglected fabrics failed to show up one day, Louise was asked to take over, with the result that she became a specialist in the rendering of feet. A more piquant version of events also had her sewing fig-leafs onto the exposed genitals of the heroes and heroines who cavorted in these woven Arcadias of the classical imagination, so as to make these scenes more acceptable to prudish collectors from Boston, Philadelphia and New York.

By Bourgeois' own account – part Marcel Proust, part Colette – the idyllic enclave in which she came of age was roiled by sexual undercurrents, and she, unready for the erotic tensions and teasing at the centre of which she found herself, felt compromised, disoriented and desperately unhappy. On the one hand there was the lewd banter of the female workers who spared the otherwise protected daughter of their employer little. On the other hand there was her

The Destruction of the Father
1974
Plaster, latex, wood, fabric
238 × 362 × 248.5 cm
below, photo © by Peter Moore

father himself who, in addition to his constant flirtations with the women around him and the risqué jokes he told in front of his children to their intense embarrassment, also invited his English lover, Sadie, into the house as the children's tutor. Forced to ignore his obvious infidelity, obliged to be courteous to the intruder who was its cause, and called upon to play go-between for her mother who had acquiesced in the arrangement in order to keep her wandering husband from wandering off, Louise effectively lived a lie. None of the considerable comforts of her existence – stylish dresses from Paul Poiret, trips in luxury touring cars and vacations in the south of France – could counterbalance her acquiescence.

The legend of The Mistress, the emotional rival whom Louise hated, and of The Father, who was charming, unfaithful and casually cruel but whom she loved, is based upon this simple triangle, and the constellation of betrayals and falsehoods its maintenance required. Until her MoMA retrospective Bourgeois had never talked publicly about her work with reference to this story, nor had she spoken much about it in private. Since then these entanglements have become a principal point of departure for almost everything written about her. One explanation for her long silence is the deliberate repression of an emotionally painful past. However, in so far as she now says that her work has been largely predicated on this drama all along, the repression has only been verbal – and incomplete, to the extent that works such as the installation piece *The Destruction of the Father* (1974) plainly allude to it – while the crux of the emotional conflicts at that drama's core have

always been sublimated in her art. Another possible explanation is that in the context of the rough-and-ready New York art worlds of the 1950s, 1960s and 1970s, Bourgeois was reluctant to go into detail about her background because describing the situation fully, with its *haut bourgeois* décors and *jeunesse dorée* privileges, could not be reconciled to prevailing bohemian or avant-garde models.

In the final analysis both factors probably influenced her initial reticence, but when she eventually did tell her tale the confessional psychology and the by-then remote and nostalgia-inducing locations provided much of its popular appeal. Indeed some critics bridled at just these features and poo-pooed the whole issue as an exaggerated variation of an utterly commonplace incidence of marital dysfunction. That may well be, and others better equipped than Bourgeois to treat such things matter-of-factly might have made something very different – or nothing at all – out of the same or similar circumstances. The basic reality, however, is that as sophisticated as she is – and her social milieu contributed greatly to that sophistication – Bourgeois suffered terrible damage as a result of the stress she experienced in the sexually immature years of her childhood and early adolescence. The obsessional return to those traumatic times, and the hope-against-hope that that damage can be undone or patched has been the driving force behind everything she has made. The periods when she has tried hardest to escape her past into an ordinary adult present, or has abandoned the effort to symbolically suture the psychic wounds she has had to endure, are the

periods when she has stopped making art at full throttle. Specifically, this happened in the early 1940s, when she attempted to be a conventional wife and mother; and in the mid-1950s, when she briefly took courses in psychology and French literature with the intention of changing careers and then, with the same aim of earning her keep, opened an antiquarian bookstore that was more a refuge from professional and domestic life than a business.

Anyone who doubts the rapidly fluctuating, alternately volcanic or maelstrom-like intensity of feeling that Bourgeois must still contend with on a daily, if not hourly basis, has only to consult her drawings. The strangeness of their shapes and the alternating agitation and urgency of their line evince the harrowing spectres and turbulent states of mind that frequently beset the artist. Often amalgamations of organic elements and growth configurations with compacted or half-fractured planar geometries, the imagery frequently suggests extreme violence involving everything from the tortuous disarticulation of buildings and bodies to other kinds of mayhem, including cannibalism. The almost interchangeable pod, yarn, hair or muscle-like motifs of other early drawings are composed of the insistent reiteration of the simple marks that define a shape's contours and delineate the striations of its inner fibres, strands and sinews, while the patterning of her more recent *Insomnia Drawings* (1994–95) are, in their repetition of words and designs, graphic countdowns for nights that seem never to end. All of these various forms of expression evidence the artist's determination to channel the chaotic

The Insomnia Drawings
1994–95
From a series of 220 sheets mixed media
Dimensions variable
opposite, Ink on music paper
30.5 × 23 cm
below, Ink, coloured pencil, sewn button on paper
30.5 × 23 cm

energies that flood her imagination into significant form. That the intensity of the weird pictorial notations made at the beginning of her troubled maturity in the 1930s, 1940s and 1950s has not abated in her later work on paper but only changed in aspects of its vocabulary (as if new words had been added to her mental dictionary of symbols) is proof that the compulsions propelling her have remained essentially constant. The marvel is that she has not been exhausted by them or escaped into the exterior calm and interior hiatus of catatonia, but has instead kept their furious pace. Indeed, as in every question regarding Bourgeois' psychological or stylistic sources, the mystery is not what she has tapped into, but how radically she has transformed it.

On that score, then, a comment about Surrealism is in order. As a student in Paris, Bourgeois lived in a building on the rue de Seine that also housed the Galerie Gradiva, a Surrealist showcase. Later, during the war years in New York, she frequented exiled members of the group, cordially detesting most of them. She disliked André Breton and André Masson in particular, while guarding a fondness for Miró that did not preclude resenting the politically effective modesty of his social manner. Taking Bourgeois' familiarity with the Surrealists and their work fully into account, and thus the undeniable fact that aspects of their aesthetic approach rubbed off on her, the overriding reality was that in most respects they rubbed her the wrong way and she rebelled against them. After all, the only real role for a woman within their movement was that of a muse to be worshipped either as a Sphinx, a seer, a

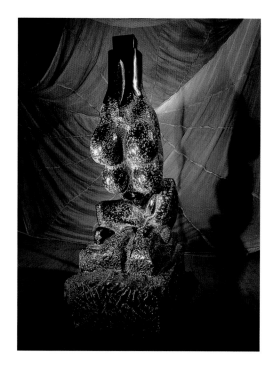

The She-Fox
1985
Black marble
179 × 68.5 × 81.5 cm

seductress or an enchanted wild-child. Never was there a question of a woman being the creative or intellectual equal of men.

More importantly, with regard to her work on paper, Bourgeois had no use for the Surrealist cultivation of the dream as a means of access to the subconscious. In her sometimes clairvoyant, sometimes panicky wakefulness Bourgeois had direct access to the deepest levels of her well-stocked and often feverishly fertile imagination. Exercising different amounts of control at different times, her primary aim was not to stylize her visions for the consumption of others but to subordinate them to her will and make her own contemplation of them bearable. And while her drawings fed on the art she knew, they did so without deference or ceremony, as if from the moment her eyes absorbed something it began to undergo the transformations that assimilated its characteristics to her specific need or hunger.

Although Bourgeois has read widely and seen a great deal, all of it intently, her education was intermittent and incomplete. Initially this was a by-product of familial obligations. Not only was her mother the superintendent of the workshop and the patient strategist determined to stalemate her husband's *amours*, she also suffered from a chronic lung ailment contracted during the influenza epidemic that hit Europe after World War I. For the sake of her health, the Bourgeois made regular trips to the Côte d'Azur with its warm temperature and fresh breezes. When Josephine's condition deteriorated and she was prohibited from returning to Paris with her husband, she was left in the care of Louise, who was taken out of the

Lycée Fénelon for that purpose. Having already been made her father's unwilling companion and confident during his nightclub excursions after Sadie was finally banished from the household, the teenage Louise now found herself in the position of being her mother's nurse. And it was one morning, while in Louise's care, that Josephine quietly died. Although her death freed Louise to go back to school, its impact was devastating. The excruciating inability to cope that Bourgeois felt when she herself eventually became a mother, and the crippling depressions that were triggered by her sense of inadequacy, are inextricably bound up in her sense of not measuring up to her own mother's stoic sovereignty, her guilt over having failed to prevent her from slipping away, and her anger at having been given a responsibility she could not shoulder.

If the sculptures of the 1970s and early 1980s are often sites in which Bourgeois sought to play out or resolve antagonisms towards The Father about which she has said so much, then from *The She-Fox* (1985) on through to the various *Spiders* of the 1990s and early 2000s, the primary archetype is The Mother, in her implacable and potentially destructive incarnation. Depending on the circumstances, the bad Mother in question can be an inverted projection of Josephine's omnipotent goodness, against which the helpless daughter symbolically revolts. Or it is a grotesque version of her own maternal ferocity inspired by the unfulfilled wish to be all-powerful, and the rage she experienced and shame she felt when faced with her failure to meet the high expectations she set, based on an idealized version of Josephine's

Spider
1997
Steel, tapestry, wood, glass,
fabric, rubber, silver, gold, bone
444.5 × 665.5 × 518 cm

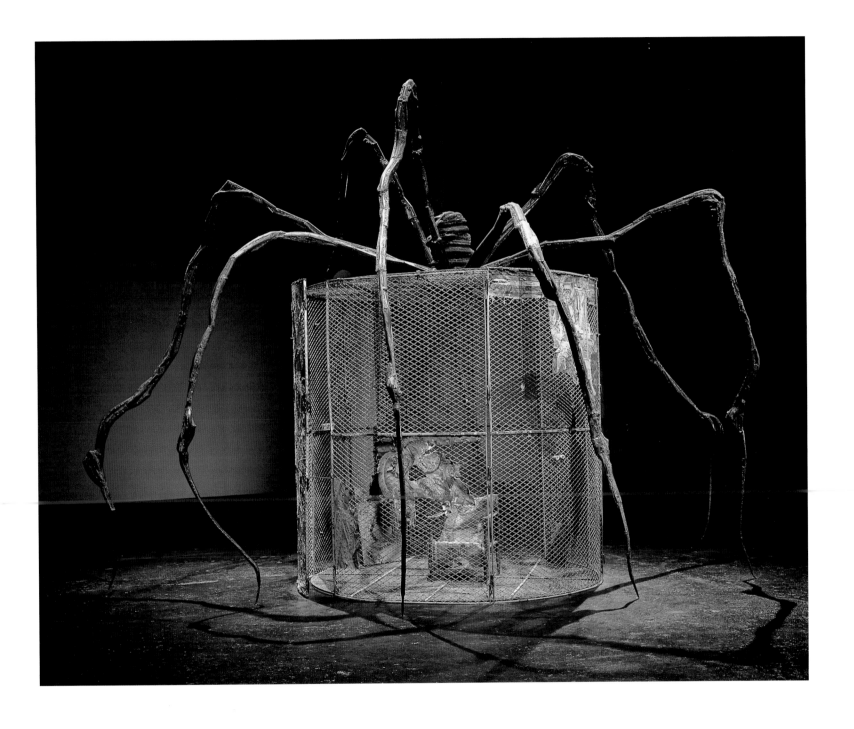

Paul Colin
Wiener et Doucet
1925
Poster

Fernand Léger
The City
1919
Oil on canvas

performance in the same role.

With Josephine gone, the nucleus of the Bourgeois family fell apart. Louis was no longer a philanderer with a secure anchor but an ageing man-about-town who had lost interest in his business. For their parts Louise's sister had married a minor civil servant to get away from it all, and her brother, who was never able to satisfy his father, drifted until he was moblized at the beginning of World War II, only to be shell-shocked and then hospitalized for much of the remainder of his life. Without the gravitational pull of her parents' marriage, Louise drifted as well. First she enrolled at the Sorbonne, where she intended to study mathematics – a subject whose strict rules she found a comforting antidote to the lawlessness of human emotions. Then she went to the Louvre where she briefly studied art history, and used her command of English – Sadie's other legacy – to distinguish herself as a docent. Thereafter she resolved to become an artist and made the rounds of the Ecole des Beaux-Arts, the Académie Julian, the Académie Ranson, the Académie de la Grande-Chaumière as well as the classes of the Art Deco poster designer Paul Colin, and the Cubist painter Fernand Léger. Léger made the biggest impression on her, teaching the talented but very timid young woman that the grace and consistency of formal relationships she admired in geometry could be freely, vigorously, even roughly manipulated rather than rigidly delineated in an academic manner.

Raised in a setting where neo-classical garden sculptures filled the lawn of her family's residence on the outskirts of Paris, Baroque tapestries hung from the walls or lay in piles around the house, late-model touring cars were parked in the garage next to it and the 'beautiful people' of Paris milled about the Café Flore downstairs from their apartment in the city, Louise developed a taste for the decorative arts that encompassed old-fashioned grandeur and early twentieth-century chic. Her own preferences in 'fine art' were for nineteenth-century Romantics, Symbolists, Impressionists and post-Impressionists, passions she pursued by purchasing odds and ends at auction and trying to resell them from a display in a corner of her family's showroom. All of which is to say that from the outset Bourgeois the artist was steeped in a visual culture that was deep, varied and historically far-reaching. Yet from the evidence that survives, her first paintings, sculptures and drawings were stylishly *moderne*, rather than truly modern. It was not until she left the capital of Modernism, Paris, and resettled in its satellite, New York, that the radical implications of the avant-garde work she saw around her took root and flourished.

In 1938, just as she was beginning to gain confidence in her own work and to exhibit at the Salon d'Automne and other venues for young artists, Bourgeois met an American, Robert Goldwater, whose eye had fastened on an album of Henri de Toulouse-Lautrec prints that he saw in a St Germain store window where she had placed it. The author of the seminal *Primitivism in Modern Art* (1938), and, later, of an equally substantial work on Symbolism, Goldwater was among the most important art historians of his day. Reserved,

Sleeping Figure
1950
Wood
h. 188 cm
Collection, The Museum of
Modern Art, New York

thoughtful and considerate, he was in every way unlike the father whose orbit Bourgeois longed to escape. The mutual attraction between her and Goldwater was instantaneous and their courtship lasted a matter of weeks. In September they married and Goldwater promptly left for the United States to resume his academic duties. In October, despite her father's jealous taunting that she had been seduced and abandoned, Bourgeois followed her husband
to New York.

There Bourgeois entered the innermost circles of the period's advanced culture. Among the writers, scholars, critics and curators she met and soon got to know intimately were Jacques Barzun, Henry Russell Hitchcock, Mary McCarthy, Erwin Panofsky, Meyer Shapiro, Edmund Wilson and, perhaps most significantly for her, Alfred Barr, the founding Director of The Museum of Modern Art. Caught up in this whirl, in love with a man who was utterly dedicated to his scholarship, and homesick for France, Bourgeois experienced a profound disorientation which she tried to remedy by plunging into the role of mother and wife. Within four years the couple had three sons – Michel, who was adopted, followed by Jean-Louis and Alain. Simultaneously Bourgeois attended classes at the Arts Students League, where Arshile Gorky, Jackson Pollock and other members of the emerging New York School had studied. She also started to make and exhibit prints. The creative constant of her first decade in America, this activity culminated in the portfolio *He Disappeared into Complete Silence,* a paradigmatic match-up of haunting pictures and stark

psychological anecdotes that she realized in 1947 at Stanley William Hayter's famous Atelier 17, where she worked quietly alongside the likes of Joan Miró and other modernist luminaries. It was also during the late 1940s that she started to carve and assemble the slender wooden sculptures that constitute her first major body of sculpture.

Bourgeois thus gradually established herself as an artist in her own right even as she juggled responsibility for her children and her role as a hostess and helpmate for a distinguished intellectual. Moreover, she did so with Goldwater's unstinting support. Contrary to the standard scenario of the long-suffering academic wife burdened and ignored by a preoccupied husband, Goldwater acted as Bourgeois' discreet but steadfast promoter, encouraging critic and principal aesthetic interlocutor. And so between 1949 and 1953 Bourgeois had three one-person exhibitions. Meanwhile, in group shows she appeared alongside many of the leading figures of Abstract Expressionism and other tendencies fostered by the then burgeoning downtown Manhattan scene. In recognition of this, Bourgeois was invited by Barr to participate in a famous panel discussion at Studio 35 organized in 1950 to define the new art – other notables included Willem de Kooning, Ad Reinhardt and Robert Motherwell. In 1953 Barr acquired *Sleeping Figure* (1950) for MoMA's collection. To the extent that any woman in the male-dominated art world of the day had a first-rank position, Bourgeois did. And then she pulled back.

I will suspend detailed biographical exposition here, except to point out that in her

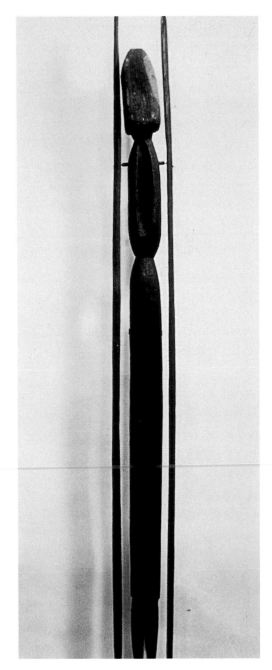

Plate 1

Once there was a girl and she loved a man.

They had a date next to the eighth street station of the sixth avenue subway.

She had put on her good clothes and a new hat. Somehow he could not come. So the purpose of this picture is to show how beautiful she was. I really mean that she was beautiful.

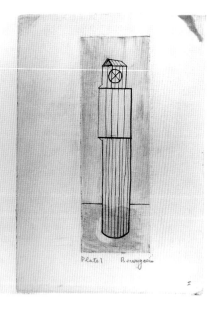

Plate 4

In the mountains of Central France forty years ago, sugar was a rare product.

Children got one piece of it at Christmas time.

A little girl that I knew when she was my mother used to be very fond and very jealous of it.

She made a hole in the ground and hid her sugar in, and she always forgot that the earth is damp.

Plate 2

The solitary death of the Woolworth building.

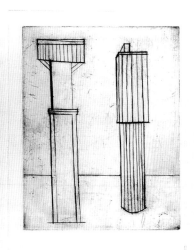

Plate 5

Once a man was waving to his friend from the elevator.

He was laughing so much that he stuck his head out and the ceiling cut it off.

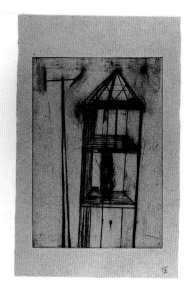

Plate 3

Once a man was telling a story, it was a very good story too, and it made him very happy, but he told it so fast that nobody understood it.

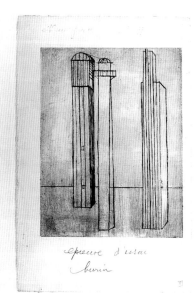

Plate 6

Leprosarium, Louisiana.

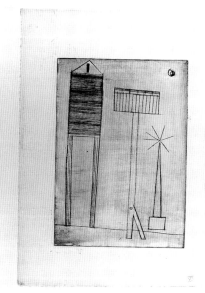

Plate 7

Once a man was angry at his
wife, he cut her in small pieces,
made a stew of her.

Then he telephoned to his
friends and asked them for a
cocktail-and-stew party.

Then all came and had a good
time.

Plate 8

Once an American man who had
been in the army for three years
became sick in one ear.

His middle ear became almost
hard.

Through the bone of the skull
back of the said ear a passage was
bored.

From then on he heard the
voice of his friend twice, first in
a high pitch and then in a low
pitch.

Later on the middle ear grew
completely hard and he became
cut off from part of the world.

Plate 9

Once there was the mother of
a son. She loved him with a com-
plete devotion.

And she protected him because
she knew how sad and wicked
this world is.

He was of a quiet nature and
rather intelligent but he was not
interested in being loved or pro-
tected because he was interested
in something else.

Consequently at an early age he
slammed the door and never came
back.

Later on she died but he did not
know it.

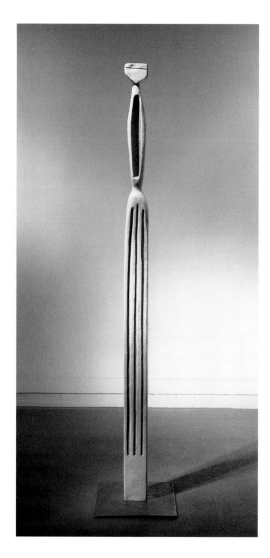

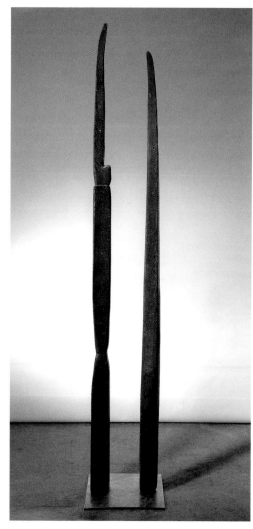

roughly ten-year absence from the forefront of the New York scene that came after this rapid rise to prominence, Bourgeois fitfully made work, returned to Paris for several protracted sojourns (during which time she made the acquaintance of Constantin Brancusi and Alberto Giacometti as

well as younger French avant-gardists of the post-war era), opened her previously mentioned antiquarian shop specializing in children's literature and illustrated books; travelled to Africa; and generally kept up appearances as best she could. There were several reasons for Bourgeois' retreat between 1953, the date of her last one-person exhibition of the decade in New York, and 1966, when she resurfaced in 'Eccentric Abstraction', which, under the rubric of a resurgence of Surrealism, united Bourgeois with Eva Hesse, as well as Nauman and other post-Minimal sculptors twenty years her junior. The chronic anguish, self-doubt and paralyzing melancholia that plagued her were the principal causes of this partial abdication. That two-steps-forward-one-step-back pattern was to continue until the 1970s, when, after Goldwater's death in 1973, she was freed from a highly conflicted part of her identity – while losing her strongest supporter – and was forced to go out into the world entirely on her own and remake her place in it. It was against this background that she bonded with and became a heroine to the feminist movement, then in its first anarchic phase, and that she started to gather around her the motley crowd of artists, writers, filmmakers, performers, curators, critics and lost souls that have sustained her in her loneliness, aided her in her work and provided her with listeners, sparring partners and interpreters, as well as a steady flow of life stories from which she distills fresh ideas about the psychological dynamics that obsess her. Moreover, it was in the mid-1970s that the once stylishly *comme-il-faut* Bourgeois became the ubiquitous,

outspoken and eccentrically dressed doyenne of the art world.

The purpose of lingering so long on the first four decades of Bourgeois' life in an essay that announced its intention to limit critical focus on the artist and concentrate on the art, is, in this abbreviated retelling, to dispel some basic assumptions that cloud the reading of her work. First, although Louise, the girl and then young woman struggling for equilibrium, was severely scarred by the patriarchal conduct of her father and by the internalization of social norms that compelled her to perform conventional feminine roles for which she was ill-suited, Bourgeois the artist was never the subordinate of a domineering spouse, and, with the exception of the Surrealists, was seldom condescended to by the male artists with whom she worked and exhibited. Second, from the beginning of her life Bourgeois was a cosmopolitan with direct exposure to and informed understanding of a wide variety of art – historical, 'primitive', avant-garde – and had firsthand contact with the cultural élites of Paris and New York. She was, in her initially diffident and later extravagant fashion, an inquisitive, supremely intelligent woman *in* the world. And, with the longest of long views, she was not only exceptionally tough – especially given the obstacles that self-defeating habits often put in her path – but also very ambitious. What she was not is a victim or martyr. Nor was she an emotionally volatile soul unaware of the full ramifications of the ideas and formal traditions she drew upon and radically altered. The former misrepresents her actual circumstances, which were far more complex even in their negative aspects; the latter caricatures her achievement in the manner of all romantic myths that pit intuition against self-conscious understanding.

III.

Bourgeois' sculpture originated in drawings and in paintings that are, in effect, drawings coloured in. Her characteristic line is brittle and insistent. The surfaces of the almost random scraps of paper she has used are scratched, scored and made irritable by the hard tools and emphatic gesture towards which she is inclined. Her pen and pencil marks are akin in this way to the gouge of an engraver's tool or the acid bite of an etching. This is logical since much of her early work of the 1940s was done in those media. When she employed ink and brush the same force and friction tend to show, since the cathartic release of Bourgeois' pent-up imaginative drive requires physical resistance. This is why, despite her prolonged study of it, painting never really gave her what she wanted.

The need for resistance lends much of her graphic work its distinctive sculptural quality, as if she were digging out or carving the shapes directly on the flat page, rather than rendering them illusionistically in three dimensions. To be sure, those shapes often have an undulating quality that seems to belie such exertions, but the forms themselves suggest stretching or contracting sinew, and the touch, though sometimes feathered or dry, never relaxes the tautness of the contour. Furthermore, the tensions and dispositions of those forms – bunched, twisted, distended, hung from heights, squashed against outer edges of the

far left, **Pillar**
1949–50
Painted wood
175 × 30.5 × 30.5 cm

left, **Knife Couple**
1949
Painted wood
174 × 30.5 × 30.5 cm

spaces in which they appear, propped against each other, mounded up or clustered – all embody sculptural properties of weight, density and placement, as well as hardness and softness, balance and imbalance. It is not just that her more or less abstract images of the 1940s and 1950s look like the lozenges she tailored out of balsa wood and cedar to make her first three-dimensional *personnages*; they actually behave like them as expanding and contracting organic masses or objects located on the implicitly rectilinear coordinates of an ordinary – though perhaps erratically torn – piece of paper.

So far I have spoken only of the biomorphs of that period, because, in an almost literal sense, they are the connective tissue between Bourgeois' apprenticeship as a painter and her emergence as a fully developed sculptor. Although her figurative work is sometimes more delicately inscribed or delineated, it shares with the abstractions the same startling immediacy. In part this is due to the extreme states of alertness in which Bourgeois drew, but a corollary to the heightened awareness that stimulated her was the general lack of interest in (or necessity for) finishing her drawings in the conventional way. Bourgeois sought to purge herself by crystallizing images latent in her mind and giving them graphic substance. However, she was not much concerned with translating them into the codified languages of art, and had even less interest in smoothing out their cadences or employing stylistically consistent accents. There is an authentic awkwardness to Bourgeois' pictographic representations of men, women, children, animals, buildings, maypoles and other

increasingly uncanny constructs or composites; not the awkwardness of a halting naif who cannot speak properly, but that of someone who knows how but in the heat of moment can only blurt out what they need to say. Of course there is invention and deliberate inflection to all significant speech, and Bourgeois' drawings have both. She is not passively taking dictation from the subconscious in an automatic manner. However, those contributions to the final picture are spontaneously arrived at and judged rather than assiduously prepared and executed. Usually the only rehearsal for an image is the equally fresh though kindred image that preceded it.

Throughout Bourgeois' career the fusion of architecture with the body or its substitution for the body has been a primary metaphor, but never more clearly than at the beginning. The leaning towers of *He Disappeared into Complete Silence* – portents of the three gigantic towers *I Do, I Undo, I Redo* (1999–2000) which she built for the inauguration of Tate Modern in London – are the first important instances of this. The poetically revealing and innovative prototypes are to be found in her contemporaneous *Femme Maison* (Woman house) paintings of 1945–47. In them the naked legs and torso of a woman are joined or conflated with the window-gridded structure of a multi-storey building. The exterior walls double as constraining pillories or straitjacket but also function as an insufficiently protective carapace, while the windows and doors serve as the blind eyes and orifices of a mask. On one level the *Femme Maison* is an image of domestic entrapment; on another of the helpless exposure of someone who cannot fully conceal

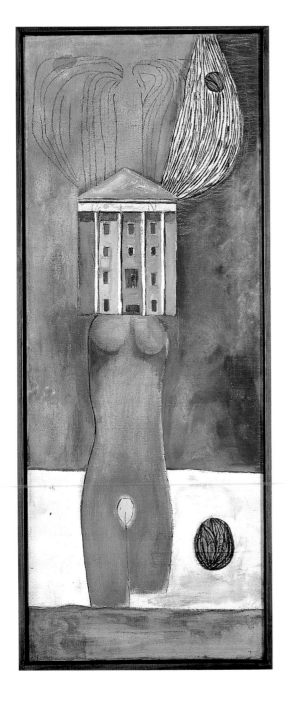
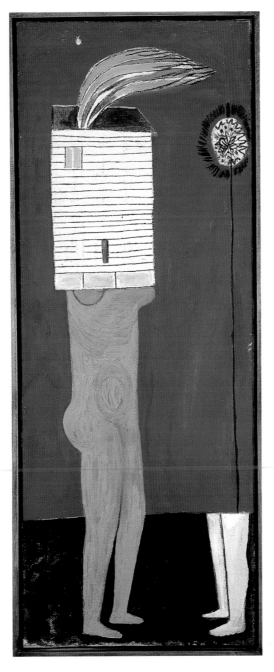
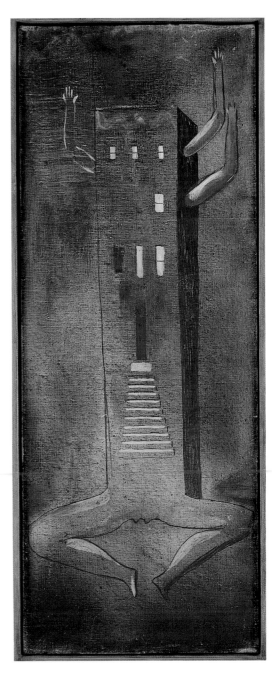

David Smith
Blackburn, Song of an Irish
Blacksmith
1949–50
Steel, bronze
118 × 103.5 × 61 cm

Persistent Antagonism
1946–48
Painted wood with metal ring
172.5 × 30.5 × 30.5 cm
Collection, San Francisco Museum
of Modern Art

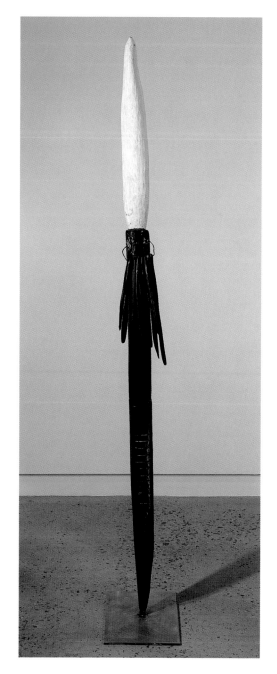

herself within her dwelling. Formally the flat planes of the house belong to Cubism, and the curves of the body to Surrealism; in that simple juxtaposition, the disjunctive syntax of Bourgeois' sculptural idiom was born. In grafting together two previously incongruent propositions – the Euclidean geometry of Renaissance perspective fractured by the Cubists and the metamorphic, topological geometry of the Surrealists – Bourgeois absorbed the former tendency into the latter and radically revised the terms available to post-war sculpture. On the whole, advanced American sculpture of the immediate post-war years gradually cut its ties with the squirmy, spikey anthropomorphisms of Surrealism and moved in the direction mapped by David Smith towards abstract drawing in space, towards assemblage in which the elements become increasing rectilinear on their way towards modularity, and towards planes and volumes detached from any descriptive function. A latent Surrealism nonetheless persisted in Smith's work, and more overt, decorative varieties survived in that of Isamu Noguchi and Alexander Calder, among others. But Bourgeois tackled the fundamental formal problems of melding the two modernist vocabularies, and beyond that of finding procedures that would allow for a direct material manipulation of biomorphic forms and topological principles analogous to that found in Abstract Expressionist painting, rather than merely illustrating the extreme metamorphic possibilities Surrealism suggested.

Yet much of this was to come later, in the 1960s. In the late 1940s and 1950s Bourgeois'

sculptures were fairly simple in their primary aspect, being predominantly needle- or bobbin-shaped lozenges unsteadily balanced 'on point' and reminiscent of the tools of her family's trade. Cavities were cut into them and various objects attached to them. In *Persistent Antagonism* (1946–48), for instance, miniature versions of the main figure cling to it like children, representing the obligations or dependents that at once threaten and help maintain the sculpture's equilibrium. In other cases egg-like balls or mirrors are set into such openings as if they were eyes, while shallow cleavages, slits and perforations suggest mouths and sexual organs. Additional examples of such personages include *Portrait of Jean-Louis* (1947–49), a phallic object on legs covered with the windows of a high-rise apartment block, and *Sleeping Figure* (1950), another phallic surrogate held upright by extended arms or crutches. Bourgeois actually proposed to Barr when he brought it for The Museum of Modern Art that the piece might be placed in various positions and that its appendages might also be manipulated like a marionette.

Indeed several of these works, which ordinarily leaned against the wall of the artist's flat like a Greek chorus of phantoms from her past, suggest multiple permutations, and each of these is formally and emotionally specific. For instance, in *Dagger Child* (1947–49), a vulnerable youngster has, in self-defence, assumed the shape of laminated blades the height of an adult, while in *Portrait of C.Y.* (1947–49), we see Bourgeois take revenge on a tiresome acquaintance (identified only by her initials) by driving nails into an area

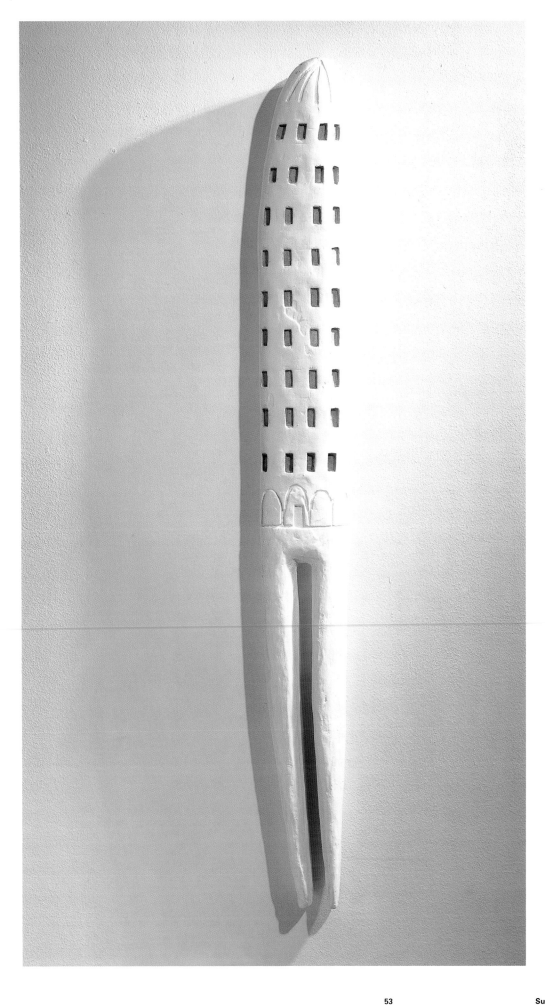

Portrait of Jean-Louis
1947–49
Bronze, painted white and blue
89 × 12.5 × 10 cm

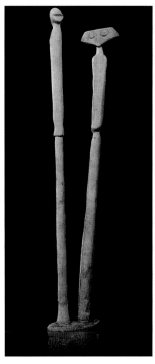

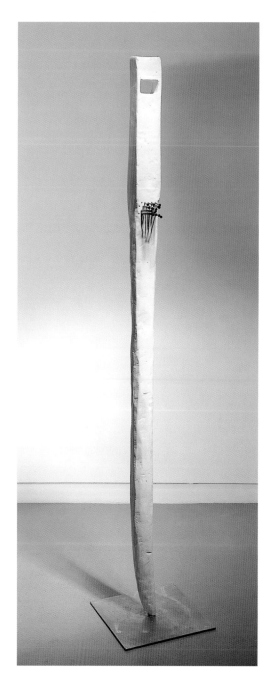

where the effigy's heart would presumably be. Of course, this latter piece recalls the nailed fetishes of Africa, just as the stepped protrusions that look like breasts or buttocks in other 'totems' resemble Dogon ladders. (For the record, Bourgeois hates the word 'totem' but it is unavoidable in as much as her work suggests the parallel on psychoanalytic grounds, involving the familial dynamic of 'totem' and 'taboo', as well as on formal.) Moreover the consistent listing to one side of these sculptures especially evident in pairs like *Brother & Sister* (1949) or groups like *Quarantania* (1947–53) inevitably recall Max Ernst's *Lunar Asparagus* (1935). There are more such correspondences scattered throughout Bourgeois' production – with Constantin Brancusi and Alberto Giacometti in particular, but also with Marcel Duchamp, Salvador Dalí, Attilio Salemme, Frederick Kiesler and Yayoi Kusama. But Bourgeois is no more ready to acknowledge them than most artists are when asked to name their influences or recognize their affinities with others. However, merely identifying Bourgeois' derivations reveals little about her work. That said, the critical question is not what she started with in a given case but what she ended up with after that source's complete assimilation and thorough transformation. Those transformations are not calculated stylizations but radical re-imaginings dictated by Bourgeois' inner imperatives and acute sense of formal nuance. Thus, rather than slicker versions of borrowed motifs we get the rough-hewn quality of her early sculptures and the raw tactility of her drawing as she bears down hard on or cuts to the quick of a given image or idea.

Dogon Ladder
Date unknown
Carved wood
Mali

Max Ernst
Lunar Asparagus
1935
Plaster
h. 165.5 cm

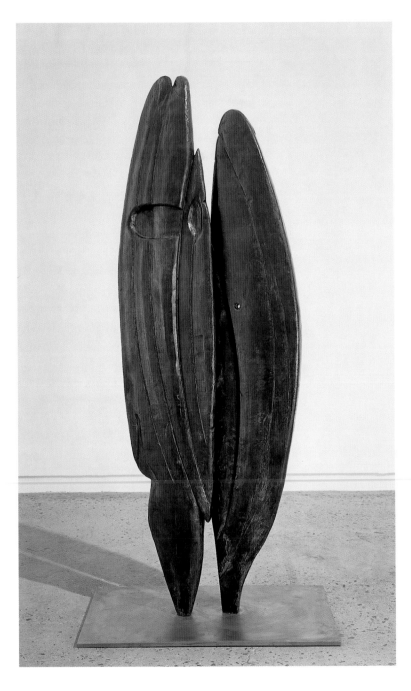

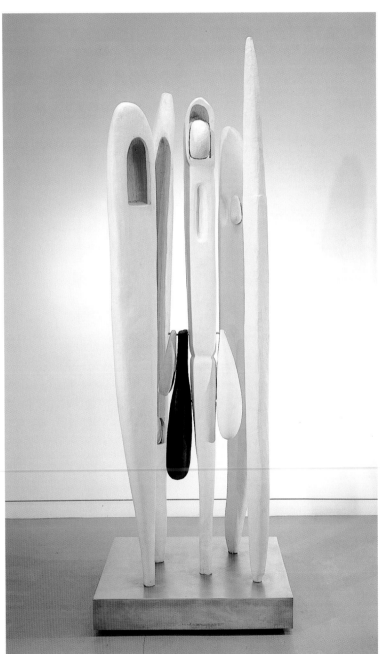

l. to r.,

Brother & Sister
1949
Bronze
165.5 × 76 × 43 cm

Quarantania
1947-53
Bronze, paint
204.5 × 68.5 × 68.5 cm

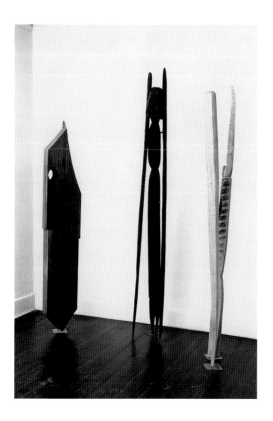

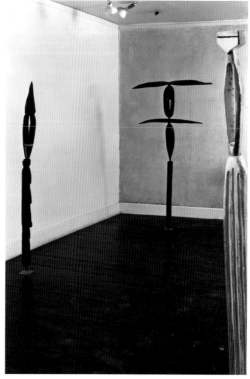

The most radical dimension of Bourgeois' reinterpretation of the anthropomorphic shapes she began with is their relation to each other and to the space around them. Although nowadays displayed on stone or metal bases, Bourgeois' sculptures of the late 1940s and early 1950s were originally installed on rods inserted straight into the floor, so that viewers encountering them in a room would, in a literal sense, find themselves on the same footing as these oddly animistic entities. To walk into New York's Peridot Gallery in 1949 when they were first shown was akin to walking into a gathering of vaguely familiar people, some standing alone, some close together like couples, and some huddled in clusters. Even now, as they tilt towards or away from each other, these personages are charged with ambivalent intimacy by the viewer's passing, and, given their insecure purchase, the possibility is left open that, of their own accord or prompted by a nudge from the onlooker, any one of them might topple into

above, installation views, Peridot
Gallery, New York, 1950

below, **Alberto Giacometti**
City Square
1948
Bronze
Approx. 22 x 63 x 43 cm

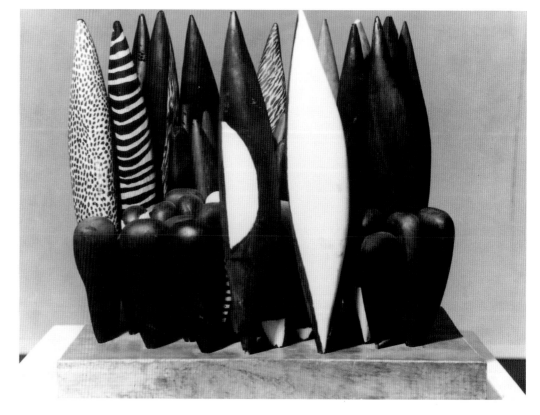

its neighbour, bringing them all down like nine-pins. Thus, by eliminating the traditional base and spreading her sculptures throughout the available space, Bourgeois made a historically early leap from carving monoliths to creating physically interactive installations.

The principal exceptions to this are *Quarantania I*, in which this implicit instability of the upright central figure – a woman with burdens – is mounted on a plinth and counterbalanced by encircling 'guardians' put there to catch her if she falls. The same holds true of the small table-top works, *Night Garden* (1953) and *One and Others* (1955). The latter names the fundamental social and psychological dynamic at the basis of all Bourgeois' work of this period, and of much of it since, that being the uneasy coexistence of the individual and the community. Meanwhile the sculpture itself, with its variegated modules – tall 'adult' ones gathered around smaller child-like ones – alludes not only to the protective insularity of a family or group, but also to its frictions, inequalities and claustrophobic density. In that regard, Bourgeois' description of alienation evokes Giacometti's later sculptures – for example, *City Square* (1948) – precisely by reversing all its formal polarities and supplanting full-bodied volume for wraith-like thinness, uneasy overcrowding for dispersal and emptiness. Bourgeois' other great innovation of this period can be seen in *Blind Leading the Blind* (1947–49). That work is composed of fourteen pieces of lumber crudely cut into elongated triangles. These are arranged in ranks and held together by a dorsal fin made up of horizontal boards reinforced

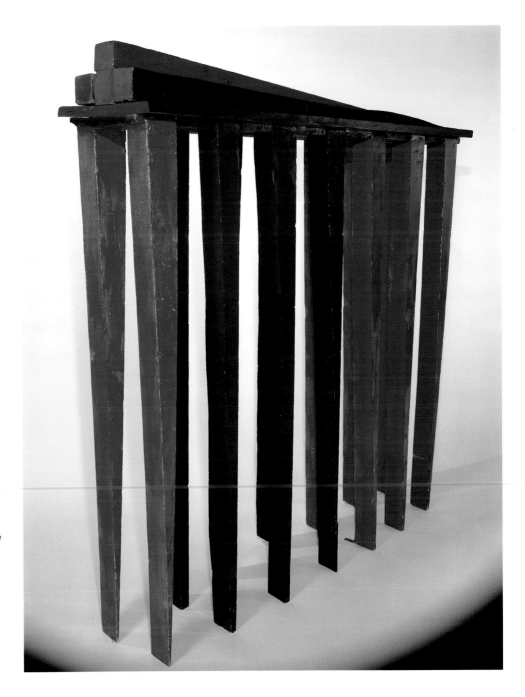

opposite, **One and Others**
1955
Paint, stained wood
46.5 × 50.5 × 42.5 cm
Collection, Whitney Museum of
American Art, New York

above, top, **Constantin Brancusi**
Endless Column
1937
Iron, steel
2,933 × 90 × 90 cm
Installed, Tirgu Jui public
park, Rumania

above, bottom, **Carl Andre**
Equivalent VIII
1966
120 fire bricks
13 × 69 × 229 cm

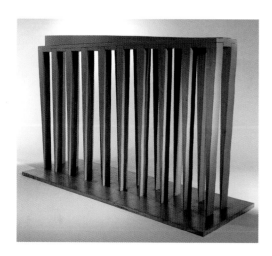

above, **C.O.Y.O.T.E.**
1947–49
Bronze, paint
132 × 209.5 × 29 cm

by additional pieces of tapered lumber. Metaphorically the lock-step march of these abstracted legs reconfigures the intimate group as an ignorant and militant mass. (Painted red and black, the first of several versions of this sculpture is explicitly fascistic, although Bourgeois has also associated it with the reactionary conformity of the post-war American McCarthy era in the 1950s. A later pink version, *C.O.Y.O.T.E.* [1947–49], took the acronym of a prostitutes' union and was reinterpreted by the artist as a symbol of feminist solidarity.) Sculpturally, *Blind Leading the Blind* involves an atavistic creation and deployment of 'minimal' units, and a wholly unprecedented inversion of the structural order whereby the 'base' holding all the components together appears on the top rather than the bottom of the ensemble.

Having abdicated the unique place in American sculpture she had claimed between 1949 and 1953 by virtue of these sculptures, Bourgeois re-emerged in 1962 with a whole new body of work. In the interim, while Bourgeois hung back, Louise Nevelson, who had been in and out of Bourgeois' studio during the early 1950s, effectively appropriated many of Bourgeois' ideas and made them over as Cubist-derived assemblages and environments. Confronted by this stiff simulacrum of her work and the sheer drive of her former-friend-turned-rival, Bourgeois went her own way. The first step, anticipated by her carved totems, were the stacked pieces she created out of scraps of wood, plaster fragments and found objects. Poetically all are in one way or another spirals that have been denied the possibility of flaring out, so that they pivot on a fixed axis. By the same token all are wavering if not contorted bodies seeking a sustainable posture. The flat white jigsaw-cut components of some resemble vertebrae twisting or a classic contrapposto pose, while the components of others are irregular and polychromed – like arthritic knuckles grinding against each other. In *Femme Volage* (1951) flanges swivel on the metal post with some extending outward as if cast out from a centre that cannot hold them. In *Memling Dawn* (1951), by contrast, the components are massive and relatively uniform blocks of wood, which in purely sculptural terms result in an object that stands halfway between Brancusi's *Endless Columns*, from which they descend, and Carl Andre's minimalist grid works which they presage. The crucial distinction is that, though often exhibited in perfect squared-off alignment, these blocks also rotate, giving to the rigid paradigm the coiling effect of a Baroque Solomonic column.

Until the 1980s and 1990s, when she resumed the practice of cannibalizing older works to make new ones, Bourgeois approached these stacked pieces as if they were a kind of knitting. From the mid-1950s into the early 1960s – the worst and most extended of her depressions – their facture was a repetitive discipline geared to accretion that quelled her panic and consumed her anger. On structural grounds these heterogeneous poles might best be thought of as vertical renditions of such horizontal aggregates as *One and Others*, and like them, they represent the constant tension that exists among similar but still distinctive and not necessarily compatible beings. For Bourgeois, 'wholeness' is forever elusive and invariably riven by anguish. When faced by

Femme Volage
1951
Wood, paint
183 × 44.5 × 33 cm
Collection, Solomon R.
Guggenheim Museum, New York

Memling Dawn
1951
Bronze
162.5 × 38 × 45.5 cm

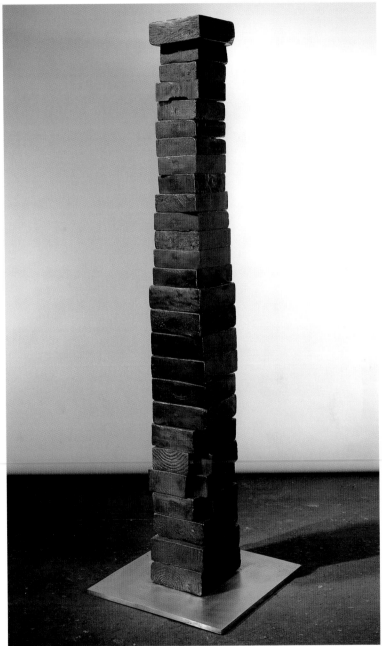

outside threats there is safety in numbers, but inside such an enclave there is never lasting security or peace.

While the shafts of several of the stacked pieces were pliant and the basic dynamic a spiral, the wooden and plaster elements of which they were composed were hard, sometimes brittle. Around 1962, Bourgeois dispensed with wood

as her primary material and further explored what plaster in its initially liquid state could do. From these experiments issued the first of her convoluted *Lairs*, bulky, often bulbous knots which conflate the principle of the spiral – a simultaneous centripetal and centrifugal form – and that of the Moebius strip, whose outside is also its inside. Gradually her studio filled with

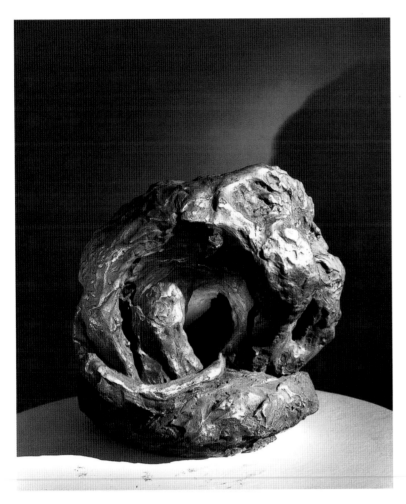

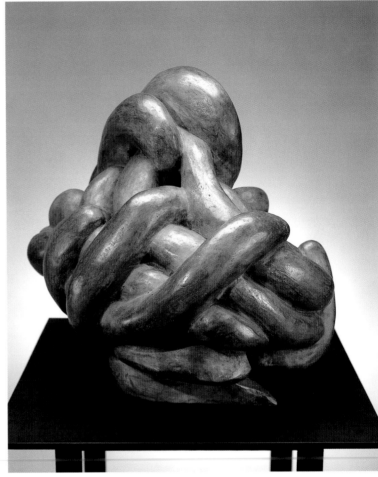

shapes that were simultaneously reminiscent of shells or exoskeletons and their quivering inhabitants; rocky grottoes; flowing lava and undulating terrain; frozen or congealed matter at its most inanimate; and flesh at its most sensitive and elastic.

 For the next decade this fundamental dialectic of hard-and-soft dominated Bourgeois' art as

she experimented with a wide variety of formats, materials and processes and tracked the metamorphosis of a series of closely linked images. With its lumpy exterior and cavernous interior – an interior that conceals several grasping human fingers met by other curious hands penetrating (or should one say, violating) those recesses – *Homage to Bernini* (1967) underscored this

left, **Rondeau for L**
1963
Bronze
28 × 28 × 26.5 cm

above, **Clutching**
1962
Bronze, silver nitrate patina
30.5 × 33 × 30.5 cm

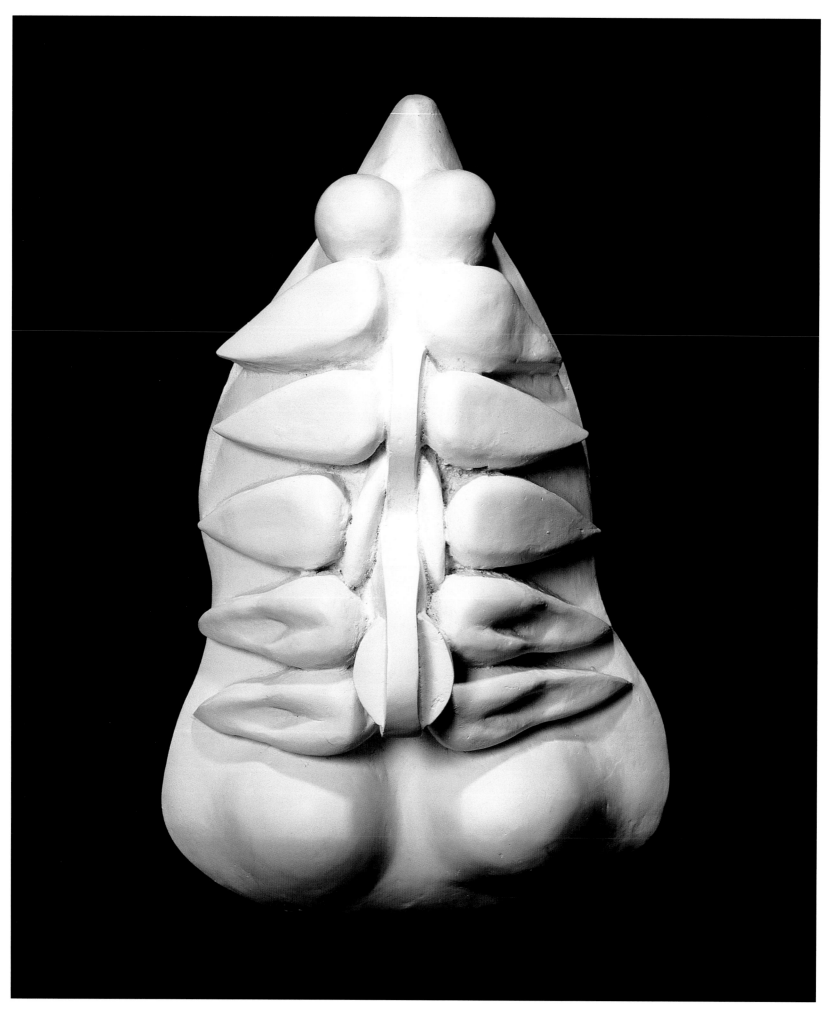

preoccupation by saluting the Baroque master who, chiselling marble with exquisite finesse, could mimic the indentation of a man's hand on a woman's thigh. Others such as *Torso, Self Portrait* (1963–64) are more uncanny still. With two round balls for breasts at the top (or are they eyes?), two buttock-like bumps at the bottom (or are they breasts?), and strange, possibly nasal, proturberances in the middle (or is it a clitoris sheathed in labial folds?), the whole surface of the curious, scarab-like shape is covered with what look like giant teeth. In fact they are the same form Bourgeois had used nine years earlier to represent children in *Blind Leading the Blind*. Nothing in the artist's vocabulary ever has a fixed meaning, and nothing is ever set aside for good.

Torso, Self Portrait is a typical sculptural oxymoron of the period: something forbidding that is at the same time helpless, something that appears indestructible which is in reality exceedingly fragile. Yet even as Bourgeois tested the limits of what could be done with a traditional artist's medium like plaster, she was among the first to explore the potential of latex, synthetic resins and other non-art materials. (Her initial forays into this area antedate those of Eva Hesse by two or three years.) Thus, using the same general format as *Torso, Self Portrait*, she cast the visceral *Portrait* (1963) in latex, taking full advantage of the at once attractive and repulsive, skin-like quality of the rubber. In other pieces such as *Soft Landscape I* (1967) she poured molasses-coloured resin over what might be phallic shapes, resulting in a slightly repellent yet richly tactile depiction of Mother (or is it Father?) Earth.

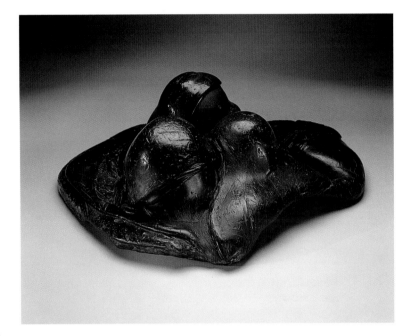

Soft Landscape III
1963
Plastic
17 × 50 × 44 cm

Soft Landscape I
1967
Plastic
10 × 30.5 × 28 cm

Le Trani Episode
1971
Bronze, dark patina
42 × 58.5 × 59 cm

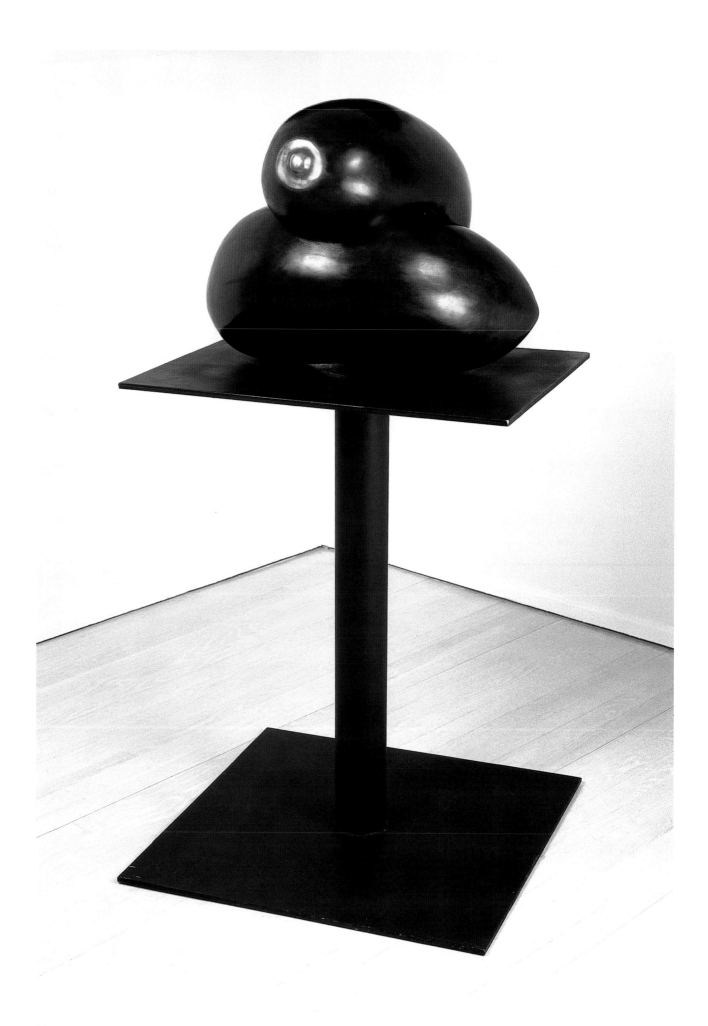

The uncertain identity of Bourgeois' images is the key to their aesthetic fascination and pyschological potency. On the one hand the mounds, or as she called them 'cumuls', that proliferated in her work from the early 1960s onwards may be read as sexual attributes; on the other they may be seen as natural geological formations; and on still another, especially when perforated with openings, as primitive architecture, troglodyte dwellings, huts or burrows – or, as she calls them 'lairs'. All of the latter are essentially organic variants on the hide-and-seek, protection-and-entrapment theme of the *Femmes Maisons*, but with an element of menace added. The danger to anyone who imaginatively 'enters' one of these labyrinthine tunnels is at least as great as the intrusive spectator's unwanted presence is to whoever or whatever is concealed within, be it a fearful, mollusc-like recluse or a female Minotaur.

The dominant issue in these and related works is the mutability of gender and the volatility of its supposed emotional predispositions. The implicit perspective from which to view this world is that of a changeling/adolescent, on the cusp of mature sexual awakening. For her, or him, the body remains an alien, unstable and partially undifferentiated appendage of the psyche, while the psyche is prone to spasms of desire, alarm, terror and violence. The double-reading of basic sexual symbols is at the basis of all Bourgeois' conjugations of the passive-aggressive verbs of erotic discourse. The tooth/child shape, for example, is her rendition of the traditional Hindu emblem for the female vulva, the yoni. The stubby

shaft with its rounded tip is likewise a representation of the Indian male principle, the lingam.

However, in *Le Trani Episode* (1971) Bourgeois puts nipples on both ends of sausage-like lingams, and then plops one over another, like sacks of flour, confounding terms and switching qualities and associations in a way that makes the phalli (if they are that) soft and breast-like, or the flaccid phallus-like breasts (if they are that) a burden to themselves. The marble *Sleep II* (1967) would also seem to be a fairly straightforward representation of a limp penis – a Freudian version of Brancusi's *Endless Column* or *Bird in Space* collapsed upon itself – and, as such, a rather tender portrayal by a woman of a man's impotence or post-coital detumescence. But reworked in plaster and cast in bronze, two of the same forms abutted at their bases result in the startlingly androgynous *Janus Fleuri* (1968). Here the foreskin of *Sleep II* has been elaborated into something that resembles vaginal lips and the head of the two penises into breasts. Hung head-high on a hook, this binary and ambivalent object confronts the spectator like meat at a meat-market. An odd dualistic mass, this Janus – which looks both ways not so much in a temporal sense as in an erotic one

Constantin Brancusi
Bird in Space
c. 1928
Bronze
h. 137 cm

Sleep II
1967
Marble
59.5 × 77 × 60.5 cm

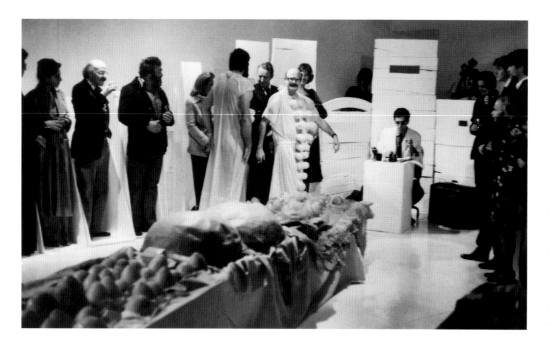

A Banquet / A Fashion Show
of Body Parts
1978
foreground, **Confrontation**
1978
Painted wood, latex, fabric
1,128 × 610 cm
Collection, Solomon R.
Guggenheim Museum, New York
Performance, 'Louise Bourgeois
New Work', Hamilton Gallery of
Contemporary Art, New York
Photo © by Peter Moore

– is carnality at its most imposing and disturbingly ambiguous.

Two equally exaggerated but larger versions of this psycho-sexual *legerdemain* are *The Destruction of the Father* (1974) and *Confrontation* and its accompanying performance piece, *A Banquet/A Fashion Show of Body Parts* (both 1978). The first is a monstrous puppet-theatre in which 'the audience' imaginatively plays out an Oedipal Grand Guignol scenario that elaborates or reverses the myth of Saturn (also known as Cronus) devouring his children to prevent them usurping his power. In Bourgeois' variant the children of an overbearing patriarch rise up from the table and eat their oppressor. The installation itself is the site of this anthropophagous feast, with the cast haunches of a lamb spread over a bed of phallus/breast shapes juxtaposed with bulbous 'cumul' shapes on the ceiling. In combination, these lumps and pointed bumps resemble canine teeth and molars in some giant maw or a *vagina dentata*, with the both grisly and obscene humour of this sculptural *double-entendre* being central to Bourgeois' meaning. *Confrontation* reprises the profiles of buildings found in Bourgeois' early engravings, examples of which surround a long palette covered with more latex lumps and bumps,

laid out like the plates of food in Pieter Brueghel's *The Peasant Wedding* (1567). (In Bourgeois' case what might at first seem far-fetched associations are not the sport of scholars but rather proof of how present in mind such precedents were for the artist. In the 1950s, as noted, Bourgeois borrowed the title of Breughel's *Blind Leading the Blind* [1568] for a sculpture, and in the 1940s her maypole imagery unmistakably bore a secondary resemblance to the gibbets and torture wheels in his *Triumph of Death* [c. 1562].) In the 'Banquet' performance itself, nude men and women – artist's models as well as art-historian colleagues of her husband – sheathed in latex costumes covered with more such protuberances paraded among the spectators to everyone's discomfort and delight.

As an engagement with Happenings and Performance art on the part of a woman already in her sixties, Bourgeois' 'Banquet' demonstrated both her eagerness to try new forms and her ability to match or surpass their previous manifestations in thematic reach and theatrical outrageousness. The visceral work of the Viennese Actionists in the late 1960s and early 1970s is of special relevance in this regard. Indeed, a poster for a New York showing of Peter Kubelka's film documentation of Actionist performances has for many years been pinned on her living-room wall. But where Actionists Günter Brus, Hermann Nitsch and Rudolf Schwarzkogler were preoccupied by the Catholic dialectic of the sacred and the profane and tended towards expressionism in their slaughterhouse-to-self-mutilation rituals (Otto Mühl was the exception in this respect), Bourgeois' *mises-en-scène* are, for all their aggressive or disconcerting

Pieter Brueghel
The Peasant Wedding
1567
Panel
114 × 163 cm

physicality, guiltless, even gleeful burlesques.

Meanwhile Bourgeois' forays into synthetic materials such as resin and rubber aligned her with a younger generation of experimental artists that, as previously mentioned included Eva Hesse among others. Beyond that her attention to the inherent properties and behaviour of these and other substances – principally plaster and Hydrocal, whose bulky flow when wet offered a whole new range of sculptural options – put her in the company of Process or Anti-form artists such as Robert Morris. However, Bourgeois' simultaneous turn to bronze and marble set her on a course in the opposite direction from the rest of the avant-garde. Or, in hindsight, it would be more accurate to say that she was ahead of the curve that brought these materials back into general usage by the end of the 1970s and into the 1980s, though her interest in them was never gratuitously 'retro', nor was the work she produced poetically reactionary in the manner of the so-called Transavantgarde of the 1980s. In the case of bronze, Bourgeois' sculptures could be as elegant as the nevertheless cloacal *End of Softness* (1967) – a kind of tactile contradiction in terms that looks as sleek as an Art Nouveau inkstand and as earthy as a cow pie – or as rough as *Rabbit* or *Heart* (both 1970), both direct copies in metal of the forms named. In a gesture of art criticism by object, the former suggests a ravaged fossil of Joseph Beuys' animal alter-ego and sometime ventriloquist's dummy.

Bourgeois' early carvings in stone run much the same gamut. Some, such as *Cumul I* (1969), recall the Baroque draperies of Bernini; others,

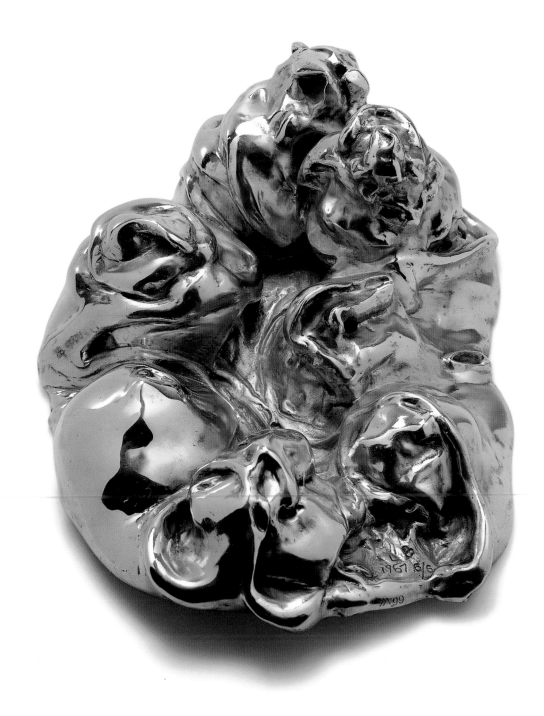

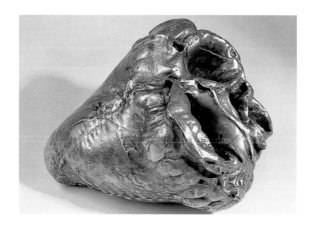

above, **Heart**
1970
Wall piece: bronze
14 × 16.5 × 20.5 cm

above, right, **Rabbit**
1970
Bronze
57 × 28 × 15 cm
Collection, Solomon R.
Guggenheim Museum, New York

below, right, **Cumul I**
1969
White marble
57 × 127 × 122 cm
Collection, Musée national d'art
moderne, Centre Georges
Pompidou, Paris

right, **Eye to Eye**
1970
Marble
80 × 76 × 76 cm

below, **Blind Man's Buff**
1984
Marble
92.5 × 89 × 63.5 cm
Collection, Cleveland Museum of
Art, Ohio

such as *Clamart*, with its marshalled lingams, are reminiscent of the sculptor Jean-Antoine Houdon, while later pieces such as *Blind Man's Buff* (1984) and *Nature Study* (1986), with the contrast of chipped bases and finely chiselled volumes, explicitly evoke Rodin. In these teasingly evocative allusions to the tradition, Bourgeois drew on her childhood familiarity with its past glories, and

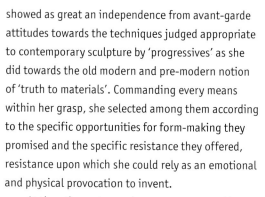

showed as great an independence from avant-garde attitudes towards the techniques judged appropriate to contemporary sculpture by 'progressives' as she did towards the old modern and pre-modern notion of 'truth to materials'. Commanding every means within her grasp, she selected among them according to the specific opportunities for form-making they promised and the specific resistance they offered, resistance upon which she could rely as an emotional and physical provocation to invent.

At the other extreme, however, are assemblages such as *Number Seventy-two (The No March)* (1972). Taking the demonstrations of the Vietnam War era and early phases of the feminist movement as her subject, Bourgeois reverted to the kind of modular composition she had explored in *Blind Leading the Blind* and in stacked pieces like *Memling Dawn*, this time employing discarded cylinders of marble drilled by the quarrymen in preparation for cutting and blasting away larger blocks of stone. Packing these fragments together she was once again able to suggest the combined fellow feeling and unease of the group, but extended that tension to the crowd. Thus, while *Eye to Eye* (1970) effectively re-created and developed not only the theme but the physical quality of *One and Others* in marble, in *Number*

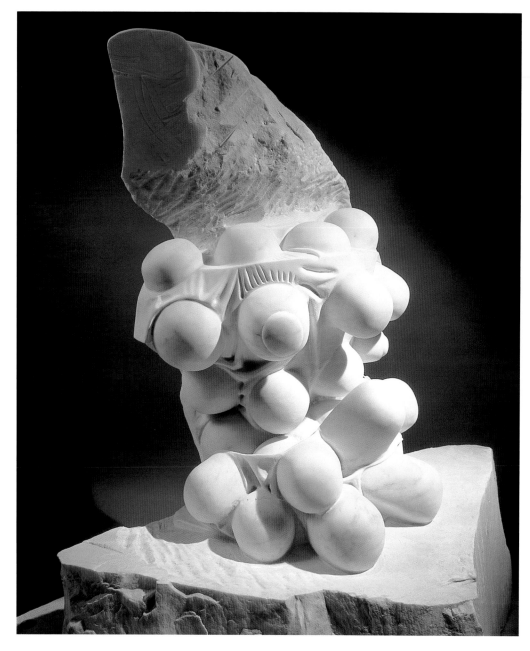

below, **Number Seventy-two
(The No March)**
1972
Marble, travertine
51 × 305 × 275 cm
Installation, 'Whitney Biennial
Exhibition', Whitney Museum of
American Art, New York, 1973
Collection, Storm King Art Centre,
Mountainville, New York
Photo © by Peter Moore

Femme Pieu (Stake Woman)
c. 1970
Wax, metal pins
9 × 6.5 × 15 cm

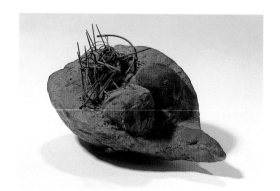

Fillette (Sweeter Version)
1968–99
Latex over plaster
59.5 × 26.5 × 19.5 cm

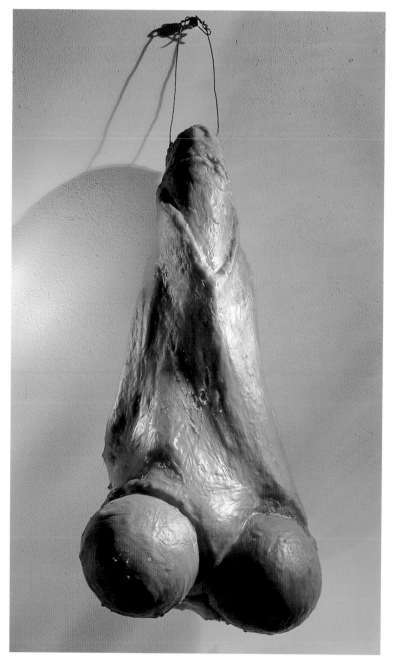

Seventy-two (The No March) she radically altered its physical presence and enlarged upon the meaning of the earlier huddle or cluster work. And while *Blind Leading the Blind* is a metonymic symbol of the slavishly obedient masses of the 1940s and 1950s, *Number Seventy-two (The No March)* is a dramatically more numerous and substantial representation of the angrily disobedient masses of the 1960s and 1970s, a palisade at the edge of a continent of dissent.

The metamorphosis of Bourgeois' imagery can be tracked in both its physical aspects and its symbolic significance along the trajectory marked at one end by *Fillette* (1968), and at the other by *Femme Couteau* (1969–70). Between the two can be found a number of sculptures that reduce the body of a limbless woman to her belly, breasts and neck, among them the pincushion-like *Femme Pieu* (Stake Woman) (*c.* 1970), *Fragile Goddess*

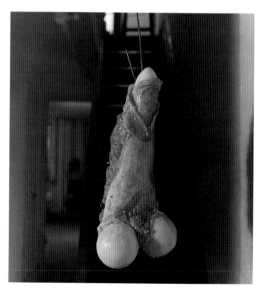

Fillette
1968
Latex over plaster
59.5 × 26.5 × 19.5 cm
Collection, The Museum of
Modern Art, New York
Photo © by Peter Moore

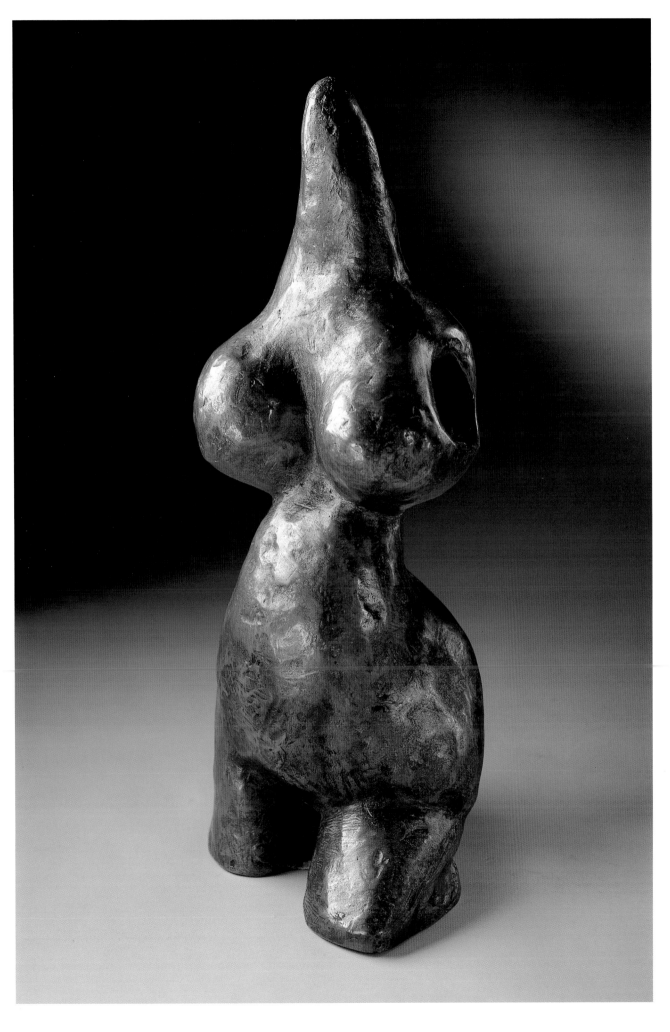

(1971), *Harmless Woman* (1969) and *Untitled* (1968–69). In each fleshy ripeness as a sign of female fecundity is paired with the vulnerability of having no arms or legs, with only the probe-like protuberance on her shoulders to guide or protect her. *Harmless Woman* and *Untitled* are the most naturalistic in this respect; *Fragile Goddess* and *Femme Pieu* the most archetypal in appearance and the closest to primitive fetishes such as the ancient *Venus of Willendorf*. *Femme Couteau*, which somewhat resembles the smooth tapered contour of Brancusi's *Hand* (1920), streamlines and abbreviates this rendition of the woman's body, wrapping all but one exposed area that might be her bust or buttocks or pudenda in a clinging sheet. The remainder is reconfigured as an archaic

Partial Recall
1979
Wood
274.5 × 228.5 × 167.5 cm

Venus of Willendorf
c. 24,000–22,000 BC
Oolitic limestone
h. 11 cm

Constantin Brancusi
Princesse X
1915–16
Polished bronze
h. 56 cm

stone blade, a weapon of defence that represents the partial transformation of the neck into the phallus, and thus the mutation of an obvious and preponderant 'womanliness' into a seemingly opposite but in fact latent or recessive 'manliness'.

The complete transformation takes place in *Fillette*. Here, plaster elements covered with leathery, amber latex depict the breasts as testicles and the neck as an oversized erect penis. *Fillette* is French for 'little girl', in this case a girl who has become what threatens her. Transfixed by her monstrous reincarnation, the viewer is dragged into the contested psychological zone where male and female, aggression and vulnerability, are virtually indistinguishable. On one level *Fillette* is a sculptural digression from another Brancusi piece, *Princesse X* (1915–16) (also a visual pun on masculinity and femininity), but where the Brancusi is sleek and slyly lubricious, Bourgeois' is repugnant and anatomically grotesque. Her subversive wit comes out in a deliberate contradiction between the work's given title and the object's self-proclaiming priapism, as well as in the two possibilities for its presentation. In the first variation *Fillette* hangs from the tip on a hook, which makes explicit the castrating force of the woman's fear and hostility. In the second version, the piece is held in the arms like a parcel (as the artist does in Robert Mapplethorpe's famous photograph), or cradled at the chest as one would a baby. In the latter orientation it achieves its fullest symbolic or existential polyvalence. Depending on whether one is male or female, child or adult, gay or straight, the danger or appeal of *Fillette* will be perceived differently, as will its subversive humour. Embraced in this fashion, *Fillette* becomes a kind of compass of gender difference for which there is no 'true North', a site-specific sculpture whose intended location is not a pedestal or suspended wire but another responsive body, with still others after that.

For the first forty years of her career, Bourgeois made her studio in the domestic spaces of her family's East Side Manhattan apartment, and later of their Chelsea brownstone, whose basement she initially took over and whose upper floors she gradually colonized in the mid to late 1970s after her sons had left home and her husband had died. Even large-scale works such as *Partial Recall* (1979) – the cloud-bank or altar-like treatment of the 'cumul' image that is one of the few serene sculptures in her entire body of work – were created in sections and constructed to fit the height and width of rooms in her house. Meanwhile, marbles and bronzes were made during visits to Italy where she worked near the quarries of Pietrasanta and Carrara from the late 1960s to the early 1980s. In 1980 Bourgeois acquired a large industrial loft in Brooklyn, where she was able to store her accumulated work both old and new, stockpile scavenged materials for future use, and pursue projects simultaneously in wood, stone or assemblage. From that point onward Bourgeois' production increased dramatically, while its scope expanded to incorporate large installations and major public commissions, such as those for the Tate Gallery in London (temporary), and the Bibliothèque nationale in Paris (permanent), as well as the siting of indoor and outdoor sculptures

Nature Study
1984
Bronze, polished patina
76 × 48 × 38 cm
Collection, Whitney Museum of
American Art, New York

in cities from Pittsburgh to São Paulo.

This change in pace and scale of operations has led to changes in the work itself that have also necessitated the recourse to assistants and the shift to fabrication. Without them mammoth sculptures like *Twosome* (1991) or her giant 'spiders' of the past ten years would have been impossible to realize. However, with the resources now available to her, the core of all her diversification and experimentation remains Bourgeois' abiding obsessions, enhanced by her extraordinary ability to project them into disparate formats. And, in the final analysis, everything comes back down to her solitary, often sleepless industry: to the wax models she makes at what was once her dining-room table; to assembling and reassembling wooden elements that she cuts on the band saw in her cellar or recuperates from dismantled works of the past; to the stitching and unstitching of old garments gleaned from chest of drawers and boxes scattered throughout the house; and to note-taking that covers the front and back of virtually any piece of paper within reach, as well as the title pages of books, and the margins of her own sketches or graphic works. Indeed the last decade and a half has seen an unexpected burst of drawing and printmaking after years of relative inactivity in these media. Although Bourgeois' art has become ubiquitous in the world and often grandly so, she herself rarely leaves the confines of her home, preferring instead to worry away at the materials in front of her with whatever tool – knife, awl, pen, brush, pencil – lends itself to her imagination.

The smaller works that have issued from

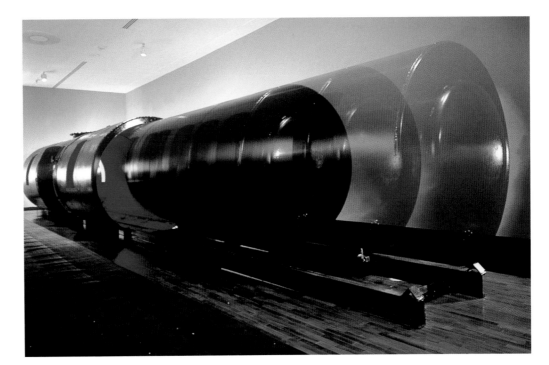

Bourgeois' studios since the 1980s range from the technically exquisite to the deftly improvised. As already noted, there has been a decided shift in emphasis from the theme of The Father to that of The Mother. In one reading, the 'spider', although encased in an armoured shell and bearing her eggs in an iron maiden-like basket, is the capable Good Mother, a patient spinner and weaver like Bourgeois' own. In another she is the ferocious Bad Mother, the controlling mistress of her own domain and a danger to everyone she binds to it. In other words, it is an expression of the dark side of Josephine's nature, but even more so than that, the dark side of the mature Bourgeois' experience as a mother. And when these arachnoid surrogates swarm, as they have done in various installations, they acquire an almost science-fiction aspect, as if loathsome aliens imbued with human characteristics of maternal possessiveness and intentional cruelty had been let loose on an unsuspecting and unprepared planet.

The bronze *Nature Study* (1984) and the black marble *The She-Fox* (1985), both based on a found decorative sculpture of a hunting hound to which Bourgeois has added multiple swollen teats, are,

Twosome
1991
Steel, paint, electric lights
203 × 1,158 × 203 cm
Installation, 'Dislocations', The Museum of Modern Art, New York, 1992

following pages, **In and Out**
1995
Metal, glass, plaster, fabric, plastic
Plastic, 211 × 165 × 287 cm
Cell, 244 × 244 × 244 cm

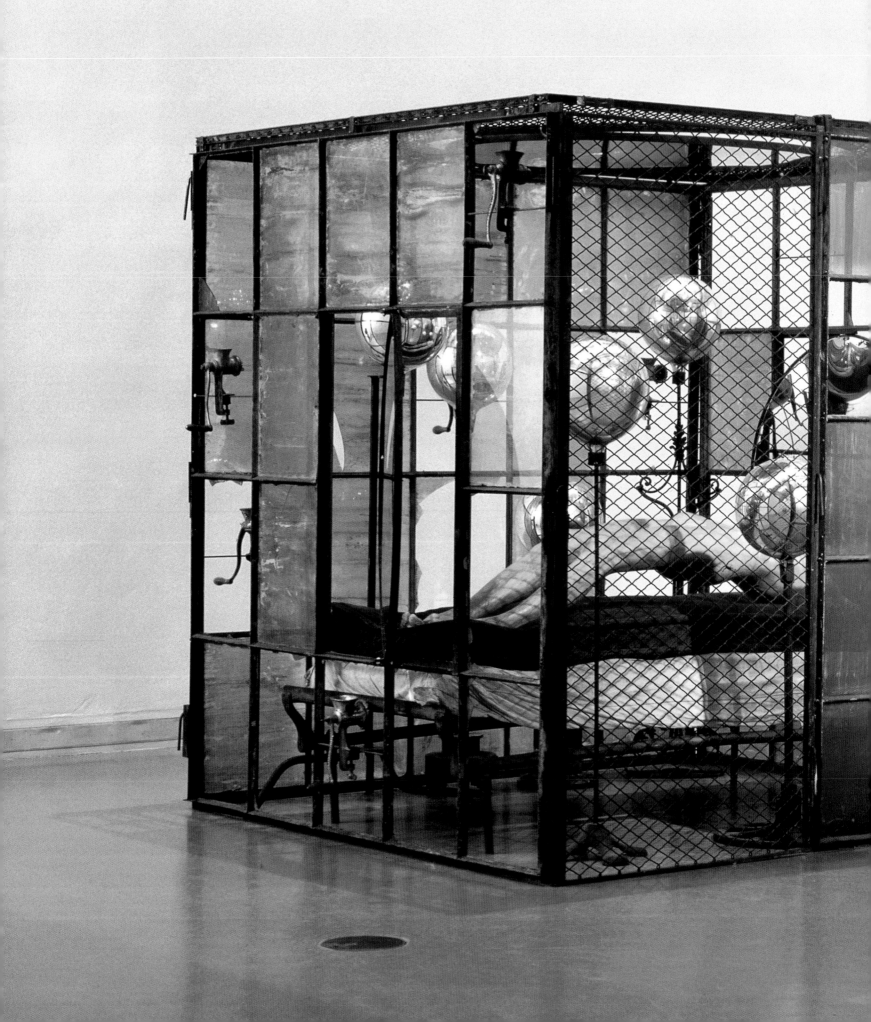

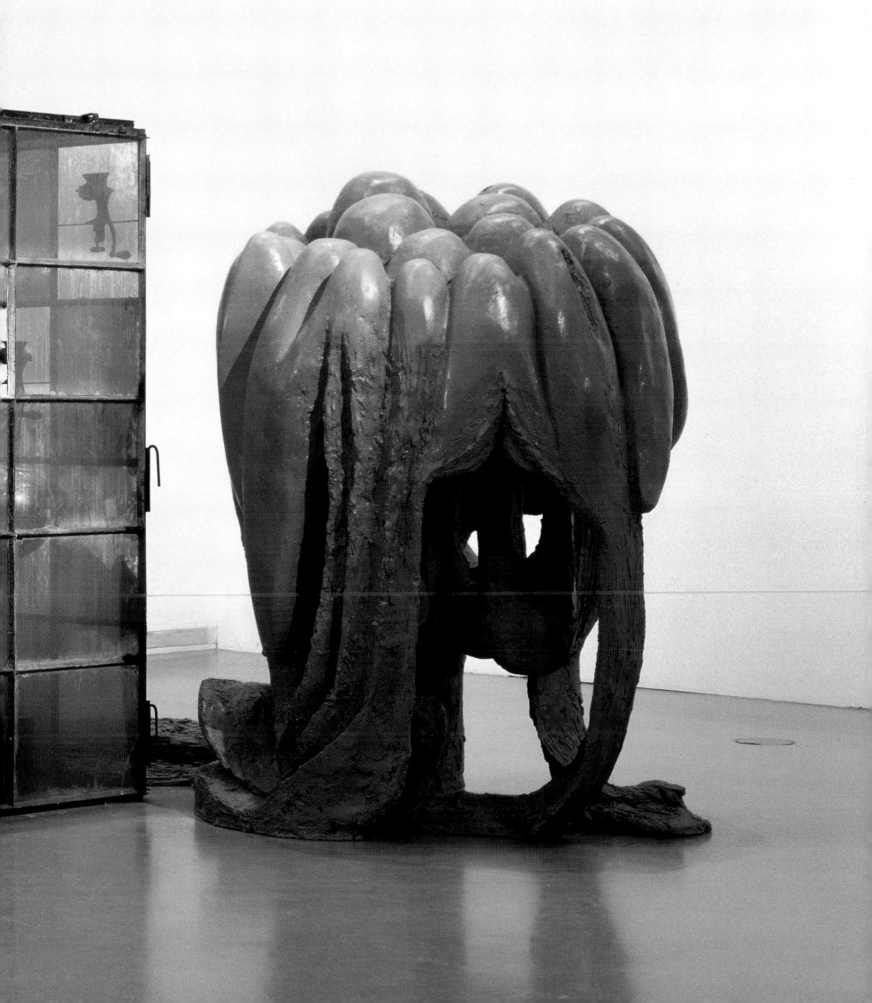

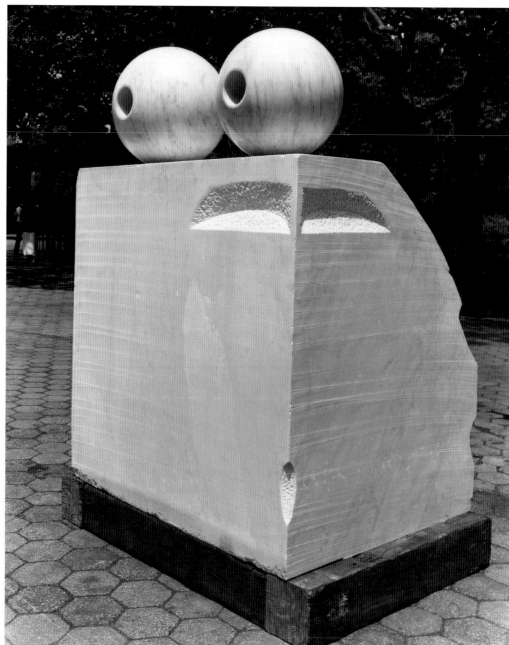

above, **Eyes** (detail)
2001
Bronze, granite, interior lighting
fixtures
Dimensions variable
Collection, Williams College
Museum of Art, Massachusetts

right, **Eyes**
1982
Marble
185.5 × 165 × 114.5 cm
Collection, Metropolitan Museum
of Art, New York

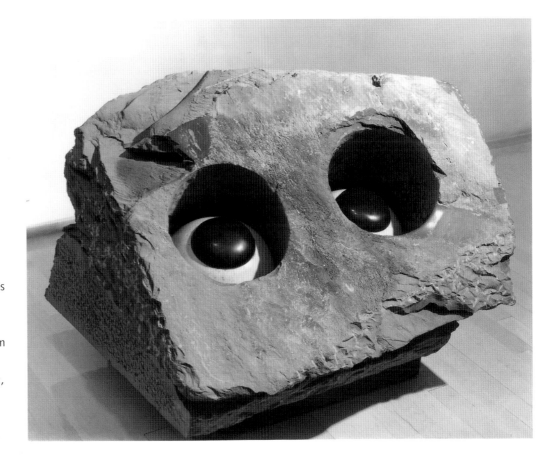

likewise, ambiguous images of the powerful Mother. And, nestled next to *The She-Fox* is a small head of a girl or young woman, who might be her daughter, attached to a pestle-like neck or body. Although the stance of this guardian-like animal figure is almost majestic, the fact is her head has been cut off – possibly in an act of Oedipal violence committed by her offspring – and her throat has been slit in a vertical, vaginal gash. As in much of Bourgeois' work of this period, the impact of Symbolist art which she knew from her youth in Paris is palpable, an affinity no doubt enhanced by her dialogue with Goldwater. From that perspective *Nature Study* and *The She- Fox* are canine embodiments of nineteenth-century images of the feline Sphinx, whose riddle Oedipus had to solve in order to save his life and whose role in Freudian cosmology is essential. By the same token *Female Portrait* (1962–82) is the Medusa whose look petrifies the object of its attention, inverting, in Bourgeois' characteristic fashion, the conventional psycho-social dynamic of the supposedly omniscient and omnipotent male gaze that transfixes and transforms its female victims. In the same vein her many renditions of eyes – *Eyes* (1982), *Nature Study, Velvet Eyes* (1984), as well as her public sculpture *Eyes* (2001) for Williams College in Massachusetts – question the gender, authority and truthfulness of the gaze, even as they harken back, like her predatory spiders, to the weird netherworld of the Symbolist painter and draftsman Odilon Redon. Once again, however, Bourgeois had so completely assimilated the artist's influence by the time it was fully felt in her sculpture that one must speak less of overt

borrowings than of the outpourings of a richly embroidered second nature.

Surely the most complex development of Bourgeois' late work – and its crowning achievement to date – are the 'Cells' to which she devoted the mid- to late 1980s and most of the 1990s. As early as World War II Bourgeois had made drawings and paintings in which partially open or semi-transparent rooms or chambers are inhabited by spectral figures, for example, *House of My Brothers* (1940–42). In all their graphic

Cell (Eyes and Mirrors)
(in progress)
1989–93
Marble, mirrors, steel, glass
236 × 211 × 218.5 cm
Collection, Tate Gallery, London

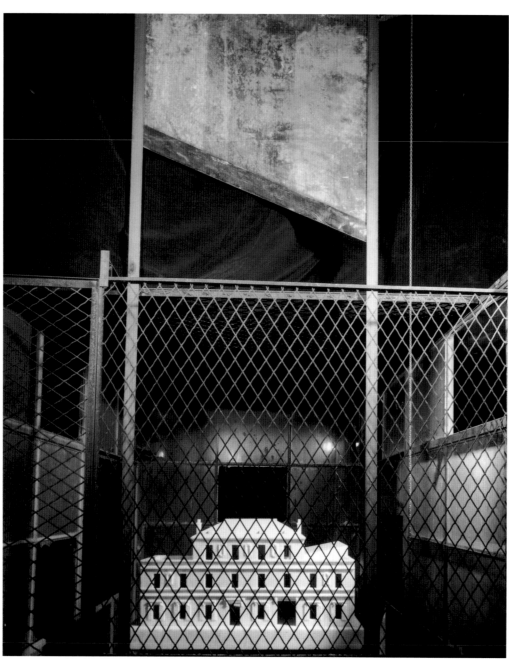

Cell (Choisy)
1990–93
Pink marble, metal, glass
306 × 170 × 241.5 cm

forms these architectural mazes are evocations of her primordial homes, the Bourgeois family villas in Anthony and Choisy-le-Roi. Forty years later, her three-dimensional re-creation of these haunted places is less specifically about her own life and more generally addressed to the experience of physical isolation or solitude within groups – once again the theme of *One and Others* – though *Cell (Choisy)* (1990–93) contains a marble replica of her family's house there, a sign from her father's workshop, and a facsimile of a guillotine, signifying the fear of being cut off from the past. The other 'cells' are in a sense more 'abstract' in their narrative, despite the fact that their contents – realistically carved marble hands, legs and ears (the latter much enlarged); casts of a virtually nude man's body pitched in the 'hysterical arch' that pioneering neurologist and Freud's mentor, Jean-Martin Charcot (1825–93), deemed symptomatic of a peculiarly feminine form of anxiety; a huge band saw; cots with soiled and lettered bedclothes; ornate perfume bottles; and sundry other emblems in the artist's repertoire of melancholy remembrance, anguished anticipation and gnawing loneliness. Some of the 'cells' are framed in wire mesh and mullioned glass from the windows of industrial lofts like the one in which she works; others are boxed out in doors rescued from dumpsters. In the case of the latter, one may peek between the hinged doors to see what is inside, and occasionally a door is left ajar so one can actually enter the space, doing so at some psychological if not physical risk. In the case of the former, only visual access is allowed, which in *Cell (Eyes and Mirrors)* (1989–93) is complicated by the

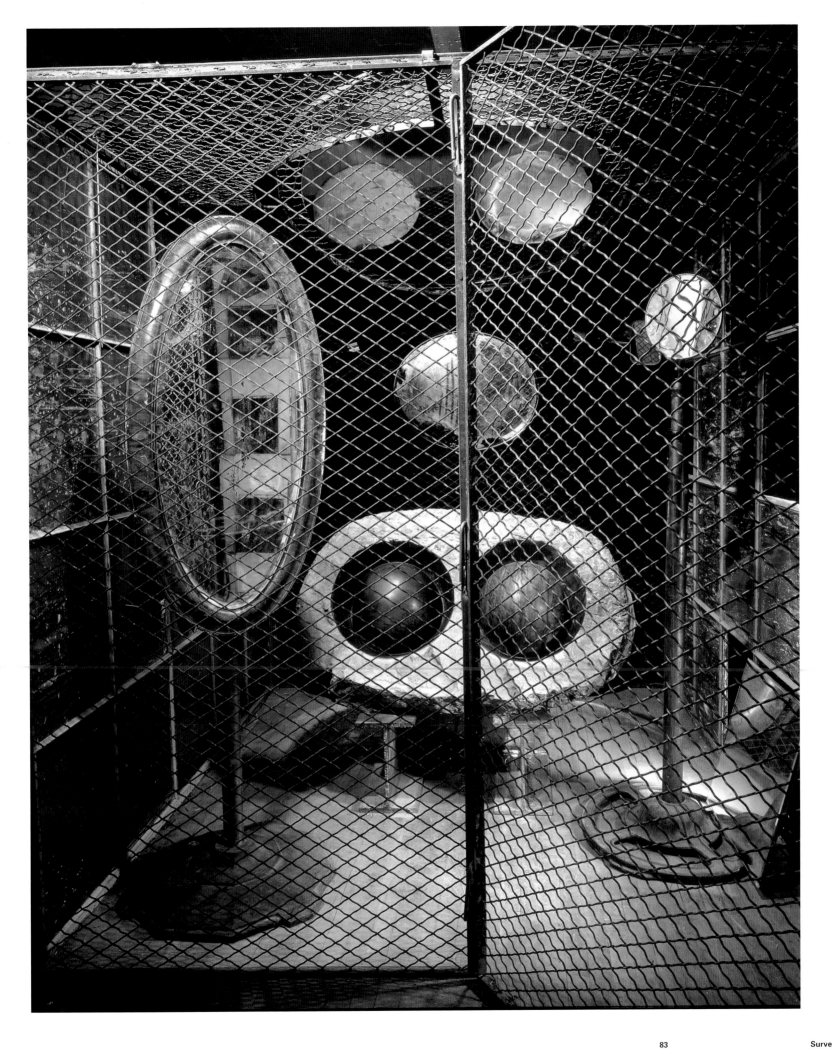

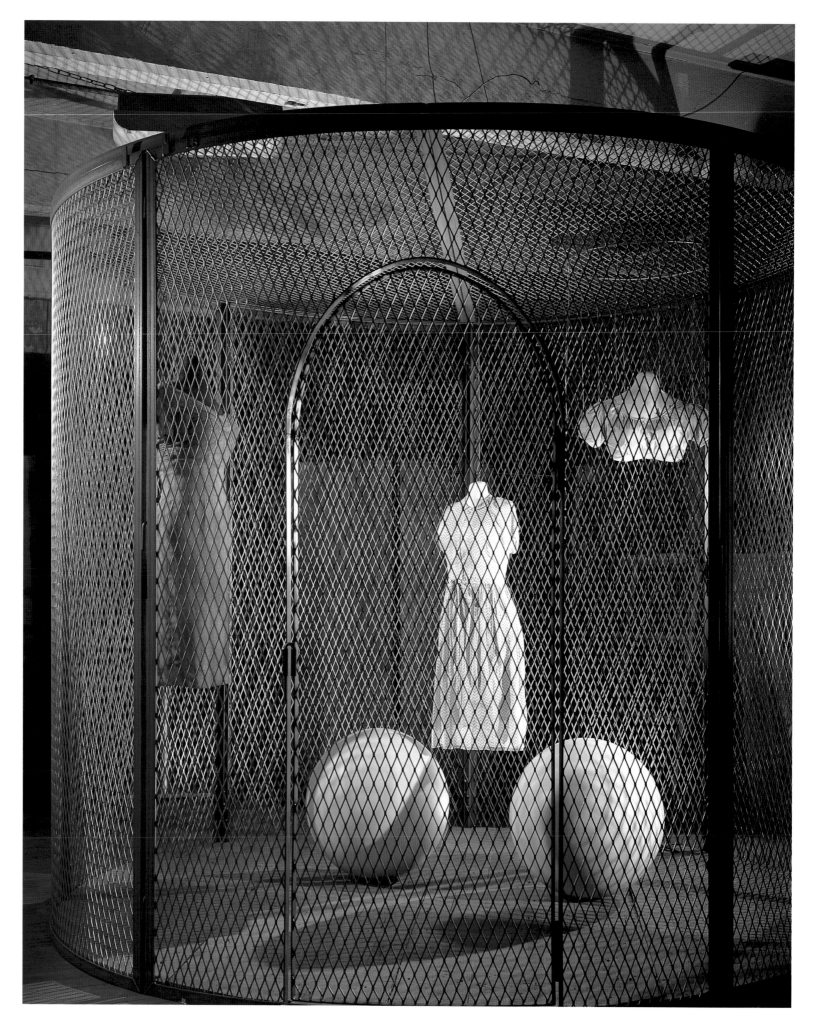

opposite, **Cell XXV (The View of the
World of the Jealous Wife)**
2001
steel, wood, marble, glass, fabric
304 × 305 × 305 cm

below, **Precious Liquids** (detail)
1992
Wood, metal, glass, alabaster,
cloth, water
425.5 × 445 cm
Collection, Musée national d'art
moderne, Centre Georges
Pompidou, Paris

effect of staring into the caged interior only to
encounter one's own reflection or those of other
people in the vicinity in the many mirrors, while
the massive black marble orbs in the centre 'look
back' blindly. All of these multiple 'points
of view' compose a variable choreography of
returned and unreturned glances.

In the *Articulated Lair* (1986) Bourgeois came
full circle to the beginning of her own involvement
with installation, making black rubber casts of her
early wooden *personnages* – *Brother & Sister* for
example – and suspending them from the sides
of an accordion-like enclosure of metal panels, at
the centre of which sits a small black stool where
the viewer can contemplate their strange,
seemingly inhabited surroundings. No longer
lightly and tenuously balanced on their tips, as in
the 1940s or 1950s, but hung upside-down so that
their exaggerated density is tangible, the inverted
'totems' are bodily symbols of the dead weight
of memory. More recently Bourgeois has filled her
'cells' with closet hangers and seamstress'
dummies draped in her old dresses and
undergarments, whose sizes and period styles from
dainty 1920s lace to hot 1960s geometric prints
constitute an autobiography in clothes. Some
she has stuffed, leading to a series of grotesque
dolls – small ones as well as others which are
ominously larger than life – who populate some of
her 'cells' and vitrines or appear by themselves or
in pairs. One example, *Single III* (1997), is a two-
headed, emphatically hermaphroditic partial
amputee, as if Bourgeois' earlier 'Janus' sculptures
had been fleshed out and reconstituted so that,
rather than looking out in opposite directions, the

left, **Articulated Lair**
1986
Painted steel, rubber, stool
335 × 335 × 335 cm
Collection, The Museum of
Modern Art, New York

Cell XIV (Portrait)
2000
Steel, glass, wood, metal, fabric
188 × 122 × 122 cm

Cell XI (Portrait)
2000
Steel, stainless steel, wood,
fabric
178 × 109 × 109 cm
Collection, Samsung Museum
of Modern Art, Seoul

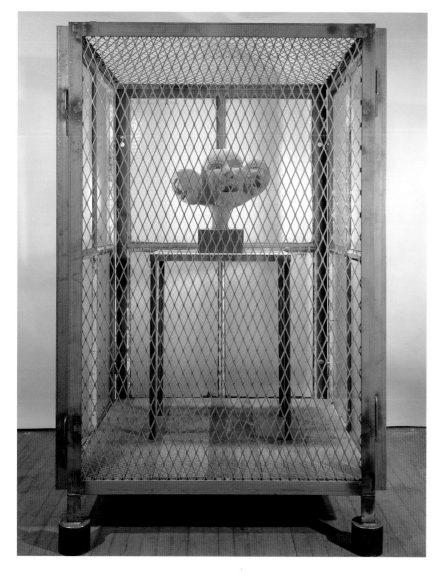

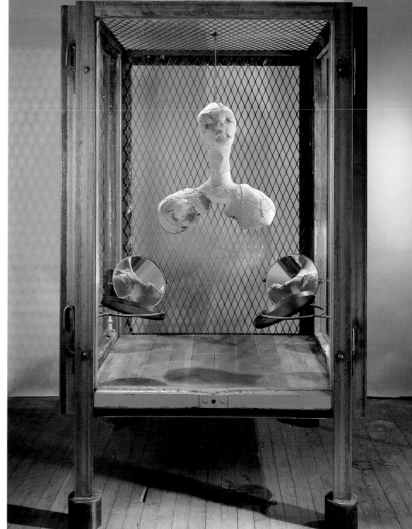

ll XXIII (Portrait)
00
eel, fabric, wood, glass
8 × 109 × 109 cm

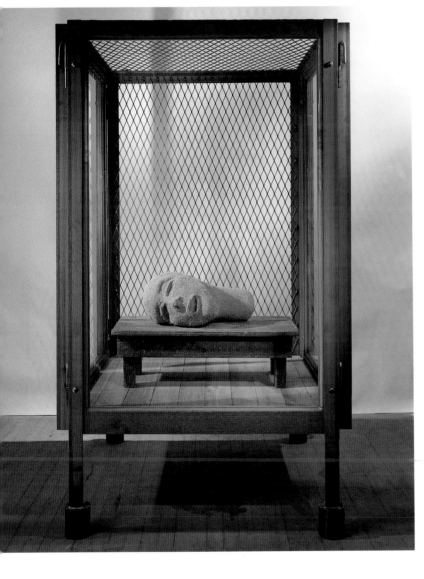

Endless Pursuit
2000
Blue fabric
45.5 × 30.5 × 30.5 cm

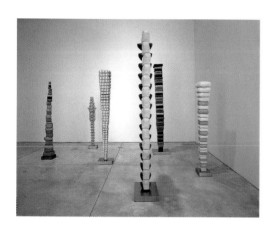

above, Installation view, 'Louise Bourgeois', Cheim & Read Gallery, New York, 2001–02

opposite, l. to r., **Untitled**
2000
Tapestry, steel
180.5 × 28.5 × 22 cm

Untitled
2001
Fabric, stainless steel
175 × 30.5 × 25.5 cm

Untitled
2000
Fabric, stainless steel
193 × 30.5 × 30.5 cm

two faces were condemned to stare at each other for eternity, even as their split genitalia and the two halves of their body never met. A more recent group of stuffed, patchwork terry-cloth figures from 2000 show men and women in various amorous positions, the comic *punctum* of all being where the lovers' feet end up in moments of passion and how awkward overall – and how desperately exposed as they dangle in the air on strings – are such couplings. Similar figures represent anorexic, bulimic or obese women in states of revelatory nakedness, while heads pieced together from irregular bits of fabric in much the same fashion grimace and howl in isolation boxes. The most fearsome of these recall the traditional feather and fibre effigies of the Hawaiian Islands; but the more anguished their expressions become the more the sutures that criss-cross them come to resemble scars, and the more their skins suggest a race of Frankensteins or the ghastly flayed characters in horror films like Jonathan Demme's *The Silence of the Lambs* (1991).

Shifting between the vignettes from a modern sexual comedy of manners and glimpses of unmitigated psychic pain, these dolls – along with soft, fabric versions of her stacked wooden sculptures of the 1950s and mid-1980s – bring us to the present, a present in which the possibilities for changing materials, introducing previously untried technical possibilities, recombining existing symbols, and the imaginative declension of old motifs into fundamentally new ones seems wide open. All in all it is a remarkable position for an artist to be in when most of her surviving contemporaries or near-contemporaries have

exhausted their creative reserves, and in a period when many artists half her age or less have sought security in a signature style.

Of necessity, the preceding account of Bourgeois' accomplishment has skipped significant parts of her work, and glossed over some of the more intricate connections among those that have been addressed. Moreover, I have merely skimmed the surface of her work's meanings, which may be approached from many angles and explored in greater depth with a variety of formal, historical and psychoanalytic methodologies. Instead I have chosen to use this essay as the chance to say a few things about the essence of all that Bourgeois has done and the essence of who she is. Given her prodigious output it is easy to lose one's sense of the integrity of her enterprise in the sheer variety of her work. It is just as easy to be distracted from the enormous determination and concentration that have been needed for her to hold her always volatile identity together by the alternately impish and seductive postures she has struck in the media since the public's attention swung her way. But the extreme stresses she been obliged to contend with as a person, and the magnitude of what she has achieved as an artist, have their intertwined logics.

At the outset I proposed that Bourgeois' art rests on the fusion of Cubism and Surrealism, where the Cubist model stands for a sundered version of classical form with its basis in planar geometry, and Surrealist paradigm is that of topological shapes and spaces that may be subject to great distortion, yet retain, so long as the surface of either is unbroken, an essential consistency and wholeness. From the Euclidian

Seven in Bed
2001
Fabric, stainless steel, glass,
wood
172.5 × 85 × 87.5 cm

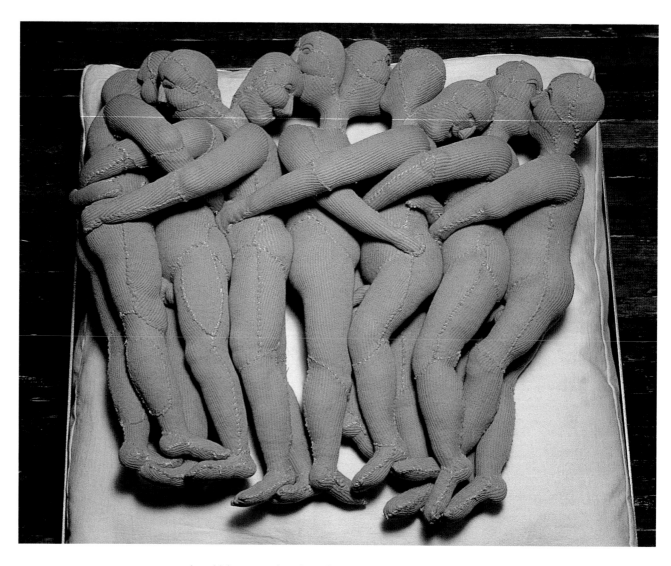

perspective which governed art from the
Renaissance to the advent of Cubism, the grid is
a fixed and inviolable template; exert excessive
pressure on it and it will bend, buckle, then break
up into fragments that can never be seamlessly
reconstructed, though the Cubists gave us
countless examples of how dynamic partial
reconstructions could be. By contrast, from a
topological point of view, the grid is elastic; tug
it, bind it, do anything but tear it, and it will
remain intact, even though the distance from
one place on the grid to another has been
expanded or contracted, and given that entire
areas may have taken on new dimensions. This
is the potential the Surrealists demonstrated but
did not fully exploit in their warped pictorial

grounds and biomorphic figures.

Born into an emotionally fraught but in many
ways strait-laced world, Bourgeois instinctively
understood the violence inherent in Cubism and
has used its tropes to express her own awareness
of the combined rigidity and instability of the old
patriarchal order, and the anxiety that this
knowledge inspired. In Surrealism, meanwhile,
she discovered not so much a vocabulary of
symbols or a poetic stance, as a world of formal
relationships in which continuity could be
maintained under the most disorienting
circumstances and against the most destructive
forces. In sum, the weave of her work – mimicking
the flux of her mind and her emotions – holds
seemingly incommensurable realities together like

previous pages, l. to r.,
Untitled
2002
Tapestry, aluminium
35.5 × 30.5 × 30.5 cm

Untitled
2002
Tapestry, aluminium
43 × 30.5 × 30.5 cm

the elaborate designs of the Baroque tapestries she grew up refurbishing. At any moment the overall coherence of her art and the fabric of her explanations for how one thing is intrinsically connected to another may seem to be skewed by some unforeseen factor, some added twist. Nevertheless, like the finest textile, the threads do not pull apart, but rather absorb this added test of their strength. Where minor mends are called for, new images enter the overall picture, not only repairing but altering and more fully articulating what had been there before. In this way, Bourgeois' recovery and re-creation of her past represents an ongoing work-in-progress, whose consequences for contemporary art are, despite her obsession with her childhood and youth, artistically more forward-looking than retrospective. Rather than pursuing the entropic dispersal of form and identity to conclusions long predicted by theorists mesmerized by the early examples of Cubism and Dada, Bourgeois has, in a thoroughly modernist, or if one prefers, post-modernist way, 'sampled' the techniques of collage, assemblage and the readymade. At the same time she has doubled back to traditional modelling, casting and carving, and bound them all to an astonishingly flexible structure of metaphors and associative procedures for which topological manipulation and topological integrity are the only useful description. The extraordinary nature of Bourgeois' work resides not only in the multiple and interchangeable ways of viewing the enigmas and contradictions of existence that it affords us, but in the fact that it, almost miraculously, is ultimately all of a piece.

Couple
2001
Fabric
50.5 × 16.5 × 7.5 cm

Contents

A number of years ago I proposed an article on Louise Bourgeois to the *New York Times*. After much deliberation, my editors rejected the idea. 'We're not sure that she's an important artist', was the response. This stupefied me, since I can think of few artists whom I consider as important. Not only is Bourgeois one of the defining artists of our time, she is one of the great artists of the twentieth century. And now, at the beginning of the twenty-first century, she is clearly at the height of her powers.

I have since come to realize that critics and curators tend to be divided in their appraisal of Bourgeois' work, either lauding her contribution or underestimating it. What, I wonder, do those who refuse to acknowledge her importance reject or fail to see? Do the conceptually oriented resist her exquisite craft? Or are the traditionalists confounded by her fluidity of materials, her ability to allow the carved and the found, the sewn and the manufactured to cohabit? Does the trouble lie with the content of Bourgeois' art? Is it the work's psychological insight that worries them? Do they find off-putting the emotional exposure at the core of her work? Or is it the presence of her rage and how effectively she has honed it that scares them off? Perhaps it is the poetry with which all this anger has been visualized that confuses them. I personally find it comforting that such an intensity of emotion can be articulated so exquisitely, and of course, Bourgeois has plenty of passionate admirers.

This critical divide is especially confounding given the impact of feminism on recent art, and Bourgeois' prescient contribution to that history. It could be argued that nothing has done more to change the face of art in the last few decades than feminism. Autobiography, the small-scale, soft materials, narrative, ambiguity, otherness – so much that has become essential to the fabric of art today would have been unacceptable had the phallocentric Modernist canon been able to continue chugging mightily along unchallenged. And once one can recognize this truth, one must acknowledge that Bourgeois and her investigation of the self, which dates back to the 1940s, and her frank examination of female sexuality, which becomes most apparent in her work in the early 1960s (well in advance of the women's movement), occupies a pivotal role in the development of modern art.

The work *Cell (You Better Grow Up)* of 1993[1] provides a useful platform for the analysis of Bourgeois' historical importance and the reasons why it has sometimes been ignored. It consists of a cell, seven foot cubed, two walls of which are made of old industrial windows,

Cell (You Better Grow Up) (detail
1993
Steel, glass, marble, ceramic, wood
211 × 208 × 212 cm

some panes cloudy with soot, some covered in ancient graffiti, others removed. The remaining two walls and the ceiling are made of industrial caging. These enclosing walls create a stark, utilitarian, abandoned space, creating a sense of past industrial activity. Inside, roughly in the centre, sits a large, rough block of marble. Exquisitely carved out of its top surface are a pair of child's hands, gently clutched and comforted by an adult's. The arms are severed below the elbow, but this is hardly a gruesome image. Indeed, the fragmented arms resting on the block seem oddly whole. The adult's gesture is comforting, and the flesh tone of the marble exudes a gentle warmth.

The block rests on two lengths of architectural I-beams, and surrounding it are various objects placed on top of worn wooden work benches: a tall glass structure roughly in the shape of a tower and suggestive of a vortex, sitting beside three empty Shalimar perfume bottles (Bourgeois wore this scent in her youth); a stack of bulbous glass ovoids containing a nude female torso, also of glass; and a handmade ceramic object resembling a bowl with three chambers, the whole suggestive of the human body with its vulvic edges and ventricular feet. All these items are found, old, and have an abandoned air, having lost

their former functionality; the 'vortex' appears to be the detritus of some outdated manufacturing process.

All three have sexual undertones: the tower is somewhat phallic, the ceramic almost uterine, and the empty scent bottles bear witness to past seductions. But what is conjured is a pre-sexual world. The only element in which a penetration of sorts takes place is the female torso encased in the glass ovoids. But even though it could be thought of as a phallus inserted into these voluptuous or feminine forms, the grouping is more suggestive of imprisonment than of sex, of the female who has not yet emerged.

The cell is loaded with echoes of the number three: the three hands, the three sets of objects on three wooden benches, the three perfume bottles, the three chambers of the ceramic vessel. In general terms, three is a magical number, evoking the Trinity, or past, present and future. On a formal, art-historical level, it is the stabilizing triangle of classical compositions. But although three is also a significant

number in Bourgeois' world – she was one of three children and herself brought up three children – it is hardly stabilizing. It is the integer of triangulation, the number of violation, referencing the mistress who intruded upon the coupling of her parents and set in motion the childhood traumas of betrayal that have fuelled the bulk of Bourgeois' art.

Much has been written about the psychosexual content of Bourgeois' work, the traumas of her childhood, the rupture in the family fabric, and how the rage and anxiety it generated created an artist with a great deal to express. Bourgeois herself – her own most insightful analyst – has written of the child's hands and the glass torso as self-portraits. In a sense, each of the objects is a self-portrait, and together they form a consummate portrayal of post-industrial fragmentation, with the cage of the cell as the frame of the past.

Too often, Bourgeois' detractors have dismissed her work by characterizing it as simply a confessional kind of autobiography. But this is to overlook its formal aspect. If the psychological content that is the point of Bourgeois' work is usually hidden or latent or subconscious in most art (or at least in Modernist interpretations), the formal content of the cell is deeply involved in a dialogue about Modern art and Bourgeois' place within it, or absence from it. In other words, Bourgeois has beaten the Modernists at their own formalist game, perhaps explaining why some might unconsciously reject her work. *Cell (You Better Grow Up)*, like many of her cells, is a cube, a perfect geometric form, and what she explores here is an alternative kind of 'cubism'. Just as the Cubists fractured the picture plane pictorially, Bourgeois pierces the surface of geometric perfection. In several of the walls, and in the ceiling, she has removed window panes and sections of caging, replacing them

with three circular mirrors that can be pivoted at any angle to reflect from various viewing perspectives objects within the work or viewers outside of it.

But although Bourgeois enters into a formalist dialogue, her purposes are more unusual. Instead of violating the surface to reinforce a painting's

'pictureness' or a sculpture's 'objectness' as the Cubists did, Bourgeois ruptures the surface to fracture her subject's isolation; to magnify and recombine her surrogate self-portraits both with one another and with the viewer; simultaneously to emphasize and violate the voyeuristic divide; to create, quite literally, a means for self-examination. In other words, Bourgeois uses the methodology of the Cubism that dominated the art scene of her youth to destroy its potency, to enact another kind of destruction of the father – in the form of patriarchal Modernism.

Art history, a Modernist invention, essentially traces the history of plastic form. Any artist not deemed critical to its evolution is viewed as an 'outsider', a maverick, or 'special' talent. Bourgeois' supporters often defend her historical importance by invoking her early association with the Surrealists, yet one hardly ever sees her Surrealist work displayed in a major museum collection alongside that of Salvador Dalí or René Magritte, or even Meret Oppenheim. Similarly, her 'personages' of the 1950s, while kindred to the existential figuration of Alberto Giacometti and the abstraction of Barnett Newman, are hardly ever to be found in such company. When her work of the 1950s is displayed, it is inevitably boxed off in its own personal space. Modern art is checkered with 'personal' artists whom it doesn't quite know where to place. Edvard Munch and Egon Schiele, for example, whose works, like Bourgeois', are rooted in autobiography, are honoured, but located somewhat outside the mainstream. When mainstream modern art is autobiographical, it is never truly personal. Instead, it expresses male sexual potency.

Bourgeois' work is important to mainstream art history precisely because it makes a shift in focus from form to content (the examination of the place and identity of the individual). This shift – from an art that is simply about art to an art concentrating on something beyond this – is nothing less than the shift from Modernism to Postmodernism. It has often been argued that the transition pivots on Andy Warhol, with his breaking down of the barriers between high and low and his exploration of art in relation to the broader culture. But in truth Bourgeois is equally crucial in this respect, for taking art out of the frame and placing the self front and centre, for making the exploration of issues of identity the purpose of art.

Central to Modern art was a fixation on The New, and the inability of some to acknowledge Bourgeois' critical importance to the history of art may boil down to the

simple reality that her work is defiantly (and not nostalgically) in dialogue with the old. *Cell (You Better Grow Up)* is a tomb filled with the cast-offs of the sort of industrial activity that fuelled the Modern, now abandoned, resting on the benches of workers long gone and forgotten. By adopting abandoned industrial waste, loving these objects and poetically recombining them, and once again giving them purpose, Bourgeois wags her finger at Modernism's compulsive and sterile obsession with The New.

This obsession resulted next in a fixation on The Young. So great was this preoccupation that most of the major artists of the twentieth century made their impact on the history of art only for a brief, shining moment, soon to be eclipsed by the next New. One of the few exceptions was Picasso, whose longevity rested on his ability to fulfill a Modern myth about the artist as an omnipotent creator whose every scribble was an expression of genius. (Another exception was Duchamp, who kept his audience guessing by spending his last decades in a kind of brilliant quasi-retirement, playing chess.) The equation of The New with youth and with artistic virility accelerated as the century progressed, and took on new meaning in the 1960s, when the baby-boomer generation came of age, the art industry reached full flower, and the power of youth culture had a direct impact on the political and social order. This meant that the obsession with The New was spinning out of control and would soon lose its currency. Not coincidentally, it coincided with the birth of Postmodernism. Warhol's prediction that everyone would be famous for fifteen minutes resulted in the 1970s and 1980s in a parade of new stars who inevitably became victims of a voracious culture machine. Although the art world persists in its prurient search for each next New, this has become more a compulsive attraction than a fruitful quest.

The equation of youth with the future died in a cruelly symbolic way in the 1980s with the AIDS epidemic and its devastating impact on the artistic community. Youth, once synonymous with invincibility and perpetual regeneration, came to signify death. Risk — the rallying cry for artistic exploration throughout the Modern era — became associated with real-life danger. And today, who are the artists taking risks? Not the majority of young artists, who now carefully measure their every move, but mature ones — those whose artistic arenas are broader than the mainstream ordinarily demands, artists who may have been off the radar for decades like Bruce Nauman, Paul McCarthy and, especially, Louise Bourgeois.

Like many of Bourgeois' cells, *Cell (You Better Grow Up)* – this tattered industrial cube retrieved from the dustbins of old News, this portrait of the ageing Modern violated by self-reflection – is a mental space where childhood traumas are stored, isolated, contained, literally caged in an ever-present past, a crypt for the Modern. Both a prisoner's cell and a monk's retreat – a place of enforced as well as self-elected personal reflection – this sculpture also addresses another kind of 'cell': the biological cell, the building block of all beings and things. And the contents of the cell are Bourgeois' personal building blocks. From this perspective, its title might be restated as an admonitory, 'Louise, grow up', or 'Get over it', which of course Bourgeois never did. And thank goodness, for it is precisely the artist's caged childhood rage that has powered her great works. But the raw emotion of the cells is not simply the expression of rage, because by imprisoning it, the artist is both articulating a sense of helpless violation and controlling it. Encountering the work is something like looking at an animal in a cage. You experience a sense of wonder and of play, but also of sadness and entrapment. The anxiety inherent in the work is less the artist's than our own, as helpless witnesses to a psychodrama within which we are neither really included nor excluded.

It is highly revealing that after creating a boundary for her rage in the cells, Bourgeois emerges a different artist. In the work that follows, we no longer see the helpless child sexually traumatized and powerless. Her spider sculptures, with their coquettish seductiveness, are the expression of a maturing woman learning the power of her biology, while the sculptural works made from her old clothing – the high style of previous eras – explore yet more kinds of self-portraiture. Having enclosed her childhood rage in a modernist cage, Bourgeois bursts forth as the spider, weaving webs of a life lived as woman, wife, mother, and now woman again, old and strong.

1 In the Rachofsky Collection, Dallas, Texas.

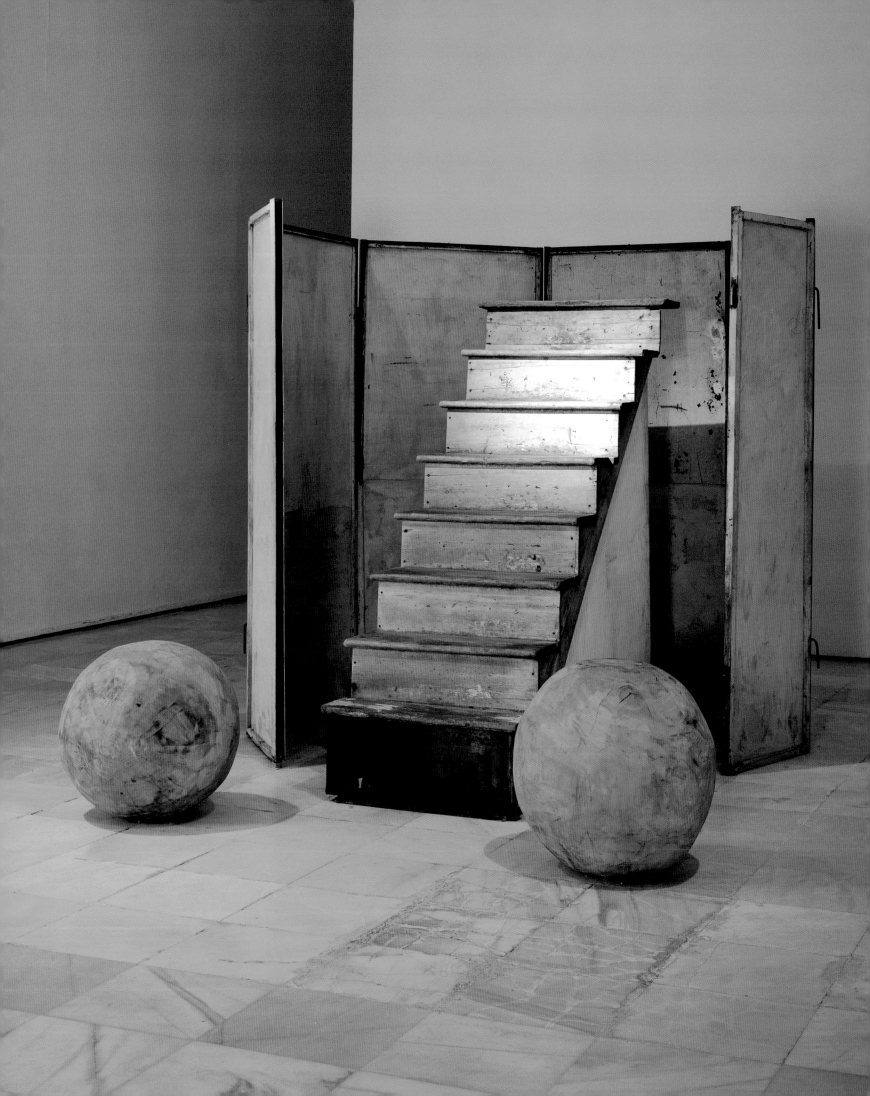

Contents

Passage Dangereux
1997
Mixed media
264 × 355.5 × 876.5 cm

Adieu tristesse

Bonjour tristesse

Tu es inscrite dans les lignes du plafond

Tu es inscrite dans les yeux que j'aime

Tu n'es pas tout à fait la misère

Car les lèvres les plus pauvres te dénoncent

Par un sourire

Bonjour tristesse

Amour des corps aimables

Puissance de l'amour

Dont l'amabilité surgit

Comme un monstre sans corps

Tête désappointée

Tristesse beau visage.

Paul Eluard

(*La vie immédiate*)

Part 1, Chapter 6

[…] The mirror reflected a sad sight. I leaned against it and peered at those dilated eyes and dry lips, the face of a stranger. Was that my face? If I was weak and cowardly, could it be because of those lips, the particular shape of my body, these odious, arbitrary physical limitations? And if I were limited, why had I only now become aware of it? I occupied myself by detesting my reflection, hating that wolf-like face, hollow and worn by debauchery. I repeated the word 'debauchery' looking into my eyes in the mirror. And then suddenly I saw myself smile. What a great debauch! A few miserable drinks, a slap in the face, and some tears! I brushed my teeth and went downstairs.

My father and Anne were already on the terrace, sitting beside each other at their breakfast tray. I sat down opposite them, muttering a 'good morning'. A feeling of shyness made me keep my eyes lowered, but after a time, as they remained silent, I was forced to look at them. Anne appeared tired, the only sign of a night of love. They were both smiling happily, and I was very much impressed, for happiness has always seemed to me a great achievement […]

Part 2, Chapter 1

How clearly I remember everything from that moment on! I acquired an added awareness of other people and of myself.

An unthinking, easy egoism had been natural to me. I had always lived like this. But the last few days had upset me deeply, forcing me to reflect, to look at myself with a critical eye. I endured all the pangs of introspection, and still couldn't become reconciled with myself. 'These feelings', I thought, 'these feelings about Anne are mean and stupid; this desire to separate her from my father is vicious.' But after all, why was I so hard on myself? Wasn't I free to judge what happened? For the first time in my life my 'self' seemed to be split, and I discovered opposing forces within that shocked me. I found good excuses, I whispered them to myself, trying to be honest, and suddenly another 'me' rose up which answered all my arguments, saying that I was fooling myself with them, although they had all the appearance of truth. But truly, wasn't it this other 'me' who was wrong? Wasn't this clear-headedness my worst mistake? Up in my room I reasoned with myself for hours on end in an attempt to discover whether the fear and hostility which Anne inspired in me were justified, or if I was merely a silly, spoiled, selfish girl pretending to be adult […]

Part 2, Chapter 9

I have spoken a great deal about Anne and myself, and very little of my father. Yet he has played the most important part in this story, and my feelings for him have been deeper and more stable than for anyone else. I know him too well, and feel too close to him to talk easily of him, and it is he above all others whom I wish to justify and present in a good light. He was neither vain nor selfish, but just incurably frivolous. I could not call him irresponsible or incapable of deep feelings. His love for me is not to be taken lightly, or regarded merely as a parental habit. He could suffer more through me than through anyone else, and, for my part, I was nearer to despair the day he turned away as if abandoning me, than I had ever been in my life. I was always more important to him than his love affairs. On many evenings, by taking me home from parties, he must have often missed what his friend Webb would have called 'a fine chance'. On the other hand, I cannot deny that he was inconstant and would always take the easiest way. He never meditated. He tried to give everything a physiological explanation, which he called being rational. 'You don't like yourself as you are? Just sleep a little more and drink a little less!' It was the same when at times he had a violent desire for a particular woman. He never thought of repressing it, or trying to elevate it into a deeper sentiment.

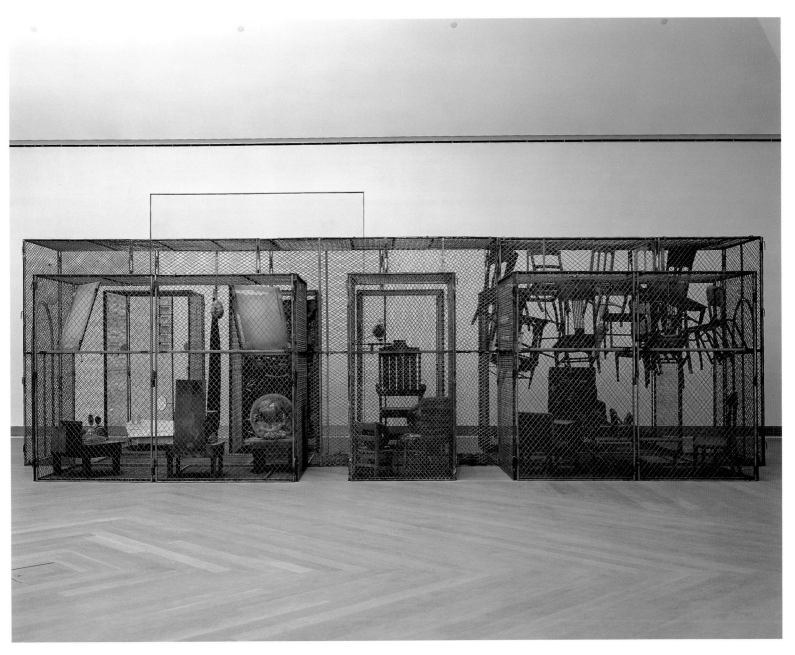

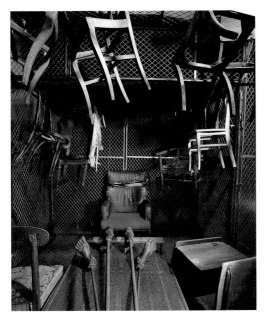

107　　Artist's Choice

left and following pages,
Red Room (Child)
1994
Mixed media
211 × 353 × 274.5 cm
Collection, Musée d'Art
Contemporain de Montreal

far left and below,
Red Room (Parents)
1994
Mixed media
248 × 427 × 424 cm

He was a materialist, if kind and understanding, with a touch of delicacy. His desire for Elsa disturbed him, though not in the way one might expect. He did not say to himself: 'I want to be unfaithful to Anne, therefore I must love her less', but: 'This need for Elsa is a nuisance. I must get over it quickly or it might cause complications with Anne.' Moreover he loved and admired Anne. She was a change from the stupid, frivolous women he had known in recent years. She satisfied his vanity, his sensuality and his sensibility all at once, for she understood him. She offered her intelligence and experience to supplement his. Yet I do not believe he realized how deeply she cared for him. He thought of her as the ideal mistress, the ideal mother for me, however I do not think he visualized her as the ideal wife for himself – with all the obligations this would entail. I am sure that in Cyril's and in Anne's eyes he was, like me, abnormal, so to speak. Still the fact that he had no high regard for his way of living did not prevent him from making it exciting or putting all his vitality into it […]

Part 2, Chapter 12
The funeral took place in Paris on a fine day. There was the usual crowd of the curious dressed in black. My father and I shook hands with Anne's elderly relations. I looked at them with interest; they would probably have come to tea with us once a year. People cast pitying glances at my father. Webb must have spread the news of his intended marriage. I saw that Cyril was looking for me after the service, but I avoided him. The resentment I felt toward him was quite unjustified, but I could not help it. Everyone was deploring the dreadful, senseless accident, and, as I was still rather doubtful whether it had been an accident, I was relieved.

In the car on the way home, my father took my hand and held it tightly. I thought: 'Now we have only each other. We are alone and unhappy.' For the first time I cried. My tears were some comfort. They were not at all like the terrible emptiness I had felt in the hospital in front of the picture of Venice. My father gave me his handkerchief without a word. His face was ravaged.

For a month we lived like a widower and an orphan, eating all our meals together and staying at home. Sometimes we spoke of Anne. 'Do you remember the day when … ' We chose our words with care, and averted our eyes for fear we might hurt each other, or that something irreparable would come between us. Our discretion and restraint brought their own recompense. Soon we could speak of Anne in a normal way as of a person dear to us, with whom we could have been happy, but whom God had called to Himself. I have written God, and not fate – but we did not believe in God. In these circumstances we were thankful to believe in fate.

Then one day at a friend's house I met a cousin of hers and liked him and he liked me. For a week I went out with him constantly, and my father, who could not bear to be alone, followed my example with a rather ambitious young woman. Life began to take its old course, as it was bound to. Now, when my father and I are alone together, we joke and discuss our latest conquests. He must suspect that my friendship with Philippe is not platonic, and I know very well that his new friend is costing him too much money. But we are happy. Winter is drawing to an end. We shall not rent the same villa again, but another one, near Juan-les-Pins.

Only when I am in bed, at dawn, listening to the cars passing below in the streets of Paris, my memory betrays me. That summer returns to me with all its memories. Anne, Anne, I repeat over and over again softly in the darkness. Something rises in me that I call to by name, with closed eyes. *Bonjour, tristesse!*

Translated by Irene Ash

tout, oublie tout oublie tout, oublie tout
Lison, oublie tout oublie tout, oublie tout
tout, oublie oublie tout, oublie tout, oublie
tout, oublie oublie tout, oublie tout oubli
tout, oublie, oublie tout, oublie tout oubli
tout, oublie tout-tout, oublie tout, oublie
à tout, oublie tout, tout, oublie, calme toi
toi calme toi calme toi calme toi calme
toi, calme toi calme toi calme toi calme toi
il n'y a rien que tu doive faire calme toi
poisson que frétille va être rejeté à l'eau
calme toi, calme toi, n'ai pas peur n'est pas peur n'ai p
peur, calme toi n'ai pas peur calme toi
tout est pour le mieux merci mon Dieu, calme toi
connais toi toi même; tu n'auras pas peur, tout est en ordre
n'est pas peur, calme toi calme toi, calme toi; calme toi;
calme toi, calme toi;
calme toi petit Lison Calme toi Petite Lison ca
toi petite Lison félicitation petite Lison félicitation
petite Lison congratulation petite Lison, félicita
Petite Lison congratulation petite Lison petite
Congratulation, oublie tout petite Lison — ou
tout oublie tout, tout est pa ou oublie tout

The Puritan: Painted Flat Triptych
#5
Text, 1947
Engravings, 1990–97
8 triptych sets of hand-painted
engravings and text
66 × 150 cm each
Collection, Diözesanmuseum,
Cologne

I.

Do you know the New York sky? You should, it is supposed to be known. It is
outstanding. It is a serious thing. Can you remember the Paris sky? How unreliable,
most of the time grey, often warm and damp, never quite perfect, indulging in clouds
and shades; rain, breeze and sun sometimes managing to appear together. But the
New York sky is blue, utterly blue. The light is white, a glorying white and the air is
strong and it is healthy too. There is no foolishness about that sky. It is a beautiful
thing. It is pure.

II.

There was a street in New York and it was full of the New York sky. It spread over it like
a blue aluminium sheet. At that particular place I know why the sky was so blue, so
completely himself. Because right under him the most formidable building in the
world was standing up. In that street, close to the sky and close to that building, there
was a house. The sky, the building, and the house knew each other and approved of
each other.

III.

This was not a living in structure. It was a working in one. There was efficiency,
everyone looked clean, lots of typewriting machines and typewriting girls, but not
the usual ones. These were earning their living with refined people and they knew it.
You could see that in their postures and noises.

IV.

In this structure there was a man, there always is, so there was and he was very fine.
He belonged to the place the way the place belonged to him. Everyone there was very
fond of him and looked up to him. He accepted this because apart from being civilized
he was kind. There was a definite, well-organized, successful and ambitiously satisfied
feeling about the place.

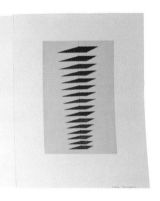

V.

The trouble came when one of the doors was left open and apparently someone came in. Maybe it was an oversight or a mistake but I doubt it because this was not in the style of that place, nor in the character of the man. We might assume the door was left open almost on purpose, as a half invitation to someone passing by to come in for fun. Well she did, she came in, though she had no taste for fun. She saw him, she saw that he was good and of course she loved him.

VI.

What happened next is that before they knew it something got between them. The wisdom of nations wants that nothing can keep apart people who love each other. Not even a million armed men packed around that house could have kept them together. There was still to try to help them such things as a common friend, a sheet of paper, and the telephone, don't forget. They saw each other sometimes too; and the eyes of someone you understand can tell you more than four Western Union telegrams. But there it was. There was a snap, and there was silence. First an expecting silence, and then the silence of the completely dead.

VII.

I told that story to my neighbour who is a resourceful man, and he assured me that some men are afraid of soldiers around their house. That besides, telephones can be tapped and typewriters have ears. Even a sheet of paper frail as it is can be frightening. But I told my neighbour he was wrong because that man was afraid of nothing, that he was just, and because of this should have had nothing to fear.

VIII.

Later on he died right in his factory of refinement. Everyone worth talking about cried and cried. Of course no one could see his soul, not even his wife. But they said that his body was dry and they think he was a puritan.

Postscript, 1990:

If you have a secret, you become afraid.
You are paralyzed by your desires, and are
in terror of the desires still to be uncovered.
The demands of love are too great, and you withdraw.

Original previously unpublished postscript, 1990:

I wrote *the puritan* in 1947.
It's the story of someone so
frightened by his love that he
withdraws. He's simply incapable.

If you have a secret, you become
afraid. You become afraid of
yourself, and what you might
want, of wanting the wrong thing,
even afraid of love.

We destroy the very thing
we most desire. It's a tragic
mystery. The subject still interests
me today.

This text, written in 1947 and based on Alfred H. Barr, Jr., then Director of The Museum of Modern Art, New York, was first published in 1990 by Osiris Editions, New York, in a limited edition with eight engravings.

On *Janus Fleuri* 1969

l. to r., **Hanging Janus with Jack**
1968
Bronze
27 × 52.5 × 16 cm

Janus in Leather Jacket
1968
Bronze
30.5 × 56 × 16.5 cm

Janus
1968
Bronze
25.5 × 33 × 17.5 cm

Every time I am asked to talk about my work I desiccate. The only way in which I can manage it is to go into my studio and walk back and forth and around a piece. Then the relations between the work and me snap alive again. At this point the how it was made is obviously of no importance or relevance. I made it the best I could, considering that the object became what it is, and this becoming was not completely under the control of conscious desire or premeditation. The fluctuation of possibilities can be minute, slow, rough, sudden, re-examinable or definite. Any way you slice it, there is always a battle to the finish between the artist and his material: sometimes with visible result, more often with experience gained but no result.

Shop talk belongs to the artist, not the art lover. Immediate concern with the materials of sculpture is an avoidance of the true issue – like admiring the frame on a painting. But for the artist shop talk continues the close involvement that, finally, allows him to shape substance to his own ends, to purposes that go beyond materials.

The ebb and flow of my work is in the pouring, then the cutting. Poured plaster is a material of the twentieth century, made possible by the flexible container and the ever present packaging – paper, plastic, cardboard, or rubber – that can be bent, stripped off and thrown away. Once poured, the plaster can be cut and filed, and so reduced, or it can be made to grow and multiply and be transformed before it is cast – as it has been here. But this is shop talk, a necessary obsession for the artist, an escape for the spectator.

If I am asked what I want to express, then this makes more sense. At that point there is a mystery we can at least talk about, since for a life-time I have wanted to say the same thing. Inner consistency is the test of the artist. Repeated disappointment in its expression is what keeps him jumping.

What then of this particular work of sculpture. It has the permanence of bronze, although it was conceived in plaster. It hangs, it is simple in outline but elusive and ambivalent in its references. Hanging from a single point at eye level it can both swing and turn, but slowly, because its centre of gravity is low. It is symmetrical, like the human body, and it has the scale of those various parts of the body to which it may, perhaps, refer: a double facial mask, two breasts, two knees. Its hung position indicates passivity, but its low slung mass expresses resistance and duration. It is perhaps a self-portrait – one of many.

First published in *Art Now*, Vol. 1, No. 7, New York, September, 1969.

Janus Fleuri
1968
Bronze, golden patina
25.5 × 31.5 × 21 cm

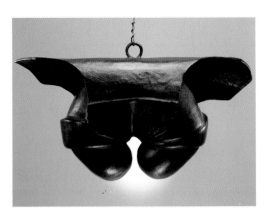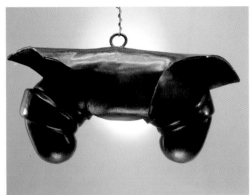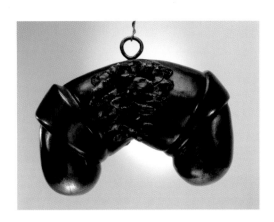

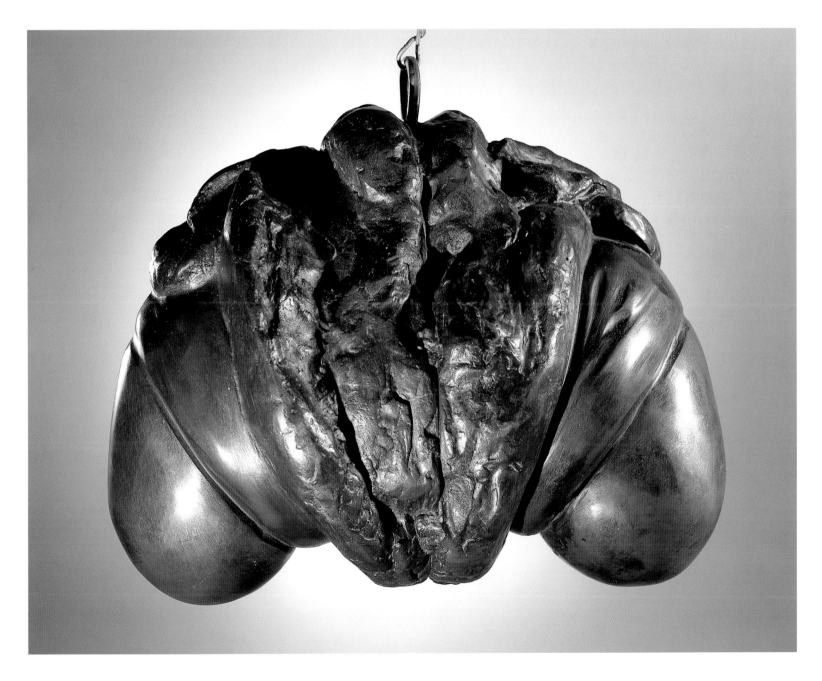

A Merging of Male and Female 1974

opposite and following page,
Child Abuse
Artforum, Vol. 20, No. 4, New Yor
December, 1982

There has always been sexual suggestiveness in my work. Sometimes I am totally concerned with female shapes – clusters of breasts like clouds – but often I merge the imagery – phallic breasts, male and female, active and passive. This marble sculpture – my *Femme Couteau* – embodies the polarity of woman, the destructive and the seductive. Why do women become hatchet women? They were not born that way. They were made that way out of fear. In the *Femme Couteau*, the woman turns into a blade, she is defensive. She identifies with the penis to defend herself. A girl can be terrified of the world. She feels vulnerable because she can be wounded by the penis. So she tries to take on the weapon of the aggressor. This is a problem stemming from childhood and from lack of sensible, sympathetic education. When I was young, sex was talked of as a dangerous thing; sexuality was forbidden. It is important to show girls that it is natural to be sexual and that men also can feel helpless and vulnerable. When I was at the Ecole des Beaux-Arts in Paris, we had a nude male model. One day he looked around and saw a woman student and suddenly he had an erection. I was shocked – then I thought, what a fantastic thing, to reveal your vulnerability, to be so publicly exposed! We are all vulnerable in some way, and we are all male-female.

New York, 11 February 1974, an issue subtitled 'Why Women are Creating Erotic Art', and in the context of the article 'The Female View of Erotica' by Dorothy Seiberling.

Femme Couteau
1982
Black marble
14 × 77.5 × 20.5 cm

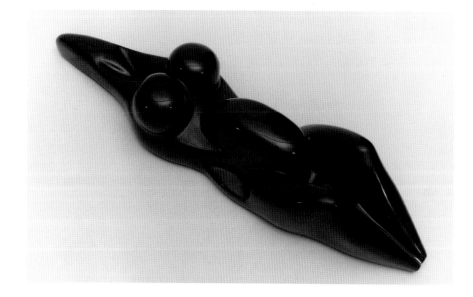

Child Abuse 1982

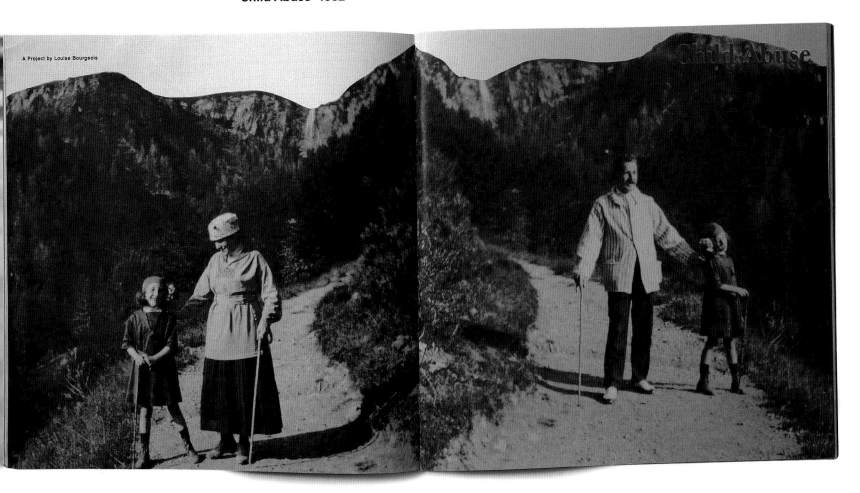

A Project by Louise Bourgeois

Child Abuse

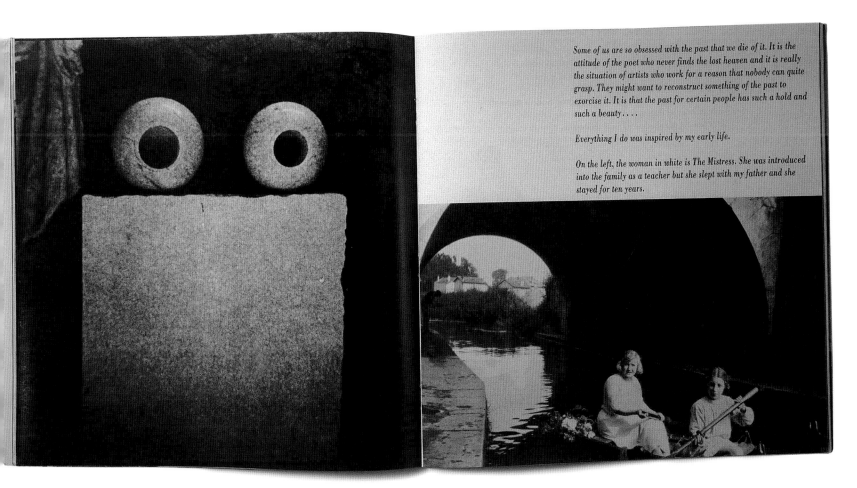

Some of us are so obsessed with the past that we die of it. It is the attitude of the poet who never finds the lost heaven and it is really the situation of artists who work for a reason that nobody can quite grasp. They might want to reconstruct something of the past to exorcise it. It is that the past for certain people has such a hold and such a beauty. . . .

Everything I do was inspired by my early life.

On the left, the woman in white is The Mistress. She was introduced into the family as a teacher but she slept with my father and she stayed for ten years.

Now you will ask me, how is it that in a middle class family a mistress was a standard piece of furniture? Well, the reason is that my mother tolerated it and that is the mystery. Why did she?

So what role do I play in this game? I am a pawn. Sadie is supposed to be there as my teacher and actually you, mother, are using me to keep track of your husband. This is child abuse.

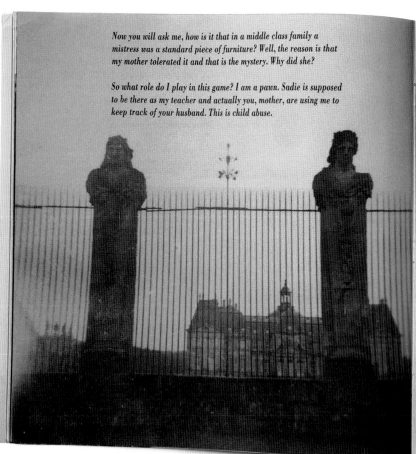

Because Sadie, if you don't mind, was mine. She was engaged to teach me English. I thought she was going to like me. Instead of which she betrayed me. I was betrayed not only by my father, damn it, but by her too. It was a double betrayal. There are rules of the game. You cannot have people breaking them right and left. In a family a minimum of conformity is expected.

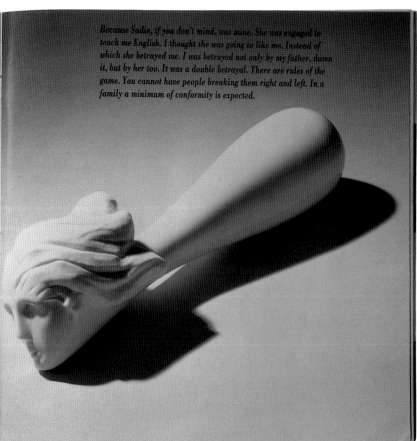

I am sorry to get so excited but I still react to it.

Concerning Sadie, for too many years I had been frustrated in my terrific desire to twist the neck of this person.

Everyday you have to abandon your past or accept it and then if you cannot accept it you become a sculptor.

47

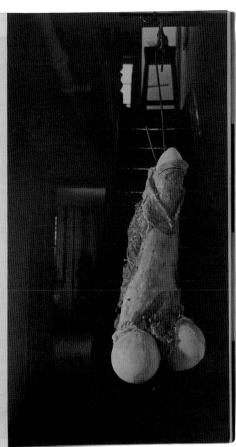

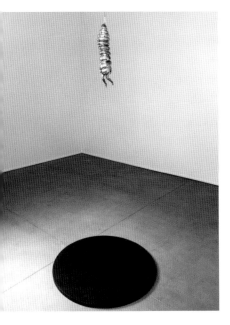

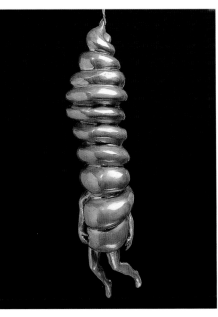

Spiral Woman
1984
Bronze, slate disc
Bronze, 48 × 10 × 14 cm; slate
disc, h. 3 cm, ∅ 86.5 cm

[…] Art is a privilege, a blessing, a relief. Privilege means that you are a favourite, that what you do is not completely to your credit, not completely due to you, but is a favour conferred upon you. Privilege entitles you when you deserve nothing. Privilege is something you have and others don't. Art was a privilege given to me, and I had to pursue it, even more than the privilege of having children. The whole art mechanism is the result of many privileges, and it was a privilege to be part of it … The privilege was the access to the unconscious. It is a fantastic privilege to have access to the unconscious. I had to be worthy of this privilege, and to exercise it. It was a privilege also to be able to sublimate. A lot of people cannot sublimate. They have no access to their unconscious. There is something very special in being able to sublimate your unconscious, and something very painful in the access to it. But there is no escape from it, and no escape from access once it is given to you, once you are favored with it, whether you want it or not … To escape you have to have a place to go. You have to have the courage to face risk. You have to have independence. All these things are gifts. They are blessings … Sublimation is a gift; lots of people cannot sublimate. The life of the artist is basically a denial of sex. I really think my power of sublimation, my power of total recall, is due to the education my parents gave me – the discipline and also the notion of what you can expect.

My feminism expresses itself in an intense interest in what women do. But I'm a complete loner. It doesn't help me to associate with people; it really doesn't help me. What helps me is to realize my own disabilities and to expose them. Another very sad statement is that I truly like only the people who help me. It is a very, very sad statement.

Alfred Barr was not a trustee [of The Museum of Modern Art, New York]; he was an employee, like all the rest. The trustees had real buying power. Alfred Barr had special skills, but he was not part of the Board of Trustees. He was on the other side. The artists who succeeded in selling at the time – Alexander Calder, Mark Rothko, Ben Shahn, they were the three – pleased the trustees. You had to entertain the Board, and these Three Stooges knew how to do that, knew how to socially entertain these important people, these trustees. I did not mind that, as a woman, but I could not do it.

Women had to work like slaves in the art world, but a lot of men got to the top through their charm. And it hurt them. To be young and pretty didn't help a woman in

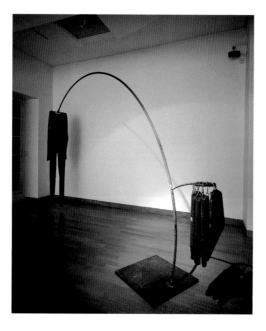 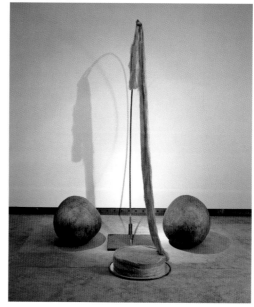

Spindle
1992
Steel, cloth
238.5 × 391 × 60.5 cm

Needle (Fuseau)
1992
Steel, flax, mirror, wood
277 × 256.5 × 142 cm

the art world, because the social scene, and the buying scene, was in the hands of women – women who had money. They wanted to be entertained – they were very lazy and sometimes stupid, and they wanted to be entertained by men of a certain age. So these charmers were what was called in the eighteenth century a *pique-assiette* in French, somebody who picks at your plate, who will come entertain for dinner, like a buffoon – it is a kind of profession that interests me very much. And they are picked from among artists because there is a certain prestige to being an artist, but from a professional point of view they are more entertainers than artists. They relate to the storyteller, which was a profession. The storytellers of the Middle Ages were men who went from place to place, telling their tales, and sometimes reached the top because of their acting and verbal abilities.

Because of the profession and personality of my husband, I lived among these people. It was interesting. And because I was French and kind of discreet, they tolerated me – with my accent I was a little strange, I was not competition – and I was cute, I guess. They took me seriously, on a certain level, but they refused to help me professionally. The trustees of the Museum of Modern Art were not interested in a young woman coming from Paris. They were not flattered by her attention. They were not interested in her three children. I was definitely not socially needed then. They wanted male artists, and they wanted male artists who did not say that they were married. They wanted male artists who would come alone and be their charming guests. Rothko could be very charming. It was a court. And the artist buffoons came to the court to entertain, to charm.

Now it has changed, now the younger men are in – older women and younger men. I am not interested in art history, in the academies of styles, a succession of fads. Art is not about art. Art is about life, and that sums it up. This remark is made to the whole academy of artists who have attempted to derive the art of the late 1980s, to try to relate it to the study of the history of art, which has nothing to do with art. It has to do with appropriation. It has to do with the attempt to prove that you can do better than the next one, and that a famous art history teacher is better than the common artist. If you are a historian, you have to have the dignity of a historian. You don't have to prove that you are better than the artist.

What modern art means is that you have to keep finding new ways to express yourself, to express the problems, that there are no settled ways, no fixed approach. This is a painful situation, and modern art is about this painful situation of having no

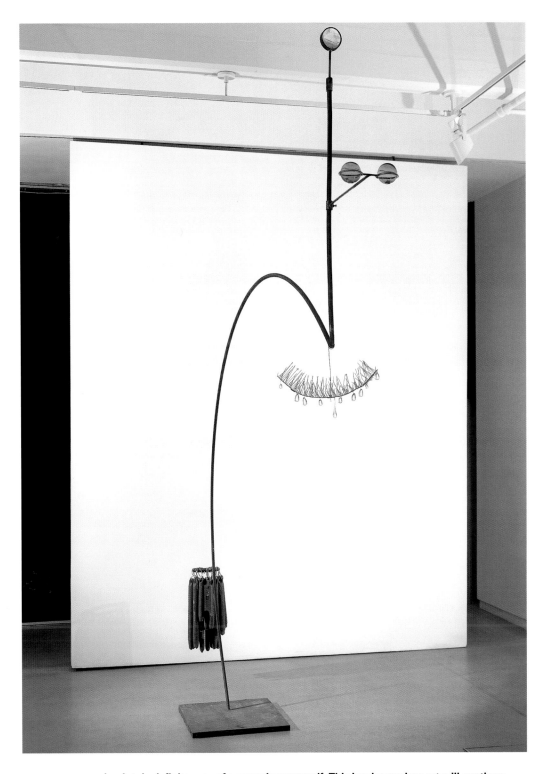

ids
93
eel, glass, metal
9.5 × 254 × 81 cm

absolutely definite way of expressing yourself. This is why modern art will continue, because this condition remains; it is the modern human condition ... it is about the hurt of not being able to express yourself properly, to express your intimate relations, your unconscious, to trust the world enough to express yourself directly in it. It is about trying to be sane in this situation, of being tentatively and temporarily sane by expressing yourself. All art comes from terrific failures and terrific needs that we have. It is about the difficulty of being a self because one is neglected. Everywhere in the modern world there is neglect, the need to be recognized, which is not satisfied. Art is a way of recognizing oneself, which is why it will always be modern.

Donald Kuspit, *Louise Bourgeois*, Random House, Inc., New York; Elizabeth Avedon Editions/Vintage Contemporary Artists, 1988, pp. 19–82.

Freud's Toys 1990

Le Defi
1991
Painted wood, glass, electric
lights
171.5 × 147.5 × 66 cm
Collection, Solomon R.
Guggenheim Museum, New York

When I look at this catalogue of Freud's collection, I think of Madame Tussaud's Wax Museum. The analogy is not entirely a put-down. The collection is a document; it has the nostalgia of a period piece, and it's very moving. Freud collected because it gave him pleasure, a kind of self-esteem. Why did he need self-esteem? I don't know. How can a man like Freud need reassurance? perhaps the collection gave him a social standing that he may have felt he lacked. Perhaps it gave him a way of decorating his office. Perhaps it gave him a distraction while he worked, since he must have been painfully weary of the sob stories of his patients. On the other hand, he must have been weary of their silences as well. It's terrible to spend an hour with somebody who will not open up, not because they don't want to but because they cannot, or because they have nothing to say, or their mind is blurred, or because they want to go and get drunk, or they want to express antagonism. God knows what the reasons for the silences are, but Freud was probably bored. I doubt very much he liked most of his patients. Which only means he was human.

Freud's collecting was a pastime. He could hold the antiquities, he could caress them, he could dust them, he could handle them physically. Although he used many archeological metaphors in his writings about the psyche and the unconscious, I doubt that these antiquities helped him in his work. He was a doctor, a neurologist, a disciple of Darwin, a student of Charcot, a materialist and a determinist. He was concerned with the laws of causality. He wanted to convince his patients to listen to reason. He even rejected hypnosis. He was solely interested in evidences, proofs and documents. The information he used very often came from his own library. Freud was interested in biographies, case studies, and written, verifiable documentation. He could not have extrapolated much from these objects. He was not a visual person: his collection has no visual consistency. He hopped from Chinese to Greek, from Greek to Roman, and from Roman to Egyptian. Strangely, African art seems not to have concerned him much. And of course he had no interest in the art of his day.

It's true, as the catalogue says, that psychoanalysis can be equated with digging. But the analogy is a cheap one. Any time you are presented with a problem, you dig. You dig in your mind. We all dig for the truth. A cat will dig in the garden to hide its shit. We all dig all day long, so the metaphor is obvious. More revealing than Freud's archeological language is his use of terms from physics and mechanics, terms like energy, condensation and displacement. He wanted to be scientific.

So these objects were not crucial to Freud's work. They were his toys. They gave him a kick. They were part of the good life, and as I said, he may have needed reassurance. I also think you have to see the enormous, threatening presence of Jung behind Freud's collection. Jung really deduced his theories from his knowledge of antiquities, although he over-did it. But Freud was a reasonable and scientific man. He was content with these little trifles, but they did not engage his intellect or his ability as a doctor. One of the ways he sometimes healed was to move his hand to the forehead of the patient and just touch it. This physical contact was so real that suddenly the patient would start to talk, start to function. So as a healer, Freud was a very powerful person. Meaning that reality for him was not in the little figures. Reality for him was in the life or death of his patient. Reality was in the struggle for the survival of his patient.

I see his office with the half-dead hysterics there as a pitiful place. I don't want to exaggerate, but I call them maggots. Freud was so in tune with the misery of people, and with the misery of their fantasies and superstitions, that he needed to look at the comforting spectacle of civilizations that have died and yet still live today. He needed relief from his constant, painful facing of the fragmented pieces of broken minds.

Although he was irreligious, he believed in a kind of resurrection. Freud treated these people because that was his way of fighting death. For selfish reasons, he was challenged to prove to himself that he was stronger than death. The patient was dying inside, but Freud could push death away. Still, he was constantly facing the disappearance of these maggots. But the comparison is strange, because a maggot is very alive. A maggot is wiggling with life. A maggot is actually a symbol of resurrection.

He found in the chaos of his relation to the patient that he was able to believe in a resurrection through culture. All the cultures that Freud put together in his collection gave him the hope that history is whole. All civilizations have the right to exist. He could make sense out of history, and that assured him he had a place in it. He belonged somewhere, in spite of the injustices he suffered. After all, he incorporated with a vengeance the suffering of his father. We all want to defend our parents. It was when Freud's father died that he started to collect, and in his collecting he was very generous. He accepted all these figures. He gave a place to every one of them, so therefore *he* had a place, too. Their being there on the desk or on his shelf was a physical thing. But they weren't important to him visually. Ten books would have done the same. In fact, Freud was in love with his library. It didn't have to be those little concrete entities.

I am not a collector. It gives me fantastic pleasure to discover something, but once I

have acquired it and I have to put my money where my mouth is, I instantly lose interest. I feel ashamed to have indulged in such a pleasure and immediately try to get rid of the object.

My father had one collection and I found it. I still have it. It was a box and inside there were pebbles. There were hundreds of pebbles, and he had it on his desk. He said, 'Every time I have a beautiful moment, it proves to me that life is worth living, and in gratitude I put a pebble in the box.' So he was collecting beautiful moments. Why did he have to do that? Probably because he was anxious, he considered life hell, and he had to prove to himself that in spite of everything, beautiful moments existed, and the pebble was the proof of their existence.

In these terms, there is no more value in a Greek statue than in a pebble. Both can help you to believe that life has an order and a *raison d'être*. Still, there is a big difference between a personal symbol and a social symbol. There is also a big difference between an artifact and art. An artifact is first of all useful, and does not relate to anything more vitally than to its use. It is isolated in its momentary meaning, and is easily reproduced. It is not an original. So much contemporary art should really be seen as artifact; but then, so should some of the objects in Freud's collection. Is a little Tanagra statuette from the Greek period a real embodiment of that civilization? These figures were made by the thousands, from moulds, because they were funerary statuettes and were placed in the tombs. They are not symbols today. Andy Warhol collected cookie jars; these are only valuable in that they represent Warhol's choice. They meant something to him, but they are not socially significant. Today they are a commodity of the mass media. A toy is fine, but it is only a toy. It's not a reality. Art is a reality. The artifact is a manufactured object; a work of art is a language. The artifact has only an educational or sentimental value. The work of art has an *absolute* value. How could Freud have had an eye for aesthetic quality when the aesthetic of some of these objects is so low?

Ultimately, I am less concerned with Freud's interest in art than with his interest in artists. I simply want to know what Freud and his treatment can do, have tried to do, are expected to do, might do, might fail to do, or were unable to do for the artist here and now. The truth is that Freud did nothing for artists, or for the artist's problem, the artist's torment – to be an artist involves some suffering. That's why artists repeat themselves – because they have no access to a cure. People sublimate and turn to art because, first of all, they would like to be sexual but they are afraid, and second, they feel guilty. In this day and age it is easy for people to be separated from sex. You certainly do not have to be religious to be afraid of sex. And the need of artists remains unsatisfied, as does their torment.

Artist's review of the exhibition 'The Sigmund Freud Antiquities: Fragments from a Buried Past' at the University Art Museum of the State University of New York, Binghampton, *Artforum*, Vol. 28, No. 5, New York, January, 1990, pp. 111–13.

MacDowell Medal Acceptance Speech 1990

What can I possibly say now? Rob Storr has said everything. His stories are so
wonderful. He has some good interpretations of my work that I do not fully agree
with, but since Rob Storr talks so much about the Mapplethorpe issue I will stay on
the subject.

The story of this photograph is actually quite complicated. When Mapplethorpe
approached us to make this portrait, I was a little apprehensive. Now, to be
photographed is quite common, but you have to know how to be casual about it.
You have to be ready for it. Instead of being photographed candidly in my own studio,
I had to go to Mapplethorpe's studio. That is how it is with highly-professional
photographers – it was the same way with Scavullo and Avedon. They work on their
own terms and operate from their own studio. It was up to us to go there. That gives
me stress.

So I prepared with Jerry Gorovoy and appeared as scheduled at Mapplethorpe's
studio. This is my attitude towards men, you have to be prepared and work at it.
It is a very strange attitude, but it is consistent. You have to prepare everything. You
have to feed them, tell them they are great, you literally have to take care of them.
They constantly get insulted, they turn what you say into the opposite. I mean, it's
really a job.

So on the day of this appointment at Robert's studio, I thought, 'What can we
bring? What prop can we bring?' Jerry's used to that. We prepare, we over prepare,
we're early, you know, we're real pros. So I got *Fillette* (1968), which is a sculpture of
mine, which was hanging among others. I knew that I would get comfort from holding
and rocking the piece. Actually my work is more me than my physical presence. So the
sculpture is in the background of the photograph.

You see the triple image of the man you have to take care of, of the child you have
to take care of, and of the photographer you have to take care of.

The *Fillette* had been done years before and relates directly to a family situation.
You see, talking about personal things in public makes me break out in a sweat. My
family, we were five. There were three children, there were no maids and my husband
was a teacher at the time. He made a moderate salary. I had three boys plus my
husband, so I had four men that I had to take care of. And I do not say that I didn't love
them, I did love them. Coming from a French background, where the wife is really
a mother, the idea of loving men means helping them. But you have to know how.

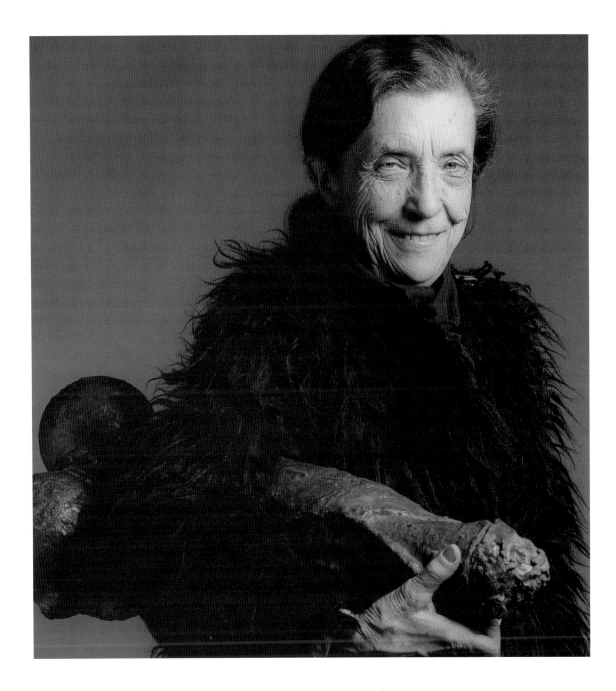

Robert Mapplethorpe
Louise Bourgeois
1982
Photo © the Estate of Robert
Mapplethorpe

You have to have bright ideas.

My mother was quite clever, much more than I. My father betrayed her. As a traditional French wife she has to humour him. French men have their little betrayals. The mother is supposed to forgive. She is supposed to say she's sorry that he betrayed her. You have to see it to believe it. There is no such thing as divorce in France, not in those days.

There I was, a wife and mother, and I was afraid of my family. I was afraid not to measure up. My mother had understood her role and was not afraid of the demands. I did not understand my role and I'm afraid I did not fill it. So what do you do when you are afraid?

Today, once again, I'm placed in a role with demands I am not sure I can fulfil. How can I help raise money for you? Maybe you picked the wrong Medallist. The challenge for me now is to prove to you that you were right to trust me […]

On 19 August 1990, The MacDowell Colony in Peterborough, New Hampshire, awarded the Edward MacDowell Medal to Louise Bourgeois. The above speech by the artist was preceded by introductory comments by Robert Storr, Curator at The Museum of Modern Art, New York. First published in *MacDowell Colony News*, Vol. 20, No. 1, Spring, 1991.

On *Cells* 1991

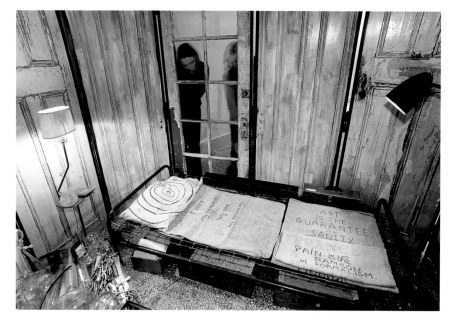

Cell I
1991
Mixed Media
211 × 244 × 274.5 cm

I.

The subject of pain is the business I am in. To give meaning and shape to frustration and suffering. What happens to my body has to be given a formal abstract shape. So you might say, pain is the ransom of formalism.

The existence of pains cannot be denied. I propose no remedies or excuses. I simply want to look at them and talk about them. I know I can't do anything to eliminate or suppress them. I can't make them disappear; they're here to stay.

The *Cells* represent different types of pain: the physical, the emotional and psychological, and the mental and intellectual. When does the emotional become physical? When does the physical become emotional? It's a circle going round and round. Pain can begin at any point and turn in either direction.

Each *Cell* deals with fear. Fear is pain. Often it is not perceived as pain, because it is always disguising itself.

Each *Cell* deals with the pleasure of the voyeur, the thrill of looking and being looked at. The *Cells* either attract or repulse each other. There is this urge to integrate, merge, or disintegrate.

II.

In this *Cell* the hands, tightly clenched in pain, are made of stone. Pain, like stone, is indestructible. It comes from the rage of not knowing how to understand, of not knowing how to learn. There is this inner resistance that keeps me from learning, that keeps me from understanding. The resistance itself is unconscious and my inability to progress puts me in a state of rage. You confuse the world of emotions, which has a personal logic, with the world of the intellect, which has a universal logic. It is the confusion that drives you to rage. It's crystal clear.

I think the rage to understand comes from the fact that you do not ask the right question. You will never find the right answer if you do not ask the proper question. It's like trying to open a door with the wrong key. There is nothing wrong with the key, and there is nothing wrong with the door. Some questions are too painful to answer. Some questions we are unwilling to ask. And some are impossible to answer.

When my mother died in 1932, this rage to understand took over me. I simply could not make out the why of her disappearance. Why my mother died and abandoned me would be clear if the question was perhaps a different one. If the question was replaced by why do I suffer so much from this loss, why am I so affected by this disappearance.

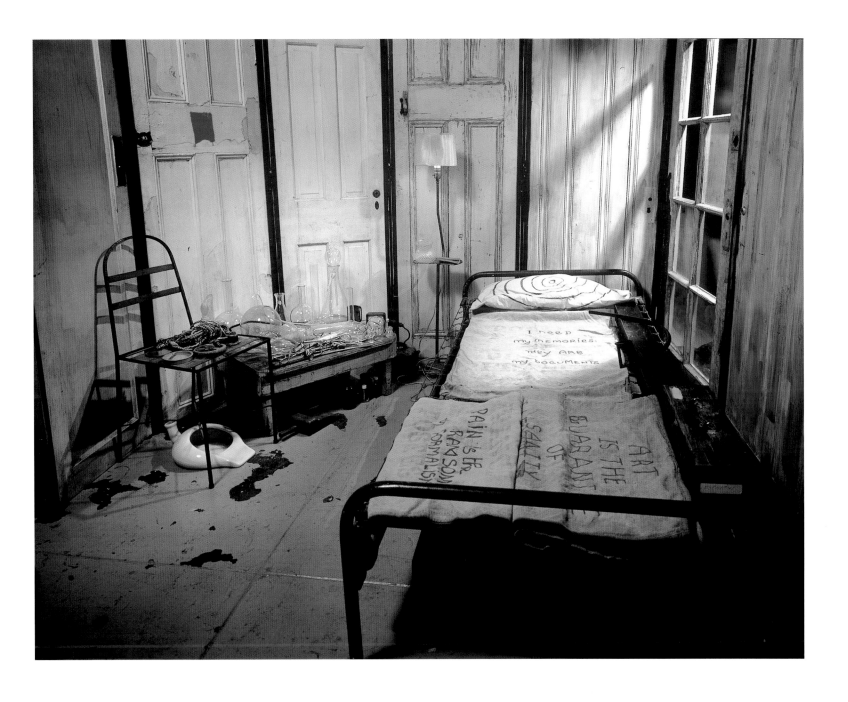

Now these questions are possible to answer. Do I feel guilty? Does it represent a danger? Does it repeat the trauma of abandonment? If you fear abandonment, it keeps you in a state of dependency, which makes you feel you are unable to cope.

So there is this rage of not knowing how to live up to your fate. It's the pain of not knowing how to make yourself loved. This pain never goes away, and you don't know what to do about it. The *Perfume* is the opposite. It's the evanescence of pleasure, the fleeting pleasure of the sense of smell. You cannot grasp it; it's so subtle you cannot touch it. You cannot hear it or see it or taste it. All the five senses show five totally different worlds. One cannot substitute for the other. Yet the sense of smell has the great power of evocation and healing.

Cell (Arch of Hysteria)
1992–93
Steel, bronze, cast iron, fabric
302 × 368.5 × 305 cm
Collection, Centro Andaluz de Arte
Contemporaneo, Seville

III.

The Cell with the figure or arch of hysteria deals with emotional and psychological pain. Here is the arch of hysteria, pleasure and pain are merged in a state of happiness. Her arch – the mounting of tension and the release of tension – is sexual. It is a substitute for orgasm, with no access to sex. She creates her own world and is very happy. Nowhere is it written that a person in these states is suffering. She functions in a self-made cell where the rules of happiness and stress are unknown to us.

The ironing board represents the flattening out of the creases, the diminishing of tension toward sleep. There is the big sleep, which is death, and the little sleep which follows orgasm.

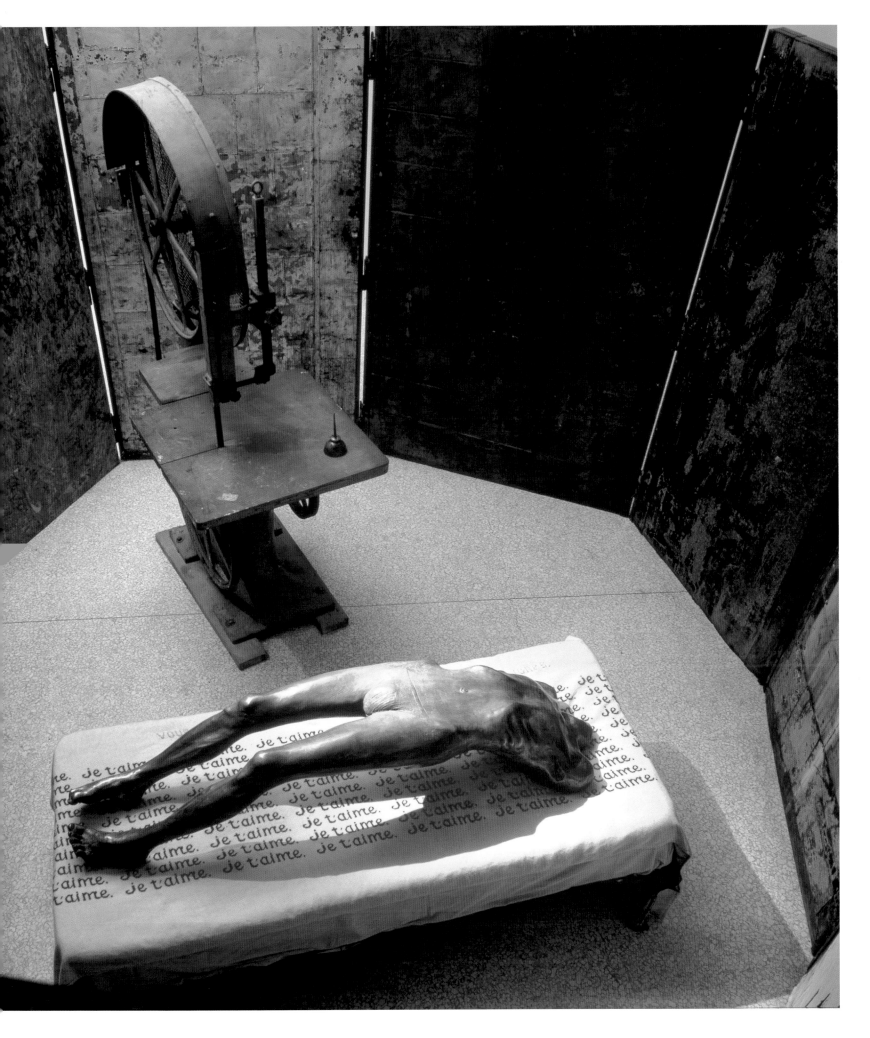

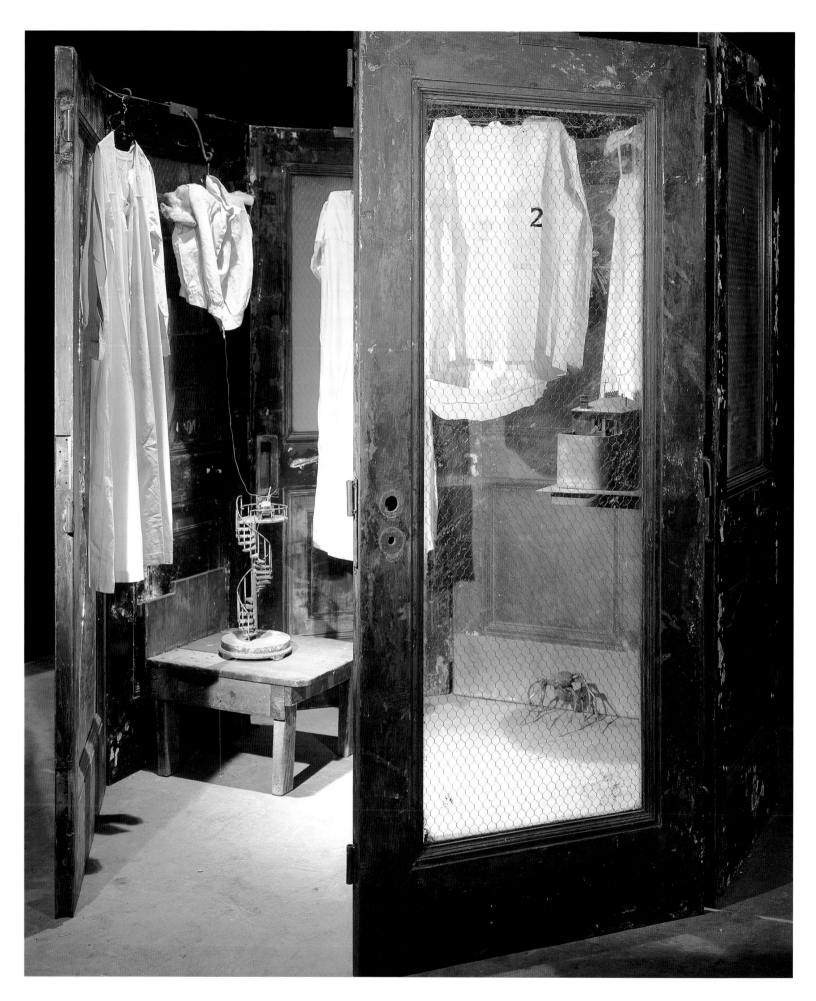

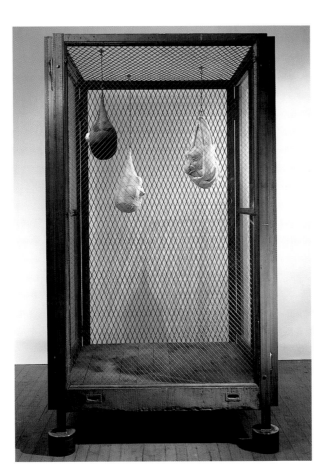

Cell XIX (Portrait)
2000
Steel, fabric, wood, glass
213.5 × 127 × 127 cm

IV.

In bed, crouching in fear, the person in this Cell is hiding. What he is hiding is his state of sickness. He is physically sick and afraid of death. But it is not that simple; he has other fears. What is not justified is his fear of people knowing about his sickness. He is afraid of not having any friends or afraid of losing those he has.

Some diseases are considered shameful because sinful. So he is intensely possessive of his privacy and fears the onlookers. He fears people are going to pry into his privacy. Yet he is projecting his fear of being seen, for he himself is a voyeur, a latent voyeur. This is expressed by the windows. If you can look out, they can look in. The clear glass represents no secrets.

Sick people die of the need of companionship, a stroking hand, a hungering for compassion. He runs away from people, and people run away from him out of fear of contagion. So he is isolated by his own fear and by that of others.

The transparent glass represents a sickness. When you're sick, people don't like you; you're not desirable. My mother was ill and used to cough up blood; I helped her to hide her illness from my father.

Carnegie International, Carnegie Museum of Art, Pittsburgh, 1991, p. 60.

Cell VII
1998
Mixed media
207 × 221 × 211 cm

Statements from Conversations with Robert Storr (extracts)
1980s–90s

The mistress is a threat because *she* is the favourite. Competition with the mother is one thing, but competition with a *chosen* favourite is unthinkable, intolerable.

To make a set is to be in full possession of analytic powers. Anxiety comes when you sense that a part is missing.

You abandon your critical role – the will or ability to differentiate – in your need for amazement. You count on your intuition and let go of your analytic spirit. The price of compulsion is the abdication of discernment. Everything is jumbled. Amazement is itself a compulsion. It is an attempt to muzzle anxiety.

I detest anything primitive. I was brought up *bourgeoise*, enlightened, optimistic, Rousseau-ian.

I have a religious temperament, which is why things are so difficult for me. I was brought up in an anti-religious attitude. There are 140 religions or so, so one more doesn't matter. And my religion is art. It allows me to make sense of everything.

The wonderment at nature, it doesn't mean we have to introduce God. So who do we have to be thankful for? That is the basic question. Well, there is no answer. We don't have to be thankful. The feeling of gratitude almost forces us to invent a god, but this is self-indulgence. Who are *you* to feel grateful. It is much better to feel lucky.

On the treatment of sex at the family dinner table in New York:
When Cosimo entered the dining room and had an erection, and we were flabbergasted, then the remark was, 'Don't worry, it is only a physiological thing.' You can't argue with that. It was a total condemnation of sex. Because it meant it had nothing to do with thinking. My children thought, therefore, that it couldn't be dangerous, but it showed a kind of terror … Sex didn't exist. We lived above these things, we lived for ideas. We were interested in the truth. Not the good; the truth.

Of life at home with Robert Goldwater in New York:
I lived in a bath of history. We talked of nothing but history. I had nothing against it, but it is not real stuff. It's not what art is made of.

piary IV

99

eel, fabric, beads, wood

.5 × 53.5 × 43 cm

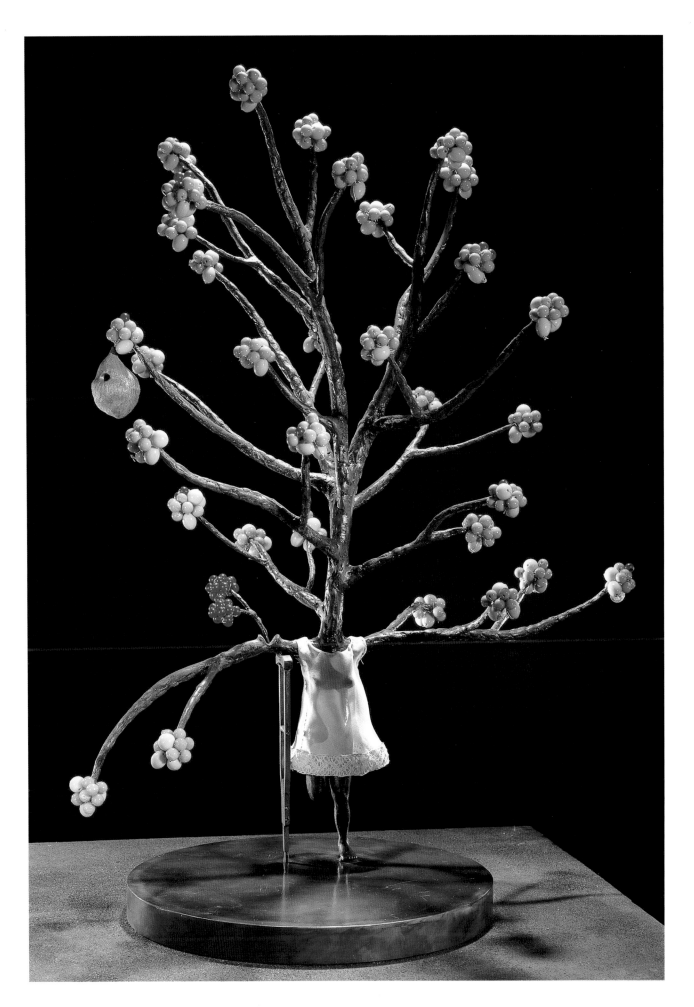

On going through old drawings:
When a woman is pictured as evil, it bothers me.

Hair is simply protection women are wrapped in. Hair is like a caterpillar in a cocoon. But hair is more friendly in that the cocoon eliminates the subject. Silk, hair, wool are everywhere. Skeins are put together in a methodical fashion, whereas hair is unruly and free. It has to be restrained or braided.

Symbols of power that I avoid? – I am very ashamed or afraid of power – I don't drive, I don't handle keys, I don't handle money, I leave it to the authority figure. I do trust, rightly or wrongly, the authority figures. The artist is in a passive position, they [*sic*] abdicate symbols of power … Mistrust happens in the rat race. It's a predatory thing. They are the brothers and sisters who barge in. You draw your strength from your loving someone – not the other way around. You have to find something that is lovable, some people who are lovable. Success is sexy. It's ridiculous but it's true. It makes men protective – of the girl-woman. It means the artist has remained a child and is perceived as such.

'The female spider' has a bad reputation – a stinger, a killer. I rehabilitate her. If I have to rehabilitate her it is because I feel criticized.

Loneliness comes from one person.

I am not interested in the body; I am interested in the mechanism. The way people move their heads on their necks, the way they dismiss someone with a shrug of their shoulder, the swing of their hips, the way they throw their feet forward to walk, and sometimes the swing of a disjointed hip. The way articulation does or doesn't work is a sign of the way people move together or against each other, the way they relate to each other. It doesn't have to have sexual connotations. Well, the fact is that it is completely sexual – but in an indirect way.

As a result of this interest in the mechanism of behaviour, the articulation of the body, I easily dislocate members of the body. I now have in the study a seven-foot leg. There is the joint of the hip, the back and forth of the knee, and the full circle rotation of the foot.

The Curved House
1990
Marble
35.5 × 94 × 33 cm

Maison
1961
Plaster
40.5 × 35.5 × 23.5 cm

...eground,
...ngle I
...96
...oric
...3.5 × 132 × 40.5 cm

...ckground,
...uple II
...96
...bric and knee brace
...5 × 152.5 × 81 cm
...llection, Albright-Knox Art
...llery, Buffalo, New York
...stallation, Prada Foundation,
...an, 1997

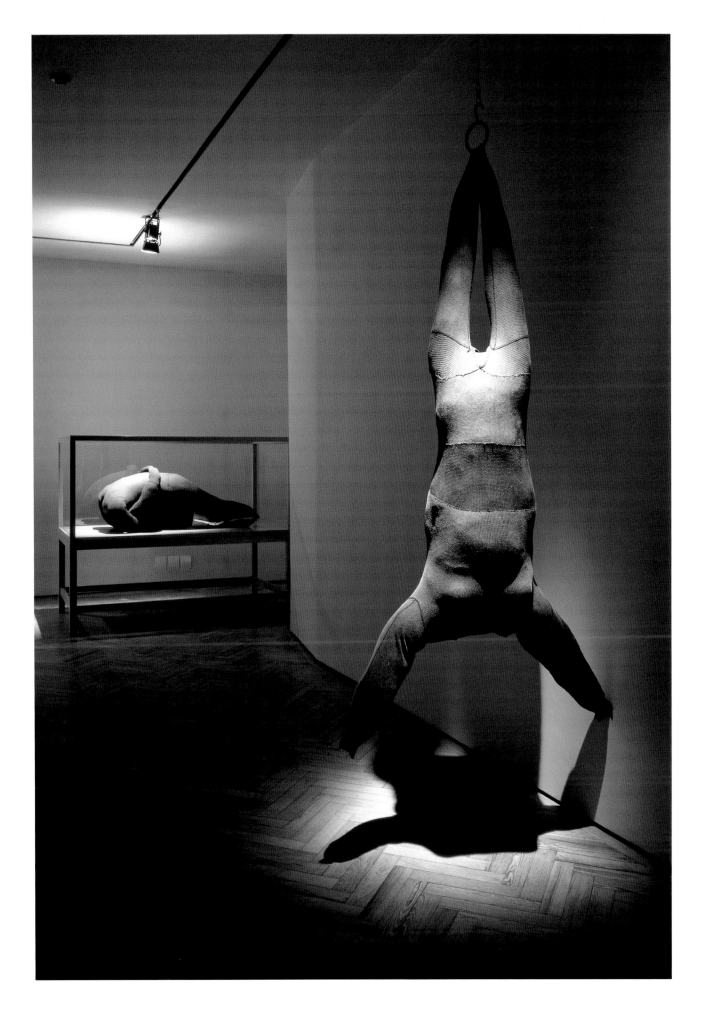

Seven feet is not too much to satisfy my curiosity. The legs in *Blind Leading the Blind* are all seven feet.[1]

There is no feminist aesthetic. Absolutely not! There is a psychological content. But it is not because I am a woman that I work the way I do. It is because of the experiences I have gone through. The women got together not because they had things in common but because they *lacked* things – they were treated the same way. I think this is the story of all minorities. Because when you get in the group there was so much rivalry.

Space does not exist, it is just a metaphor for the structure of our existence.

A spiral is completely predictable. A knot is unpredictable.

When you are angry you become not sinful but ugly – take out a mirror.

1 The legs in the sculpture *The Blind Leading the Blind* (1947–49) are actually 5.5 feet long, but there are seven pairs of them.

Louise Bourgeois: Destruction of the Father, Reconstruction of the Father: Writings and Interviews 1923–1997, ed. Marie-Laure

Bernadac and Hans Ulrich Obrist, MIT Press, Cambridge, Massachusetts, in association with Violette Editions, London, 1998.

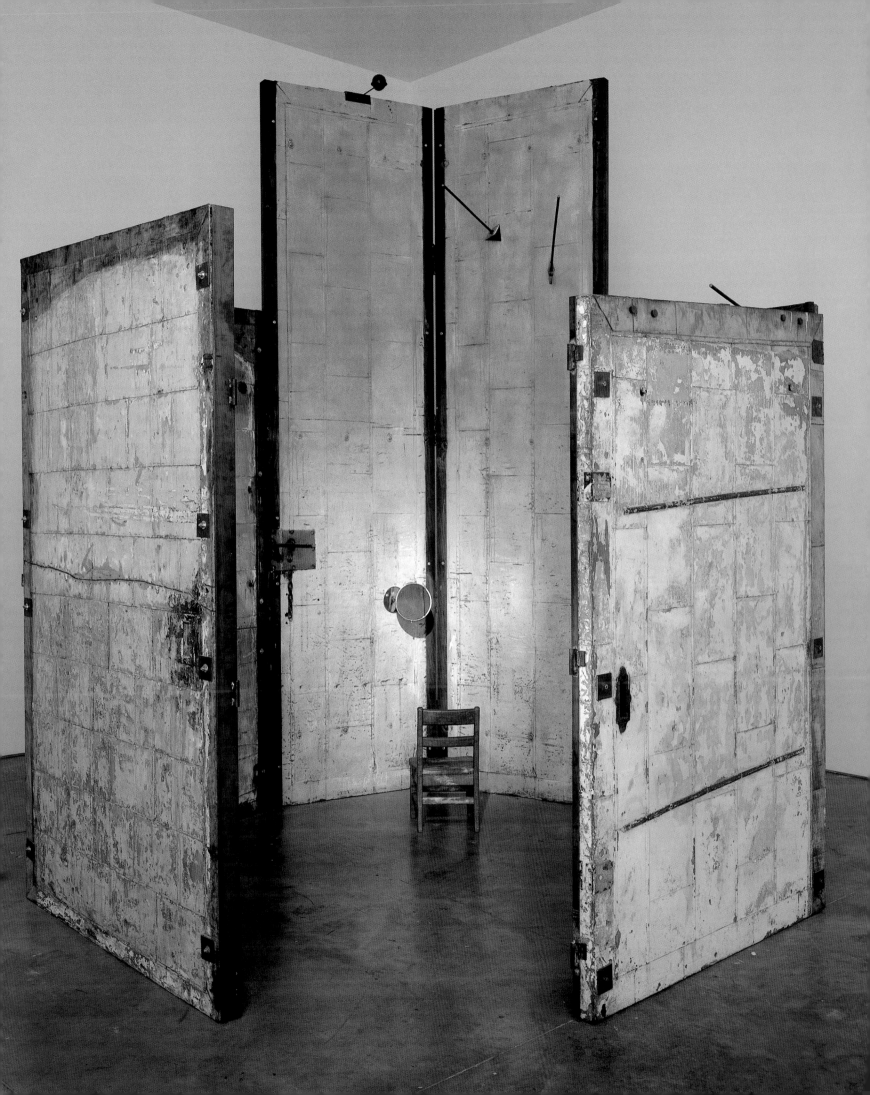

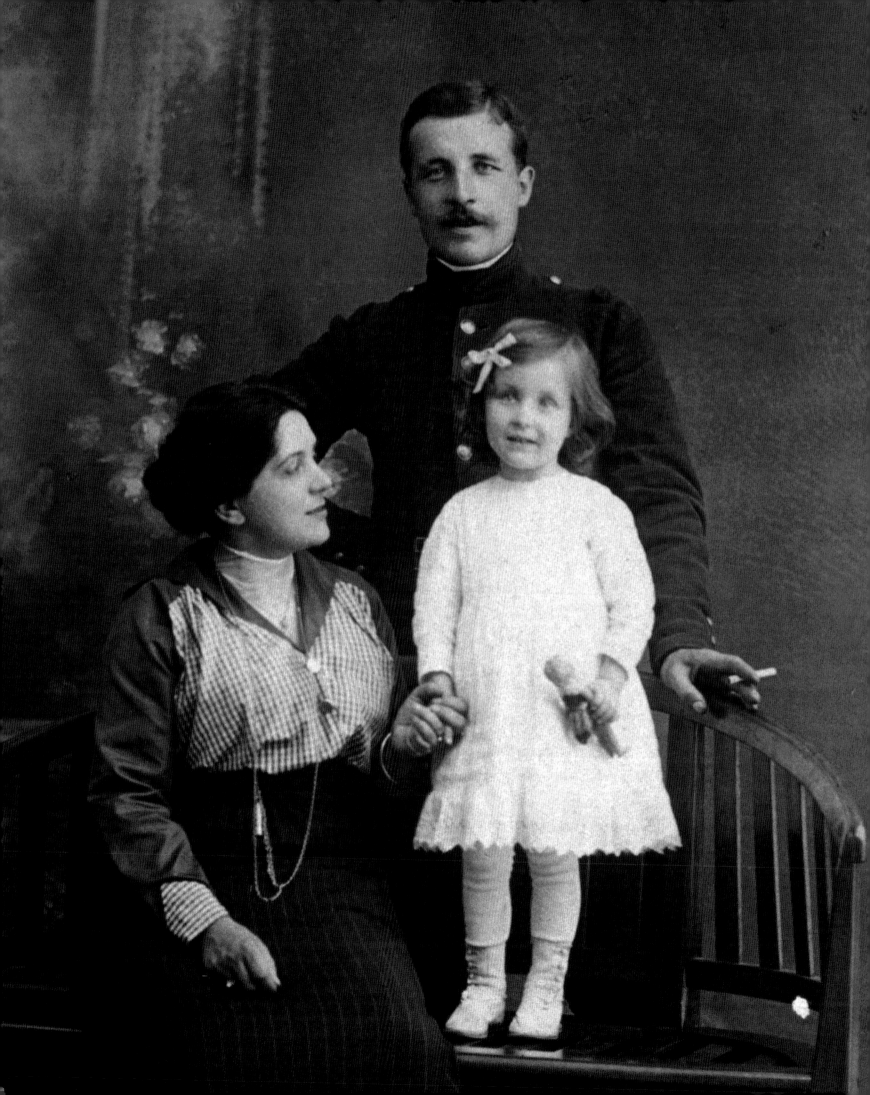

Contents

Chronology Louise Bourgeois Born 1911 in Paris, lives and works in New York

Selected exhibitions and projects
1921–56

1921–27
Studies, Lycée Fénelon and Collège Sévigné, Paris

1932
Studies, Sorbonne, Paris

1936–38
Studies, École des Beaux-Arts, Paris

1936
'Exposition de L'Atelier de la Grande Chaumière',
Galerie De Paris, Paris (group)

1937
'La Groupe 1938–1939 de l'Academie Ranson',
7, rue Joseph-Bara, Paris (group)

1938
Moves to New York

1940
'Fine Prints for Mass Production'
Brooklyn Museum of Art, New York (group)

1944
'Modern Drawings'
San Francisco Museum of Art; The Museum of Modern Art, New York (group)

1945
'Paintings by Louise Bourgeois',
Bertha Schaefer Gallery, New York (solo)

'Annual Exhibition of Contemporary American Painting',
Whitney Museum of American Art, New York (group)

1947
'Louise Bourgeois: Paintings',
Norlyst Gallery, New York (solo)

1949
'Louise Bourgeois, Recent Work 1947–1949: Seventeen Standing Figures in Wood'
Peridot Gallery, New York (solo)

1950
'Louise Bourgeois: Sculptures',
Peridot Gallery, New York (solo)

1953
'Louise Bourgeois: Drawings for Sculpture and Sculpture'
Peridot Gallery, New York (solo)

Allan Frumkin Gallery, Chicago (solo)

1954
'Reality and Fantasy 1900–1954'
Walker Art Center, Minneapolis (group)
Cat. *Reality and Fantasy, 1900–1954*, Walker Art Center, Minneapolis, 1955, text H.H. Arnason

1956
'Black and White'
Stable Gallery, New York (group)

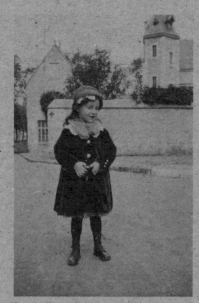

The artist, Chartres, France, 1915

Selected articles and interviews
1921–56

The artist with her parents in Le Cannet, 1922

The artist's student card, 1934–35

The artist on the roof of her apartment building, East 18th Steet, New York, 1944

1945
'Exhibition review, Bertha Schaefer Gallery', *ARTnews*, New York, June
Devree, Howard, 'Exhibition review, Bertha Schaefer Gallery', *New York Times*, 10 June

1947
'Exhibition review, Norlyst Gallery', *ARTnews*, New York, November

1949
Bewley, Marius, 'An Introduction to Louise Bourgeois', *The Tiger's Eye*, 15 March

1950
R.C., 'Exhibition review, Peridot Gallery', *ARTnews*, New York, October

1953
Porter, Fairfield, 'Exhibition review, Peridot Gallery', *ARTnews*, New York, April

1954
Krasne, Belle, '10 Artists in the Margin', *Design Quarterly*, Minneapolis, No. 30

1956

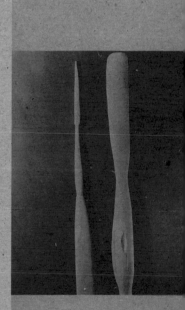

Selected exhibitions and projects
1956–71

1958
'Nature in Abstraction'
Whitney Museum of American Art, New York (group)
Cat. *Nature of Abstraction*, Whitney Museum of
American Art, New York, text John Baur

1959
'Sculpture by Louise Bourgeois',
Andrew D. White Art Museum, Cornell University,
Ithaca, New York (solo)

1960
'Aspects de la Sculpture Americaine'.
Claude Bernard Gallery, Paris (group)

1964
'Louise Bourgeois: Recent Sculpture',
Stable Gallery, New York (solo)

1965
'XXVII Salon de la Jeune Sculpture',
Musée Rodin, Paris (group)
Cat. *Les Etats-Unis: Sculpture du XX Siecle*, Musée Rodin,
Paris

1966
'Eccentric Abstraction',
Fischbach Gallery, New York (group)
Cat. *Eccentric Abstraction*, Fischbach Gallery, New York,
text Lucy R. Lippard

1968
'Soft Sculpture',
American Federation of Arts, New York (group)

1969
'6th Biennale Internazionale di Scultura',
Carrara, Italy (group)

'The New American Painting and Sculpture: The First
Generation',
The Museum of Modern Art, New York (group)
Cat. *The New American Painting and Sculpture: The First
Generation*, The Museum of Modern Art, New York, text,
Robert Goldwater

1970
'Annual Exhibition of Contemporary American
Scupture',
Whitney Museum of American Art, New York (group)

The artist , mid 1960s

Selected articles and interviews
1956–71

Goldwater, Robert, 'La Sculpture Actuelle a New York',
Cimaise, Paris, November–December

1958
Hess, Thomas B., 'Inside Nature', *ARTnews*, New York,
February

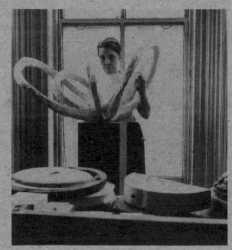
The artist , early 1960s

1964
Edgar, Natalie, 'Exhibition review, Stable Gallery',
ARTnews, New York, January
Robbins, Daniel, 'Sculpture by Louise Bourgeois', *Art
International*, Paris, 20 October

1966
Antin, David, 'Another Category: 'Eccentric
Abstraction', *Artforum*, New York, November
Bochner, Mel, 'Eccentric Abstraction', *Arts*, New York,
November
Lippard, Lucy R., 'Eccentric Abstraction', *Art
International*, Paris, 20 November

1969

Rubin, William, 'Some Reflections Prompted by the
Recent Work of Louise Bourgeois', *Art International*,
Paris, April

1970
Glueck, Grace, 'Women Artists Demonstrate at
Whitney', *New York Times*, 12 December

1971
Marandel, J. Patrice, 'Louise Bourgeois', *Art
International*, Paris, 20 December
Nemser, Cindy, 'Forum: Women in Art', *Arts*, New York,
February

Selected exhibitions and projects
1971–78

1972
'13 Women Artists',
Women's Ad Hoc Committee at 117–119 Prince Street, New York (group)

'American Women Artists Show'
Kunsthaus, Hamburg (group)

1973
Artist Grant, National Endowment for the Arts

'Sculpture in the Fields',
Storm King Art Center, Mountainville, NY (group)

'Biennial Exhibition: Contemporary American Art',
Whitney Museum of American Art, New York (group)

1974
'Louise Bourgeois: Sculpture 1970–1974',
112 Greene Street, New York (solo)

1975
'American Art Since 1945 From the Collection of The Museum of Modern Art',
The Museum of Modern Art, New York (group)

1976
'118 Artists',
Landmark Gallery, New York (group)

The artist in a latex costume designed an made by her, New York, c. 1975
Photo © by Peter Moore

1977
Honorary Doctor of Fine Arts Degree from Yale University, New Haven, Connecticut

1978
'Louise Bourgeois: New Work', includes a performance
'A Banquet/A Fashion Show of Body Parts' in conjunction with the work *Confrontation*,
Hamilton Gallery of Contemporary Art, New York (solo)

'Louise Bourgeois: Triangles: New Sculpture and Drawings, 1978',
Xavier Fourcade Gallery, New York (solo)

'Louise Bourgeois: Matrix / Berkeley 17',
Berkeley Art Museum, University of California (solo)

Selected articles and interviews
1971–78

Nochlin, Linda, 'Why Have There Been No Great Women Artists?', *ARTnews*, New York, January

1974
Andre, Michael, 'Exhibition review, 112 Greene Street Gallery', *ARTnews*, New York, February, 1975
Sondheim, Alan, 'Exhibition review, 112 Greene Street Gallery', *Arts*, New York, March, 1975

1975

Baldwin, Carl R., 'Louise Bourgeois: An Iconography of Abstraction', *Art in America*, New York, March–April
Lippard, Lucy R., 'Louise Bourgeois: From the Inside Out', *Artforum*, New York, March

1976

Bloch, Susi, 'An Interview with Louise Bourgeois', *Art Journal*, New York, Summer
Robins, Corinne, 'Louise Bourgeois: Primordial Environments', *Arts*, New York, June

1977

Duncan, Carol, 'The Esthetics of Power in Modern Erotic Art', *Heresies*, New York, January
Kuspit, Donald, 'Louise Bourgeois', *Art in America*, New York, September–October

1978
Gibson, Eric, 'New York Letter: Louise Bourgeois', *Art International*, Paris, November–December
Harnett, Lila, 'Exhibition review: Hamilton and Fourcade Galleries', *Cue*, New York, 27 October

Selected exhibitions and projects
1978–82

Cat. *Louise Bourgeois: Matrix/Berkeley 17*, University
Art Museum, University of California, Berkeley, text
Deborah Wye

1979
'Artists Against Nuclear Power Plants'
112 Greene Street Gallery, New York (group)

1980
Award for Outstanding Achievement in the Visual Arts
from Women's Caucus for Art

'The Iconography of Louise Bourgeois',
Max Hutchinson Gallery, New York (solo)
Cat. *The Iconography of Louise Bourgeois*, Max
Hutchinson Gallery, New York, text Jerry Gorovoy

1981
'Louise Bourgeois: Femme Maison',
The Renaissance Society at the University of Chicago
(solo)
Cat. *Louise Bourgeois: Femme Maison*, The Renaissance
Society at the University of Chicago, text Patrice J.
Marandel

1982
'Bourgeois Truth',
Robert Miller Gallery, New York (solo)
Cat. *Bourgeois Truth*, Robert Miller Gallery, New York,
text Robert Pincus-Whitten

'Louise Bourgeois: Retrospective',
The Museum of Modern Art, New York, toured to
Contemporary Arts Museum, Houston; **Museum of
Contemporary Art**, Chicago; **Akron Art Museum**,
Akron, Ohio (solo)
Cat. *Louise Bourgeois*, The Museum of Modern Art, New
York, 1983, text Deborah Wye

Daniel Weinberg Gallery, San Francisco (solo)

Selected articles and interviews
1978–82

Ashbery, John, 'Art/Anxious Architecture', *New York*,
16 October
Marandel, J. Patrice, 'Louise Bourgeois', *Arts*, New
York, October
Ratcliff, Carter, 'Louise Bourgeois', *Art International*,
Paris, November–December

1979

Munro, Eleanor, 'The Rise of Louise Bourgeois', *Ms.
Magazine*, New York, July
Pels, Marsha, 'Louise Bourgeois: A Search for Gravity',
Art International, Paris, October
Russell, John, 'Art: The Sculpture of Louise Bourgeois',
New York Times, New York, 5 October

1980

Cohen, Ronny H., 'Louise Bourgeois: Max Hutchinson
Gallery', *Artforum*, New York, November
Lawson, Thomas, 'Exhibition Review: Max Hutchinson
Gallery', *Flash Art*, New York, November

Gardner, Paul, 'The Discreet Charm of Louise
Bourgeois', *ARTnews*, New York, February
Ratcliff, Carter, 'Louise Bourgeois', *Vogue*, New York,
October

1981
Kirshner, Judith Russi, 'Exhibition review: The
Renaissance Society at the University of Chicago',
Artforum, New York, November

Larson, Kay, 'Louise Bourgeois: Her Re-emergence
Feels Like a Discovery', *ARTnews*, New York, May

1982

Ratcliff, Carter, 'New York: Louise Bourgeois at the
Museum of Modern Art', *Flash Art*, Milan, January,
1983

Bourgeois, Louise, 'A Project by Louise Bourgeois',
Artforum, New York, December

Selected exhibitions and projects
1983–87

1983
Named Officier de L'Ordre des Arts et des Lettres, by
Jack Lang, French Minister of Culture

1984
President's Fellows Award, Whitney Museum of
American Art, New York

'Louise Bourgeois Sculpture',
Robert Miller Gallery, New York (solo)

'Louise Bourgeois',
Daniel Weinberg Gallery, Los Angeles (solo)

'Correspondences: New York Choice 84',
Laforet Museum, Tokyo (group)

'Primitivism',
The Museum of Modern Art, New York (group)

1985
'Louise Bourgeois',
Serpentine Gallery, London (solo)
Cat. *Louise Bourgeois*, Serpentine Gallery, London

'Eau de Cologne',
Monika Sprüth Gallery, Cologne (group)
Cat. *Eau de Cologne*, Monika Spruth Gallery, Cologne,
text Ingrid Sischy

'Spuren, Skulpturen und Monumente ihrer präzisen
Reise',
Kunsthaus, Zurich (group)
Cat. *Spuren Skulpturen und Monumente ihrer präzisen
Reise*, Kunsthaus, Zurich, text Harald Szeemann

1986
'Louise Bourgeois',
Robert Miller Gallery, New York (solo)
Cat. *Louise Bourgeois*, Robert Miller Gallery, New York,
text Jerry Gorovoy

Installation, *Eyes*, the Doris Freedman Plaza
Fifth Avenue at 60th Street, New York,
sponsored by the Public Art Fund and New York City
Department of Parks and Recreation

1987
'Louise Bourgeois',
Taft Museum, Cincinnati, toured to **Art Museum at
Florida International University**, Miami; Laguna
Gloria Art Museum, Austin; **Gallery of Art**,
Washington University, St. Louis; **Everson Museum of
Art**, Syracuse, New York (solo)
Cat. *Louise Bourgeois*, Taft Museum, Cincinnati, text
Stuart Morgan

Selected articles and interviews
1983–87

1983

Storr, Robert, 'Louise Bourgeois: Gender &
Possession', *Art in America*, New York, April

1984

Silverthorne, Jeanne, 'Louise Bourgeois at Robert
Miller Gallery', *Artforum*, New York, December

1985
Holman, Martin, 'Louise Bourgeois: Sculpture and
Drawings', *Literary Review*, London, June
Russell-Taylor, John, 'Louise Bourgeois at Serpentine
Gallery', *The Times*, London, 28 May

Cabanne, Pierre, 'Louise Bourgeois: sculpteur pour
tuer le pere', *Le Matin*, Paris, 18 February

1986
Morgan, Stuart, 'Louise Bourgeois at Robert Miller',
Artscribe, London, September–October

Brenson, Michael, 'A Bountiful Season in Outdoor
Sculpture Reveals Glimmers of a New Sensibility', *New
York Times*, 18 July

Robert Storr, 'Meaning, Material, Milieu, Reflections
on Recent Work by Louise Bourgeois: Interview by
Robert Storr', *Parkett*, Zurich, No. 9

1987

Selected exhibitions and projects
1987–89

'L'Etat de Choses I',
Kunstmuseum, Luzern, Switzerland (group)

'La Femme Et Le Surrealisme',
Musée Cantonal des Beaux Arts, Lausanne (group)

1988
'Louise Bourgeois: Works from 1943–1987',
Henry Art Gallery, University of Washington, Seattle
(solo)

'Enchantment/Disturbance',
The Power Plant, Toronto (group)
Cat. *Enchantment/Disturbance*, Power Plant, Toronto,
text Renee Baert

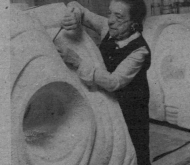

The artist with **The Sail** (in progress) 1988

1989
'Distinguished Artist Award for Lifetime Achievement',
College Art Association

'Louise Bourgeois: Sculpture',
Robert Miller Gallery, New York (solo)

'Louise Bourgeois: Progressions and Regressions',
Galerie Lelong, New York (solo)

'Louise Bourgeois: Works from the 50's'
Sperone-Westwater Gallery, New York (solo)

'Recent Sculpture by Louise Bourgeois',
Art Gallery of York University, North York, Ontario
(solo)

'Louise Bourgeois: Legs',
Ydessa Hendeles Art Foundation, Toronto (solo)

'Louise Bourgeois: A Retrospective Exhibition',
Kunstverein, Frankfurt, toured to **Stadtische Galerie
im Lenbachhaus**, Munich; **Musée d'art
Contemporain**, Lyon; **Fundación Tàpies**, Barcelona;
Kunstmuseum, Bern; **Kröller-Müller Museum**,
Otterlo, The Netherlands (solo)
Cat. *Louise Bourgeois*, Frankfurter Kunstverein,
Frankfurt; Musee d'art Contemporain, Lyon; Tapies
Foundation, Barcelona, texts Peter Weiermair, Lucy
Lippard, Rosalind Kraus, et al.

'Prospect 89',
Kunstverein, Frankfurt (group)
Cat. *Prospect 89*, Kunstverein, Frankfurt, 1990

Installation view, 'Louise Bourgeois: Works from the 50's',
Sperone-Westwater Gallery, New York (solo)

Selected articles and interviews
1987–89

Kuspit, Donald, 'Louise Bourgeois – Where Angels Fear
To Tread', *Artforum*, New York, March
Rose, Barbara, 'Sex, Rage & Louise Bourgeois', *Vogue*,
New York, September

1988
Grisham, Therese, 'Louise Bourgeois: Volcanic Charm',
Artsfocus, Seattle, Washtington, January, 1989

Linker, Kate, 'Louise Bourgeois', *Artforum*, New York,
April
Malen, Lenore, 'Louise Bourgeois', *ARTnews*, New York,
April
Morgan, Stuart, 'Taking Cover: Louise Bourgeois
interviewed by Stuart Morgan', *Artscribe*, London,
January–February

1989
Ottman, Klaus, 'Louise Bourgeois/Lelong, Miller',
Flash Art, New York, October
Schwendenwein, Jude, 'Louise Bourgeois at Robert
Miller & Galerie Lelong', *Artscribe*, London,
November–December

Installation view, 'Louise Bourgeois: A Retrospective Exhibition', Musée
d'art Contemporain, Lyon

Eigenheer, Marianne, 'Louise Bourgeois: ein
Interview', *Kunst Bulletin*, November, 1990
Smulders, Caroline, 'Louise Bourgeois', *Art Press*, Paris,
October, 1990
Tazzi, Pier Luigi, 'Louise Bourgeois at the Kunstverein',
Artforum, New York, Summer, 1990
Weiermair, Peter, 'Louise Bourgeois', *Noema*,
September–October, 1990
'Louise Bourgeois Retrospective', *Flash Art*, New York,
January–February, 1990

Selected exhibitions and projects
1989–91

'Bilderstreit',
Museum Ludwig, Cologne (group)

'Magiciens de la Terre',
Centre Georges Pompidou, Paris (group)

1990
'The Sculpture Center Award for Distinction in
Sculpture 1990', The Sculpture Center, New York

'Louise Bourgeois: 1984–1989',
Riverside Studios, London (solo)
Cat. *Louise Bourgeois: Recent Work 1984–1989*,
Riverside Studios, London, text Stuart Morgan

'Louise Bourgeois 1939-89 Skulpturen und
Zeichnungen',
Galerie Krinzinger Wien, Vienna (solo)

'Art Pro Choice',
565 Broadway, New York, single evening exhibition to
benefit the National Abortion Rights Action League
(group)

1991
Lifetime Achievement Award, International Sculpture
Center, Washington, DC (first recipient)

Awarded the Grand Prix National de Sculpture by the
French Ministry of Culture

'Louise Bourgeois',
Ydessa Hendeles Art Foundation, Toronto (solo)

'Louise Bourgeois: Recent Sculpture',
Robert Miller Gallery, New York (solo)

'Carnegie International',
Carnegie Museum of Art, Pittsburgh (group)
Cat. *Carnegie International 1991*, Rizzoli, New York;
Carnegie Museum of Art, Pittsburg, texts Lynne Cooke,
Mark Francis

'Dislocations',
The Museum of Modern Art, New York (group)
Cat. *Dislocations*, The Museum of Modern Art, New
York, text Robert Storr

Selected articles and interviews
1989–91

Gardner, Paul, 'Louise Bourgeois', *Contemporanea*,
Bologna, October
Hardy, Ellen, 'Louise Bourgeois', *Arts*, New York,
September
Harris, Ann Sutherland, 'Entering the Mainstream:
Women Sculptors of the 20th Century, Part Two: Louise
Bourgeois and Eva Hesse', *Gallerie: Women's Art*,
Vancouver, Winter
Kirili, Alain, 'The Passion For Sculpture: A Conversation
with Louise Bourgeois', *Arts*, New York, March
Storr, Robert, 'Louise Bourgeois', *Galeries Magazine*,
Paris, June–July, 1990

1990

Graham-Dixon, Andrew, 'Just Dismember This',
Independent, London, 15 May

1991

Helfenstein, Josef, 'The Power of Intimacy'; Meyer-
Thoss, Christiane, 'I Am a Woman with No Secrets',
(statements by Louise Bourgeois); Nixon, Mignon,
'Pretty as a Picture'; Borja-Villel, Manuel J., 'Louise
Bourgeois' DÉFI'; Szeeman, Harald, 'The Fount of
Youth', *Parkett*, Zurich, No. 27, March

Selected exhibitions and projects
1991–93

1992
'Currents 21: Louise Bourgeois',
Milwaukee Art Museum, Milwaukee, WI (solo)

'Louise Bourgeois: Drawings',
Second Floor, Reykjavik (solo)

'The Fabric Workshop's 15th Anniversary Annual
Benefit Honoring Louise Bourgeois and Anne
d'Harnoncourt', with a new performance by Louise
Bourgeois in collaboration with The Fabric Workshop,
'She Lost It'
The Fabric Workshop, Philadelphia (solo)

'Louise Bourgeois',
Ydessa Hendeles Art Foundation, Toronto (solo)

'Louise Bourgeois',
Galerie Karsten Greve, Paris (solo)

'Documenta IX',
Kassel, Germany (group)
Cat. *Documenta IX*, Edition Cantz, Stuttgart; Harry N.
Abrams, New York, texts Jan Hoet, Bart De Baere,
Denys Zacharopoulos, Pier Luigi Tazzi, Claudia Herstatt
et.al.

'Cross Section',
Battery Park City and World Financial Center, New
York (group)

1993
Honorary Doctorate in Fine Arts (DFA) by Pratt
Institute, Brooklyn, New York

'Louise Bourgeois',
Linda Cathcart Gallery, Santa Monica (solo)

'Louise Bourgeois Personages, 1940s / Installations,
1990s',
Laura Carpenter Fine Art, Santa Fe (solo)

'Louise Bourgeois',
Galerie Ramis Barquet, Monterrey, Mexico (solo)
Cat. *Louise Bourgeois*, Mexico Galeria Ramis Barquet,
Mexico City, text Jorge Garcia Murillo

American Pavilion,
XLV Venice Biennale (group)

Selected articles and interviews
1991–93

Paparoni, Demetrio, 'Louise Bourgeois', *Tema Celeste*,
Milan, March–April (reprinted in English in
International Edition, May–June, 1991)

1992

McEvilley, Thomas, 'Louise Bourgeois Fabric
Workshop', *Artforum*, New York, Summer, 1993

Mays, John Bentley, 'A Descent into the Hell of Modern
Anguish', *Globe and Mail*, Toronto, 23 May

Geldzahler, Henry, 'Louise Bourgeois', *Interview*, New
York, March
Leigh, Christian, 'Rooms, Doors, Windows: Making
Entrances & Exits (When Necessary). Louise
Bourgeois's Theatre of the Body', *Balcon*, Madrid, Nos.
8–9
Morgan, Stuart, 'les totems et les tabous de Louise
Bourgeois', *Beaux Arts*, Paris, November
Wye, Pamela, 'Louise Bourgeois', *Arts*, New York,
January

1993

Spector, Nancy; Bourgeois, Louise, 'Louise Bourgeois
at the Venice Biennale', *Guggenheim Magazine*, New
York, Summer

Selected exhibitions and projects
1993–95

'Louise Bourgeois: The Locus of Memory',
Brooklyn Museum of Art; **Corcoran Gallery of Art**,
Washington, DC; **Galerie Rudolfinum**, Prague; **Musée
d'Art Moderne de la Ville de Paris**; **Deichtorhallen**,
Hamburg; **Musée d'Art Contemporain de Montreal**
(solo)
Cat. *Louise Bourgeois: The Locus of Memory,
1982–1993*, Harry N. Abrams, New York; Brooklyn
Museum, New York, texts Charlotta Kotik, Christian
Leigh, Terrie Sultan

'Et tous ils changent le monde',
Biennale d'art Contemporain, Lyon, France (group)
Cat. *Et tous ils changent le monde*, Réunion des Musées
Nationaux, Paris, ed. Marc Dachy, texts Thierry Prat,
Thierry Raspail

1994
'Louise Bourgeois',
Galerie Espace, Amsterdam (solo)

'Louise Bourgeois: The Personages',
Saint Louis Art Museum (solo)
Cat. *Louise Bourgeois: The Personages*, St. Louis
Museum of Art, text Jeremy Strick

'Louise Bourgeois',
Nelson-Atkins Museum of Art, Kansas City (solo)

'Louise Bourgeois: Sculptures',
Kestner-Gesellschaft, Hannover (solo)
Cat. *Louise Bourgeois Sculptures and Installations*,
Kestner-Gesellschaft, Hannover, texts Carsten Ahrens,
Barbara Catoir, Carl Haenlein, et al.

'Louise Bourgeois: The Red Rooms',
Peter Blum, New York (solo)

1995
'Louise Bourgeois: Pensées-plumes',
Centre Georges Pompidou, Paris, toured to **Helsinki
City Art Museum** (solo)
Cat. *Louise Bourgeois Pensée-Plumes*, Cabinet d'art
graphique, Centre Georges Pompidou, Paris, text
Marie-Laure Bernadac

'Louise Bourgeois: Dessins pour Duras',
Theatre du Vieux Colombier, Paris (solo)

Selected articles and interviews
1993–95

Rimanelli, David, 'Louise Bourgeois Brooklyn Museum
New York', *Artforum*, New York, September, 1994

Danto, Ginger, 'Lyon, Biennial of Contemporary Art',
ArtNews, New York, January, 1994

Amsellem, Patrick, 'Louise Bourgeois', *Beckerell*,
Malmo, Sweden, Summer
Graham-Dixon, Andrew, 'Totem and taboo', *British
Vogue*, London, June
Lapis, Milan, June (Entire issue of feminist Italian
magazine illustrated with Bourgeois works, including
cover)
Maxwell, Douglas, 'Louise Bourgeois', *Modern Painters*,
London, Summer
Nesbitt, Lois, 'Louise Bourgeois', *Art & Antiques*,
Atlanta, February

1994

Heartney, Eleanor, 'Louise Bourgeois at Peter Blum',
Art in America, New York, January, 1995

Bonami, Francesco, 'Louise Bourgeois: In a Strange
Way, Things are Getting Better and Better', *Flash Art*,
New York, January–February
Gibson, Ann, 'Louise Bourgeois's Retroactive Politics of
Gender', *Art Journal*, New York, Winter

1995
Dagen, Philippe, 'Louise Bourgeois: pourquoi une telle
outrance?', *Connaissance des Arts*, Paris, July–August
Tiihonen, Matti, 'Louise Bourgeois murskaa muistoja',
Vapaala, Finland, 27 June

Selected exhibitions and projects
1995–96

'Louise Bourgeois',
Mitsubishi-Jisho Artium, Fukuoka City, Japan, toured
to **Walker Hill Art Center**, Seoul, Korea (solo)
Cat. *Louise Bourgeois*, Mitsubishi-Jisho Artium with
the cooperation of MOMA Contemporary Co. Ltd.,
Fukuoka City, text Atsuko Murayama

'Louise Bourgeois',
MARCO, Monterrey, Mexico, toured to **Centro Andaluz
de Arte Contemporaneo**, Seville; **Museo Rufino
Tamayo**, Mexico City (solo)
Cat. *Escultura de Louise Bourgeois: La Eleganca de la
Ironia*, Museo de Art Contemporaneo de Monterrey
(MARCO), Monterrey, texts Richard D. Marshall, Paulo
Herkenhoff

'Louise Bourgeois',
National Gallery of Victoria, Melbourne, toured to
Museum of Contemporary Art, Sydney (solo)
Cat. *Louise Bourgeois*, National Gallery of Victoria,
Melbourne, texts Jason Smith, Robert Storr

'ARS 95 Helsinki',
Nyktaiteen Museo, Helsinki (group)

XLVI Venice Biennale (group)

'Rites of Passage',
Tate Gallery, London (group)
Cat. *Rites of Passage: Art for the End of the Century*,
Tate Gallery Publications, London, texts Stuart
Morgan, Frances Morris

'The 2nd Fujisankei Biennale',
Utsukushi-ga-hara Open-Air Museum, Japan (group)
Cat. *The 2nd Fujisankei Biennale*, Hakone Open-Air
Museum and The Utsukushi-ga-hara Open-Air Museum,
Japan, texts Yoshihiko Kobayashi, Shinya Ueda, Sam
Hunter

1996
'Louise Bourgeois',
Gallery Paule Anglim, San Francisco (solo)

Permanent installation, *Les Bienvenus*,
Parc de la Mairie de Choisy-le-Roi (solo)

'Louise Bourgeois: Spiders',
Baumgartner Galleries, Inc., Washington, DC (solo)

'Louise Bourgeois',
Galerie Soledad Lorenzo, Madrid (solo)
Cat. *Looking Inwards*, Galeria Soledad Lorenzo, Madrid,
text Estrella De Diego

'Louise Bourgeois',
Xavier Hufkens Gallery, Brussels (solo)

'Inside the Visible',
Institute of Contemporary Art, Boston, toured to
National Museum of Women in the Arts, Washington,
DC; **Whitechapel Art Gallery**, London (group)

Selected articles and interviews
1995–96

Caballero, Patricia, 'Expondrá Marco la obra de Louise
Bourgeois', *ABC*, Monterrey, Mexico, 10 June

Sladen, Mark, 'Louise Bourgeois', *Art Monthly*, London,
December
Storr, Robert, 'The Discreet Charm of Louise
Bourgeois', *Tate Magazine*, London, Summer

1996

Selected exhibitions and projects
1996–98

Cat. *Inside the Visible*, The Institute of Contemporary Art, Boston; MIT Press, Cambridge, Massachusetts, texts Rosi Huhn, et al.

XXIII International São Paulo Bienal (group)

'The Visible & The Invisible: Re-presenting the Body in Contemporary Art and Society',
organized by the Institute of International Visual Arts, London
St. Pancras Church, London (group)

1997
National Medal of Arts presented by President Clinton at the White House, Washington, DC

'Louise Bourgeois: Spider,
Cheim & Read, New York (solo)

'Louise Bourgeois: Sculpture',
Centro Cultural Banco Cultural do Brasil, Rio de Janeiro (solo)
Cat. *Louise Bourgeois*, Centro Cultural do Brasil, Rio de Janeiro, text Paulo Herkenhoff

'Louise Bourgeois',
Galerie Karsten Greve, Cologne (solo)

'Louise Bourgeois: Blue Days and Pink Days',
Prada Foundation, Milan (solo)
Cat. *Louise Bourgeois: Blue Days and Pink Days*, Fondazione Prada, Milan, texts Pandora Tabatabai Asbaghi, Jerry Gorovoy, Paulo Herkenhoff

'Louise Bourgeois: Homesickness',
Yokohama Museum of Art, Yokohama, Japan (solo)
Cat. *Louise Bourgeois: Homesickness*, Yokohama Museum of Art, Yokahama, texts Taro Amano, Jerry Gorovoy, Robert Storr, Louise Neri

'Inside the Visible: Alternative Views of 20th Century Art Through Women's Eyes',
Art Gallery of Western Australia, Perth (group)

'Amour',
Fondation Cartier, Paris (group)

'Angel, Angel',
Kunsthalle, Vienna, toured to Biennale de Kwangju, Korea (group)

'Chimeriques Polymeres',
Biennale d'art Contemporain de Lyon,
Maison De Lyon, France (group)

Fifth International Istanbul Biennial (group)

1998
'Louise Bourgeois: Topiary,
Whitney Museum of American Art, New York (solo)

Selected articles and interviews
1996–98

Leffingwell, Edward, 'Report from São Paulo: Nationalism and Beyond', *Art in America*, New York, March, 1997

Govier, Katherine, 'The Prime of Madame Bourgeois', *Canadian Art*, Toronto, Spring

1997

'Bourgeois at Prada', *Flash Art*, Milan, New York, Summer

McDonald, John, 'Spectrum Arts: Pearls from Perth', *Sydney Morning Herald*, 5 April

Sischy, Ingrid. 'Louise Bourgeois', *Interview*, New York, October

1998

Selected exhibitions and projects
1998–2000

'Present Tense: Louise Bourgeois',
Art Gallery of Ontario, Toronto (solo)

'Louise Bourgeois: New Work',
Galerie Lars Bohman, Stockholm (solo)

'Louise Bourgeois: Geometry of Pleasure',
Barbara Krakow Gallery, Boston (solo)

'Louise Bourgeois',
capc Musée d'Art Contemporain, Bordeaux, toured to
Foundation Belem, Lisbon; **Malmo Konsthall**, Malmo,
Sweden; **Serpentine Gallery**, London (solo)
Cat. *Louise Bourgeois*, capc Musee d'Art Contemporain,
Bordeaux; Serpentine Gallery, London, texts Marie-
Laure Bernadac, Louise Neri, Paulo Herkenhoff

'Mirror Images: Women, Surrealism and Self-
Representation',
MIT List Visual Arts Center, Cambridge, Massacusetts,
toured to **Miami Art Museum**; **San Francisco Museum
of Modern Art** (group)

'Les Champs de La Sculpture',
Taipei Fine Arts Museum, Taiwan (group)
Cat. *Les Champs de la Sculpture*, Taipei Fine Arts
Museum, Taipei

1999
Awarded the Golden Lion, for a living master of
contemporary art, by Venice Biennale

'Louise Bourgeois',
Kunsthalle, Bielefeld, Germany (solo)
Cat. *Louise Bourgeois*, Kunsthalle, Bielefeld, text
Thomas Kellein

'Louise Bourgeois: Architecture and Memory',
Museo Nacional Centro de Arte - Reina Sofia, Madrid
(solo)
Cat. *Louise Bourgeois: Architecture and Memory*, Museo
Nacional Centro de Arte - Reina Sofia, Madrid, texts
Jerry Gorovoy, Danielle Tilkin, Joseph Helfenstein,
Beatriz Colomina, Christiane Terrisse, Lynne Cooke,
Mieke Bal, Jennifer Bloomer

2000
'Louise Bourgeois',
Galerie Hauser & Wirth, Zurich (solo)

'Louise Bourgeois: Inaugural Installation of the Tate
Modern Art at Turbine Hall',
Tate Modern, London (solo)
Cat. *Louise Bourgeois*, Tate Publishing, London, texts
Frances Morris, Marina Warner

'Louise Bourgeois: The Space of Memory',
National Museum of Contemporary Art, Kyunggi-Do,
Korea (solo)
Cat. *Louise Bourgeois*, National Museum of
Contemporary Art, Kyunggi-Do, texts Seung-Wan
Kang, Mihwa Park, Bernard Marcade

Selected articles and interviews
1998–2000

Knutson, Ulrika, 'Ett laddat magasin', *Manads
Journalen*, Stockholm, March

Unger, Miles, 'Louise Bourgeois at Barbara Krakow',
ARTnews, New York, March, 1999

1999

'Art Umfrage Skulptur: Louise Bourgeois', *Art Das
Kunstmagazin*, Hamburg, November

Gorovoy, Jerry; Tilkin, Danielle, 'Louise Bourgeois:
'Recordar es existir', *Guadalimar*, Madrid, October–
November

'Louise Bourgeois la tissandière', *L'oeil*, Lausanne,
Switzerland, April
Nixon, Mignon; Bird, Jon, eds. *Oxford Art Journal*,
Oxford, Vol. 22, No. 2

2000

Madoff, Steven Henry. 'Towers of London / Louise
Bourgeois: I Do, I Undo and I Redo; 1999–2000',
Artforum, New York, Summer

'Exhibition and Theme: Louise Bourgeois', *The Art
Magazine Wolgan Misool*, Korea, September

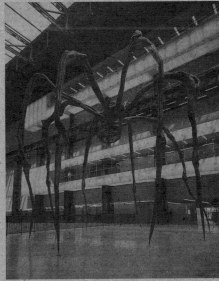

Maman, 1999, installed Tate Modern, London, 2000

Selected exhibitions and projects
2000–03

12th Biennale of Sydney,
Sydney, Australia

2001
Guggenheim Museum Bilbao, Bilbao, Spain (solo)

Cheim & Read, New York (solo)
Cat. *Louise Bourgeois: New Work*, Cheim & Read, texts
John Cheim, Thomas Whitridge, Raymond Carver

'Louise Bourgeois at the Hermitage',
State Hermitage Museum, St. Petersburg, toured to
Helsinki City Art Museum, Finland; **Kulturhuset**,
Stockholm; **Museet for Samtidskunst**, Oslo;
Louisiana Museum of Modern Art, Copenhagen (solo)
Cat. *Louise Bourgeois at the Hermitage*, State
Hermitage Museum, St. Petersburg

'The Surreal Woman',
Kunsthalle, Bielefeld (group)

2002
'Louise Bourgeois: Childhood'
Ars TEOR / éTica Fundación, San José, Costa Rica (solo)

'Louise Bourgeois: Le Jour La Nuit Le Jour',
Palais de Tokyo, Paris (solo)

Documenta 11,
Kassel, Germany (group)

'Louise Bourgeois: Drawings and Sculpture',
Kunsthaus Bregenz, Austria; **Zacheta Gallery of Art**,
Warsaw; **Akademie der Künste**, Berlin-Brandenburg,
Germany (solo)

'Louise Bourgeois: Recent Sculptures and Drawings',
Beaumontpublic, Luxembourg (solo)
Cat. *Louise Bourgeois: Recent Sculptures and Drawings*,
Beaumontpublic, Luxembourg, texts Jean-Christophe
Ammann, Dr. FrancisHermann, Allison Plath-Moseley

CD, *Louise Bourgeois: C'est le murmure de l'eau qui
chante*, produced by Brigitte Cornand, Les Films du
Siamois, Paris

2003
Award, Wolf Prize in the Arts (Painting and Sculpture),
Wolf Foundation, Israel

White Cube, London (solo)

Galerie Karsten Greve, Cologne (solo)

Irish Museum of Modern Art, Dublin (solo)

'Louise Bourgeois: The Insomnia Drawings',
Whitney Museum of American Art, New York (solo)

Louise Bourgeois : The Space of Memory
루이즈 부르주아 : 기억의 공간

국립현대미술관 제2전시실, 중앙홀 2000년 9월 7일 - 11월 5일

Selected articles and interviews
2000–03

Malineau, Sandrine, 'Couleurs Bourgeois', *art actuel*,
Quebec, Canada, January

2001

Princenthal, Nancy, 'Louise Bourgeois at Cheim &
Read', *Art in America*, New York, March, 2002

Castro, Jan Garden, 'Louise Bourgeois: Turning Myths
Inside Out', *Sculpture*, Washington, DC, January–
February
Vendrame, Simona, 'Louise Bourgeois', *Tema Celeste*,
Milan, May–June

2002

Acocella, Joan, 'The Spider's Web: Louise Bourgeois
and her Art', *New Yorker*, 4 February

Ahrens, Carsten, *Louise Bourgeois Sculptures and Installations*, Kestner-Gesellschaft, Hannover, 1994

Bal, Mieke, *Louise Bourgeois: Architecture and Memory*, Museo Nacional Centro de Arte - Reina Sofia, Madrid, 1999

Baldwin, Carl R., 'Louise Bourgeois: An Iconography of Abstraction', *Art in America*, New York, March–April, 1975

Bernadac, Marie-Laure, *Louise Bourgeois Pensée-Plumes*, Cabinet d'art graphique, Centre Georges Pompidou, Paris, 1995

Bernadac, Marie-Laure, *Louise Bourgeois*, capc Musee d'Art Contemporarin, Bordeaux; Serpentine Gallery, London, 1998

Bloch, Susi, 'An Interview with Louise Bourgeois', *Art Journal*, New York, Summer, 1976

Bloomer, Jennifer, *Louise Bourgeois: Architecture and Memory*, Museo Nacional Centro de Arte - Reina Sofia, Madrid, 1999

Bochner, Mel, 'Eccentric Abstraction', *Arts*, New York, November, 1966

Bonami, Francesco, 'Louise Bourgeois: In a Strange Way, Things are Getting Better and Better', *Flash Art*, New York, January–February, 1994

Borja-Villel, Manuel J., 'Louise Bourgeois' DÉFI', *Parkett*, Zurich, No. 27, 1991

Bourgeois, Louise, *Destruction of the Father, Reconstruction of the Father: Writings and Interviews, 1923–1997*, ed. Marie-Laure Bernadac and Hans Ulrich Obrist, MIT Press, Cambridge, Massachusetts, in association with Violette Editions, London, 1998

Cabanne, Pierre, 'Louise Bourgeois: sculpteur pour tuer le pere', *Le Matin*, Paris, 18 February, 1985

Carver, Raymond, *Louise Bourgeois: New Work*, Cheim & Read, New York, 2001

Catoir, Barbara, *Louise Bourgeois Sculptures and Installations*, Kestner-Gesellschaft, Hannover, 1994

Cheim, John, *Louise Bourgeois: New Work*, Cheim & Read, New York, 2001

Cohen, Ronny H., 'Louise Bourgeois: Max Hutchinson Gallery', *Artforum*, New York, November, 1980

Colomina, Beatriz, *Louise Bourgeois: Architecture and Memory*, Museo Nacional Centro de Arte - Reina Sofia, Madrid, 1999

Cooke, Lynne, *Louise Bourgeois: Architecture and Memory*, Museo Nacional Centro de Arte - Reina Sofia, Madrid, 1999

Gardner, Paul, 'The Discreet Charm of Louise Bourgeois', *ARTnews*, New York, February, 1980

Geldzahler, Henry, 'Louise Bourgeois', *Interview*, New York, March, 1992

Gibson, Ann, 'Louise Bourgeois's Retroactive Politics of Gender', *Art Journal*, New York, Winter, 1994

Gibson, Eric, 'New York Letter: Louise Bourgeois', *Art International*, Paris, November–December, 1978

Gorovoy, Jerry, *The Iconography of Louise Bourgeois*, Max Hutchinson Gallery, New York, 1980

Gorovoy, Jerry, *Louise Bourgeois*, Robert Miller Gallery, New York, 1986

Gorovoy, Jerry, *Louise Bourgeois: Blue Days and Pink Days*, Fondazione Prada, Milan, 1997

Gorovoy, Jerry, *Louise Bourgeois: Homesickness*, Yokohama Museum of Art, Yokahama, 1997

Gorovoy, Jerry, *Louise Bourgeois: Architecture and Memory*, Museo Nacional Centro de Arte - Reina Sofia, Madrid, 1999

Haenlein, Carl, *Louise Bourgeois Sculptures and Installations*, Kestner-Gesellschaft, Hannover, 1994

Helfenstein, Josef, 'The Power of Intimacy', *Parkett*, Zurich, No. 27, 1991

Helfenstein, Joseph, *Louise Bourgeois: Architecture and Memory*, Museo Nacional Centro de Arte - Reina Sofia, Madrid, 1999

Herkenhoff, Paulo, *Escultura de Louise Bourgeois: La Eleganca de la Ironia*, Museo de Art Contemporaneo de Monterrey (MARCO), Monterrey, 1995

Herkenhoff, Paulo, *Louise Bourgeois: Blue Days and Pink Days*, Fondazione Prada, Milan, 1997

Herkenhoff, Paulo, *Louise Bourgeois*, Centro Cultural do Brasil, Rio de Janeiro, 1997

Herkenhoff, Paulo, *Louise Bourgeois*, capc Musee d'Art Contemporarin, Bordeaux; Serpentine Gallery, London, 1998

Holman, Martin, 'Louise Bourgeois: Sculpture and Drawings', *Literary Review*, London, June, 1985

Kellein, Thomas, *Louise Bourgeois*, Kunsthalle, Bielefeld, 1999

Kirili, Alain, 'The Passion For Sculpture: A Conversation with Louise Bourgeois', *Arts*, New York, March, 1989

Kotik, Charlotta, *Louise Bourgeois: The Locus of Memory, 1982–1993*, Harry N. Abrams, New York; Brooklyn Museum, New York, 1993

Kraus, Rosalind, *Louise Bourgeois*, Frankfurter Kunstverein, Frankfurt; Musee d'art Contemporain, Lyon; Tapies Foundation, Barcelona, 1989

Kuspit, Donald, 'Louise Bourgeois', *Art in America*, New York, September–October, 1977

Kuspit, Donald, 'Louise Bourgeois – Where Angels Fear To Tread', *Artforum*, New York, March, 1987

Larson, Kay, 'Louise Bourgeois: Her Re-emergence Feels Like a Discovery', *ARTnews*, New York, May, 1981

Lawson, Thomas, 'Exhibition Review: Max Hutchinson Gallery', *Flash Art*, New York, November, 1980

Leffingwell, Edward, 'Report from São Paulo: Nationalism and Beyond', *Art in America*, New York, March, 1997

Leigh, Christian, 'Rooms, Doors, Windows: Making Entrances & Exits (When Necessary). Louise Bourgeois's Theatre of the Body', *Balcon*, Madrid, Nos. 8–9, 1992

Leigh, Christian, *Louise Bourgeois: The Locus of Memory, 1982–1993*, Harry N. Abrams, New York; Brooklyn Museum, New York, 1993

Linker, Kate, 'Louise Bourgeois', *Artforum*, New York, April, 1988

Lippard, Lucy R., *Eccentric Abstraction*, Fischbach Gallery, New York, 1966

Lippard, Lucy R., 'Louise Bourgeois: From the Inside Out', *Artforum*, New York, March, 1975

Lippard, Lucy R., *Louise Bourgeois*, Frankfurter Kunstverein, Frankfurt; Musee d'art Contemporain, Lyon; Tapies Foundation, Barcelona, 1989

Madoff, Steven Henry, 'Towers of London / Louise Bourgeois: I Do, I Undo and I Redo, 1999–2000', *Artforum*, New York, Summer, 2000

Malen, Lenore, 'Louise Bourgeois', *ARTnews*, New York, April, 1988

Marandel, Patrice J., *Louise Bourgeois: Femme Maison*, The Renaissance Society at the University of Chicago, 1981

McEvilley, Thomas, 'Louise Bourgeois Fabric Workshop', *Artforum*, New York, Summer, 1993

Meyer-Thoss, Christiane, 'I Am a Woman with No Secrets', *Parkett*, Zurich, No. 27, 1991

Morgan, Stuart, 'Louise Bourgeois at Robert Miller', *Artscribe*, London, September–October, 1986

Morgan, Stuart, *Louise Bourgeois*, Taft Museum, Cincinnati, 1987

Morgan, Stuart, 'Taking Cover: Louise Bourgeois interviewed by Stuart Morgan', *Artscribe*, London, January–February, 1988

Morgan, Stuart, *Louise Bourgeois: Recent Work 1984–1989*, Riverside Studios, London, 1990

Morgan, Stuart, 'les totems et les tabous de Louise Bourgeois', *Beaux Arts*, Paris, November, 1992

Morris, Frances, *Louise Bourgeois*, Tate Publishing, London, 2000

Nemser, Cindy, 'Forum: Women in Art', *Arts*, New York, February, 1971

Neri, Louise, *Louise Bourgeois: Homesickness*, Yokohama Museum of Art, Yokohama, 1997

Neri, Louise, *Louise Bourgeois*, capc Musee d'Art Contemporarin, Bordeaux; Serpentine Gallery, London, 1998

Nesbitt, Lois, 'Louise Bourgeois', *Art & Antiques*, Atlanta, February, 1993

Nixon, Mignon, 'Pretty as a Picture', *Parkett*, Zurich, No. 27, 1991

Nochlin, Linda, 'Why Have There Been No Great Women Artists?', *ARTnews*, New York, January, 1971

Paparoni, Demetrio, 'Louise Bourgeois', *Tema Celeste*, Milan, March–April, 1991 (reprinted in English in International Edition, May–June, 1991)

Pels, Marsha, 'Louise Bourgeois: A Search for Gravity', *Art International*, Paris, October, 1979

Pincus-Whitten, Robert, *Bourgeois Truth*, Robert Miller Gallery, New York, 1982

Porter, Fairfield, 'Exhibition review, Peridot Gallery', *ARTnews*, New York, April, 1953

Princenthal, Nancy, 'Louise Bourgeois at Cheim & Read', *Art in America*, New York, March, 2002

Ratcliff, Carter, 'Louise Bourgeois', *Art International*, Paris, November–December, 1978

Rose, Barbara, 'Sex, Rage & Louise Bourgeois', *Vogue*, New York, September, 1987

Smith, Jason, *Louise Bourgeois*, National Gallery of Victoria, Melbourne, 1995

Spector, Nancy, Bourgeois, Louise, 'Louise Bourgeois at the Venice Biennale', *Guggenheim Magazine*, New York, Summer, 1993

Storr, Robert, 'Louise Bourgeois: Gender & Possession', *Art in America*, New York, April, 1983

Storr, Robert, 'Meaning, Material, Milieu, Reflections on Recent Work by Louise Bourgeois: Interview by Robert Storr', *Parkett*, Zurich, No. 9, 1986

Storr, Robert, 'Louise Bourgeois', *Galeries Magazine*, Paris, June–July, 1990

Storr, Robert, *Louise Bourgeois*, National Gallery of Victoria, Melbourne, 1995

Storr, Robert, 'The Discreet Charm of Louise Bourgeois', *Tate Magazine*, London, Summer, 1995

Storr, Robert, *Louise Bourgeois: Homesickness*, Yokohama Museum of Art, Yokahama, 1997

Strick, Jeremy, *Louise Bourgeois: The Personages*, St. Louis Museum of Art, 1994

Sultan, Terrie, *Louise Bourgeois: The Locus of Memory, 1982–1993*, Harry N. Abrams, New York; Brooklyn Museum, New York, 1993

Szeemann, Harald, 'The Fount of Youth', *Parkett*, Zurich, No. 27, 1991

Tazzi, Pier Luigi, 'Louise Bourgeois at the Kunstverein', *Artforum*, New York, Summer, 1990

Terrisse, Christiane, *Louise Bourgeois: Architecture and Memory*, Museo Nacional Centro de Arte - Reina Sofia, Madrid, 1999

Tilkin, Danielle, *Louise Bourgeois: Architecture and Memory*, Museo Nacional Centro de Arte - Reina Sofia, Madrid, 1999

Vendrame, Simona, *Louise Bourgeois*, *Tema Celeste*, Milan, May–June, 2001

Warner, Marina, *Louise Bourgeois*, Tate Publishing, London, 2000

Weiermair, Peter, *Louise Bourgeois*, Frankfurter Kunstverein, Frankfurt; Musee d'art Contemporain, Lyon; Tapies Foundation, Barcelona, 1989

Whitridge, Thomas, *Louise Bourgeois: New Work*, Cheim & Read, New York, 2001

Wye, Deborah, *Louise Bourgeois: Matrix/Berkeley 17*, University Art Museum, University of California, Berkeley, 1967

Wye, Deborah, *Louise Bourgeois*, The Museum of Modern Art, New York, 1983

Public collections

Kunstmuseum, Basel
Kunstmuseum, Bern
Guggenheim Museum Bilbao, Spain
Albright-Knox Art Gallery, Buffalo, New York
Fogg Art Museum, Cambridge, Massachusetts
Australian National Gallery, Canberra, Australia
Jane Addams Park, Chicago
Cleveland Museum of Art, Ohio
Museum Ludwig, Cologne
Denver Art Museum
Modern Art Museum of Fort Worth, Texas
Uffizi Museum, Flórence
Museum of Fine Arts, Houston, Texas
British Museum, London
Des Moines Art Center, Iowa
Detroit Institute of the Arts
Sheldon Memorial Art Gallery, Lincoln
Tate Gallery, London
Kunstmuseum, Luzern
Reina Sophia, Madrid
Walker Art Center, Minneapolis
New Orleans Museum of Art
Musée d'art Contemporain de Montreal, Canada
Storm King Art Center, Mountainville, New York
American Craft Museum, New York
Brooklyn Museum, New York
Battery Park City Authority for the Robert F. Wagner, Jr. Park, New York
Solomon R. Guggenheim Museum, New York
Metropolitan Museum of Art, New York
The Museum of Modern Art, New York
New York Public Library
New York University
Whitney Museum of American Art, New York
Bibliotheque Nationale de Paris
Jardin des Tuileries, Paris
Musée d'art Moderne de la Ville de Paris
Musée National d'Art Moderne, Centre Georges Pompidou, Paris
Tuileries, Paris
Philadelphia Museum of Art
Carnegie Museum, Pittsburgh
Pittsburgh Cultural Trust
Portland Museum of Art
Rhode Island School of Design, Providence
Olympic Park, Seoul, Korea
Saint Louis Art Museum
Hakone Open-Air Museum, Tokyo
Tokyo International Forum Art Work Project, Japan

Ydessa Hendeles Foundation, Toronto
Ulmer Museum, Ulm
National Gallery of Victoria, Australia
Grafische Sammlung Albertina, Vienna
Museum of Modern Art, Vienna
Hirshhorn Museum and Sculpture Garden, Washington, DC
National Gallery of Art, Washington, DC
Williams College Museum of Art

Comparative Images

page 11, **Bernice Abbott**
Louise Bourgeois

page 10, **Edvard Munch**
Lovers in the Waves
1896

page 24, **Gian Lorenzo Bernini**
The Ecstasy of Saint Theresa
Cornaro Chapel, Santa Maria della Vittoria, Rome

page 44, **Paul Colin**
Wiener et Doucet

page 44, **Fernand Léger**
The City
Philadelphia Museum of Art

page 52, **David Smith**
Blackburn, Song of an Irish Blacksmith
Stiftung Wilhelm Lehmbruck Museum, Duisburg

page 54, **Dogon Ladder**

page 54, **Max Ernst**
Lunar Asparagus
The Museum of Modern Art, New York

page 56, **Alberto Giacometti**
City Square

page 58, **Carl Andre**
Equivalent VIII

page 58, **Constantin Brancusi**
Endless Column
Installed, Tirgu Jui public park, Rumania

page 65, **Constantin Brancusi**
Bird in Space
The Museum of Modern Art, New York

page 66, **Pieter Brueghel**
The Peasant Wedding
Kunsthistorisches Museum, Vienna

page 75, **Venus of Willendorf**
Naturhistorisches Museum, Vienna

page 75, **Constantin Brancusi**
Princesse X

page 131, **Robert Mapplethorpe**
Louise Bourgeois

List of Illustrated Works

page 23, **Arch of Hysteria**, 1993
page 85, **Articulated Lair**, 1986
page 57, **The Blind Leading the Blind**, 1947–49
page 70, **Blind Man's Buff**, 1984
page 55, **Brother & Sister**, 1949
page 66, **A Banquet / A Fashion Show of Body Parts**, 1978
page 58, **C.O.Y.O.T.E.**, 1947–49
pages 134–35, **Cell (Arch of Hysteria)**, 1992–93
page 82, **Cell (Choisy)**, 1990–93
page 21, **Cell (Clothes)**, 1996
page 83, **Cell (Eyes and Mirrors)**, 1989–93
pages 94, 97, 98–99, 100, 103, **Cell (You Better Grow Up)**, 1993
pages 132, 133, **Cell I**, 1991
page 136, **Cell VII**, 1998
page 86, **Cell XI (Portrait)**, 2000
page 86, **Cell XIV (Portrait)**, 2000
page 137, **Cell XIX (Portrait)**, 2000
page 87, **Cell XXIII (Portrait)**, 2000
page 84, **Cell XXV (The View of the World of the Jealous Wife)**, 2001
page 121, 122, **Child Abuse**, 1982
page 61, **Clutching**, 1962
page 66, **Confrontation**, 1978
page 93, **Couple**, 2001
page 68, **Cumul I**, 1969
page 140, **The Curved House**, 1990
pages 38, 39, **The Destruction of the Father**, 1974
page 67, **End of Softness**, 1967
page 87, **Endless Pursuit**, 2000
page 70, **Eye to Eye**, 1970
page 80, **Eyes**, 1982
page 80, **Eyes**, 2001
page 120, **Femme Couteau**, 1982
page 51, **Femme Maison**, 1945–47
page 51, **Femme Maison**, 1946–47
page 51, **Femme Maison**, 1946–47
page 72, **Femme Pieu**, c. 1970
page 59, **Femme Volage**, 1951
page 72, **Fillette (Sweeter Version)**, 1968–99
page 72, **Fillette**, 1968
page 29, **Girl Falling**, 1947
page 119, **Hanging Janus with Jacket**, 1968
page 73, **Harmless Woman**, 1969
pages 46, 47, **He Disappeared into Complete Silence**, 1947
page 68, **Heart**, 1970
page 143, **Henriette**, 1985
page 24, **Homage to Bernini**, 1967
page 8, **The Hour is Devoted to Revenge**, 1999

pages 15, 16, **I Do**, 1999–2000
pages 15, 17, **I Redo**, 1999–2000
pages 15, 16, **I Undo**, 1999–2000
pages 78–79, **In and Out**, 1995
pages 40, 41, **The Insomnia Drawings**, 1994–95
page 119, **Janus**, 1968
page 119, **Janus Fleuri**, 1968
page 119, **Janus in Leather Jacket**, 1968
page 48, **Knife Couple**, 1949
page 60, **Lair**, 1962
page 127, **Le Defi**, 1991
page 64, **Le Trani Eposide**, 1971
page 60, **Labyrinthine Tower**, 1962
page 140, **Maison**, 1961
page 4, **Maman**, 1999
page 24, **Mamelles**, 1991
page 59, **Memling Dawn**, 1951
page 76, **Nature Study**, 1984
page 81, **Nature Study, Velvet Eyes**, 1984
page 124, **Needle (Fuseau)**, 1992
page 104, **No Exit**, 1989
page 69, **Noir Veine**, 1968
page 71, **Number Seventy-two (The No March)**, 1972
page 56, **One and Others**, 1955
page 129, **Orange Episode**, 1990
page 74, **Partial Recall**, 1979
page 107, **Passage Dangereux**, 1997
page 52, **Persistent Antagonism**, 1946–48
page 48, **Pillar**, 1949–50
page 21, **Pink Days and Blue Days**, 1997
page 125, **Poids**, 1993
page 54, **Portrait of C.Y.**, 1947–49
page 53, **Portrait of Jean-Louis**, 1947–49
page 25, **Portrait of Robert**, 1969
page 85, **Precious Liquids**, 1992
page 115, **The Puritan: Painted Flat Triptych No. 5**, 1990–97
page 55, **Quarantania**, 1947–53
page 68, **Rabbit**, 1970
pages 108, 110–11, **Red Room (Child)**, 1994
pages 108, **Red Room (Parents)**, 1994
page 13, **Rejection**, 2000
page 36, **Resin Eight**, 1965
page 61, **Rondeau for L**, 1963
page 92, **Seven in Bed**, 2001
page 42, **The She-Fox**, 1985
page 29, **Skains**, 1943
page 65, **Sleep II**, 1967
page 45, **Sleeping Figure**, 1950
page 63, **Soft Landscape**, 1963
page 63, **Soft Landscape I**, 1967
page 19, **Spider IV**, 1996
page 18, **Spider**, 1995
page 4, **Spider**, 1996
page 18, **Spider**, 1996
page 43, **Spider**, 1997

page 124, **Spindle**, 1992
page 123, **Spiral Woman**, 1984
page 139, **Topiary IV**, 1999
page 9, **Torment**, 1999
page 62, **Torso, Self Portrait**, 1963–64
page 77, **Twosome**, 1991
page 28, **Untitled**, 1940
page 28, **Untitled**, 1941
page 28, **Untitled**, 1943
pages 34–35, **Untitled**, 1946–48
page 30, **Untitled**, 1947
page 30, **Untitled**, 1947
page 30, **Untitled**, 1947
page 32, **Untitled**, 1947
page 89, **Untitled**, 2000
page 89, **Untitled**, 2000
page 89, **Untitled**, 2001
page 90, **Untitled**, 2002
page 91, **Untitled**, 2002
page 14, **Untitled**, c. 1970
page 12, **Untitled (I Have Been to Hell and Back)**, 1996
page 26, **The Winged Figure**, 1948